How to photograph
FLOWERS, PLANTS & LANDSCAPES

Derek Fell

Executive Editor: Carl Shipman
Editor: David A. Silverman
Art Director: Don Burton
Book Design & Assembly: George Haigh
Typography: Cindy Coatsworth, Joanne Nociti

Notice: The information contained in this book is true and complete to the best of our knowledge. All recommendations are made without any guarantes on the part of the author or HPBooks. The author and publisher disclaim all liability incurred in connection with the use of this information.

Published by H.P. Books, P.O. Box 5367, Tucson, AZ 85703 602/888-2150
ISBN: O-89586-O68-6 Library of Congress Catalog No. 8O-82571
©198O Fisher Publishing, Inc. Printed in U.S.A

Contents

 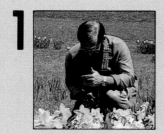

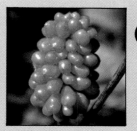 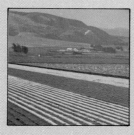

Planting the Seed

Photography and gardening are America's top leisure time activities, and no two pastimes make a finer combination. Plant photography is fun, exciting and can be full of adventure. It opens your eyes to a new world of beauty you may have taken for granted. It's healthy and rewarding, creative and enlightening. Success does not depend on a mass of complicated equipment, a lavish studio or a comprehensive knowledge of camera terms and techniques. The formula for success is a few simple, easy-to-learn basics.

Most of the photographs in this book, both color and black-and-white, *were taken using just four fundamental items of equipment*—a *camera body*, a *close-up lens*, a *roll of film* and a *light meter*, no tripod, no flash, no filters, no cable release, no extension rings, no bellows, no wind breaks—in other words, no fancy equipment.

A student once wrote to me asking what qualifications are required to become a "plant photographer." With some regret I had to explain that there are very few positions in the world that carry the title "plant photographer." I know of only one gardening magazine, one seed company and one horticultural institution that employ a "plant photographer."

All other plant photographs used by magazines, catalog houses, book publishers, encyclopedias, calendar and greeting card manufacturers, horticultural societies and lecturers are contributed by an active group of amateurs and semi-professionals who make a living at something else. They supply the market by photographing plants on weekends, in spare time and on holidays, building collections of beautiful pictures.

Some are elderly people who discovered a liking for plant photography after they had reached retirement, and use it as an answer to the problem of finding "something to do." Many of them are women or husband-and-wife teams.

I consider myself fortunate in having developed an interest in plant photography at an early age. It is an enjoyable pastime that more young people can find immensely satisfying.

Although this book is written for the average photo enthusiast, whether or not he is a gardener, photographer or just an "outdoor type," I believe that many professional photographers will find valuable information here. My aggressive stand on *simplicity* may be surprising, but it works. Also, my observations and first-hand experience with various kinds of plants and garden situations should be of value.

Neither gardening nor photography need be complicated. If this book encourages a few people to give my methods a try, I will be very pleased.

ABOUT THE AUTHOR
Derek Fell is a widely published plant photographer and writer. He has traveled throughout the world taking photographs of flowers, plants and landscapes, and has more than 15,000 color transparencies in his horticultural picture library. His work appears regularly in *Architectural Digest, Time, National Geographic* books, *Woman's Day, Plants Alive, Flower & Garden, Mother Earth News, Encyclopaedia Britannica* and many other publications. Fell is past director of All-America Selections (the national seed trials), the National Garden Bureau (an information office sponsored by the American garden seed industry) and the Garden Writers Association of America, and has also served as president of the Hobby Greenhouse Association.

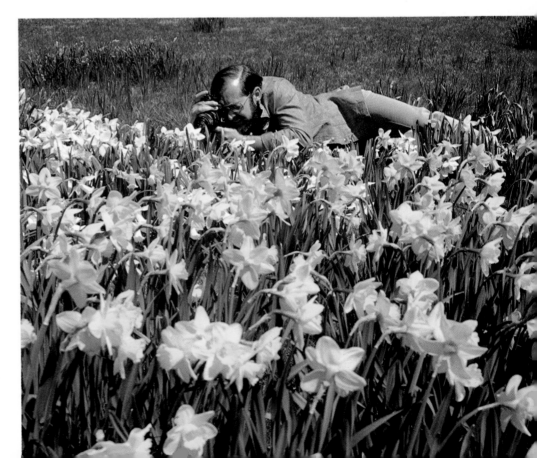

1
Equipment—Keep It Simple

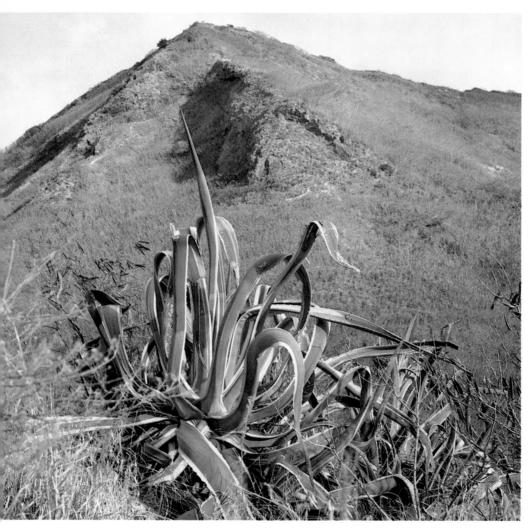

To capture this picture of wild variegated century plants, *Agave americana* Variegata, high up on a crater rim, I made a strenuous climb up steep, slippery slopes. I was thankful that my medium-format Rolleiflex was lightweight and didn't hinder my climbing abilities.

While working for a British advertising agency, I had to produce some advertisements for a seed company that had developed a new strain of hybrid cabbage. I needed a photographer to shoot color transparencies suitable for reproduction. The editor of a national garden magazine recommended an elderly gentleman—Harry Smith, a retired schoolteacher—who was producing some extremely good work. I gave Harry his first commercial assignment—photographing cabbages growing at a research farm. The client and I went out to watch Harry in action.

He turned up at the farm with little more than a roll-film camera, a tripod and a set of close-up lenses. The client was surprised at the lack of equipment and wanted to know who this character was, taking "pot-shots" of his plants. I suggested we shouldn't judge him until we saw the results, although I said it with apprehension.

A week later Harry brought the pictures to my office. I will never forget the effect his work had on me. The color transparencies were beautiful, and I couldn't believe that such beauty had been achieved with so little effort. From that moment on, I was hooked on plant photography. I bought the same camera and the same set of close-up lenses he used, and started to emulate his style. Harry went on to greater accomplishments: Within seven years he became the most widely published plant photographer in the world, shooting tens of thousands of plant pictures with his simple system. Shortly before his death in

When I first became interested in photography, I thought a good photographer had to amass a lot of expensive equipment and master some complicated photographic systems. Visiting photographic exhibits looking for ideas and inspiration, I was impressed with the special effects; but all the filters, lighting equipment and different lenses confused me. It seemed that to be a professional photographer you had to be more of a technician than an artist. Fortunately, something happened that changed my mind and convinced me that good photography can be simple.

1974, he was awarded a Silver Medal from the Royal Horticultural Society of Great Britain for his outstanding work as a plant photographer.

I never saw Harry use a filter or any supplementary lens other than screw-on close-up lenses; the only time he used a second camera was on one special assignment where the publisher insisted the job be photographed on 35mm film—a format he had not used before. Harry told me about the assignment—to shoot the photographs for a book entitled *The Rothschild Rhododendrons*. He considered it to be the most exciting assignment of his career because the photography had to be done over a period of a year at the Rothschild estate of Exbury in England, but the thought of having to use a different camera system terrified him. He bought a good 35mm single-lens-reflex (SLR) camera, and the results were magnificent.

The book is a masterpiece because of Harry's color photography. A copy was presented to the White House by Baron Edmund de Rothschild—and the British Royal Family purchased four copies!

Simplicity has also worked well for me. My main objective from the very beginning was to build up a large file of plant pictures as quickly as possible, for the purpose of renting specimen shots to publishers. I have visited a botanical garden and photographed over 200 specimen plants in a single day—every exposure a salable picture. This kind of productivity is difficult when you have a lot of accessories to carry around.

There are literally hundreds of cameras, films and accessories you can use for plant photography. However, there's no need to complicate things with a lot of non-essential equipment that can hinder more than help. My cardinal rule is *keep it simple*. Four basic items are all that's necessary to take good plant pictures: *a camera, a close-up lens, film,* and *a light meter*. With these fundamental tools, you can become a competent plant photographer and experience a great deal of fun and satisfaction.

Botanical Definitions Used In This Book
Anthers—pollen-bearing part of flower; the male organs.
Bracts—modified leaves, usually surrounding a flower and forming a pattern.
Catkins—drooping flowers found on trees.
Double flowers—flowers with more than one row of petals.
Espalier—method of training trees and shrubs so their branches grow flat against a wall or trellis.
Hybrid—a cross between two genetically different, but sexually compatible plants, in the same way that crossing a donkey with a mare produces a mule.
Mulch—a covering of material over soil to control weeds, usually straw, pine needles, bark chips or black plastic.
Naturalized plantings—plantings that appear to be part of a natural landscape, usually covering a large area of meadow, woods or rock garden, and increasing in numbers each year.
Parterre—an ornamental garden area of low clipped hedges forming a pattern.
Single flower—flower possessing one row of petals.
Species—individual plants that are generally similar to each other and interbreed freely.
Stamens—the pollen-bearing part of the flower. The anthers, and the stalk supporting it, the filament, are collectively known as stamens.
Stigma—part of the flower which accepts pollen for fertilization; the tip of the female organ.
Strain—a group of plants with common lineage.

CAMERAS

The more versatile and easy-to-use your camera is, the better it will be for plant photography. Plants grow where you find them, and to take the best natural pictures, you must often squeeze into some tight places. While equipment is important, it's easier to master a few essentials than it is to contend with a welter of paraphernalia. Learn to do the essentials well, and you'll soon find yourself reacting automatically to a situation, gaining excellent pictures most of the time.

Weight of equipment is an extremely important consideration. Chasing around 1,000 acres such as at Longwood Gardens in Pennsylvania, searching for the best specimens to photograph, can be tiring even without a camera. The easier your equipment is to carry, the more ground you will cover and the more good pictures you will obtain.

Once I explored Koko Crater Botanical Garden near Honolulu, Hawaii. I was high up on the slopes of the crater, slipping and sliding on the bone-dry, stony soil, trying to reach a magnificent stand of variegated century plants. Everything I carried felt like a lead weight. The slightest move required tremendous exertion, yet the sight of those beautiful plants drove me on. I felt compelled to touch them, to marvel at them, but most of all to photograph them.

When I finally reached the plants, I realized how fortunate I was to have a lightweight camera. With anything heavier, or a bulky bag of accessories, I could never have made that climb, or taken such beautiful pictures of the wild plants with the volcano rim in the background.

Camera bodies are generally classified by the film size they use, in three main types. When planning equipment purchase, keep in mind that you may be carrying it around for a *long* day.

5

SHEET-FILM CAMERAS

The largest format is the sheet-film camera, sometimes called *large-format*. The camera and lens are relatively expensive and bulky, and film must be loaded into individual sheet-film holders. They are used mostly by professional photographers specializing in commercial photography requiring high quality reproduction for presentations, exhibition displays and blow-ups such as posters. Loading film is slow, a high degree of technical know-how is required, and a black cloth is needed over your head so you can see the upside-down, laterally reversed image on the ground glass focusing screen.

The 8 x 10-inch large-format camera is a complicated system, physically unwieldy and extremely restrictive. Smaller sizes are 5 x 7-inch and 4 x 5-inch. Although much smaller than the 8 x 10-inch camera, they are still bulky and hard to use without a sturdy tripod.

There are a number of dedicated nature and plant photographers who use large-format cameras and endure the resulting restrictions to gain impressive image size. Perhaps when I reach retirement and have the time, I might be converted to a large-format camera. For now, they are too cumbersome and slow for me.

MEDIUM-FORMAT CAMERAS

This system uses 120 or 220 roll film, producing square or rectangular images. Two formats are square — 4.5 x 4.5 cm (1-5/8 x 1-5/8 inch) and 6 x 6 cm (2-1/4 x 2-1/4 inch); and two are rectangular—6 x 4.5 cm (2-1/4 x 1-5/8 inch) and 6 x 7 cm (2-1/4 x 2-3/4 inch). Of these, 6 x 6 cm is the one I use.

Medium-format cameras offer a lot of advantages for plant photographers, especially if you want to sell your work.

They offer waist-level viewfinders which show the *actual size* of

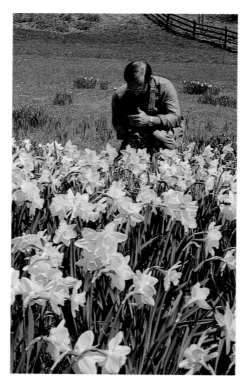

Which is more comfortable for you? Waist-level viewing is more comfortable for most plant photography, but if you decide to work at eye level as illustrated on page 3, be sure to wear old clothes.

the photograph so that what you see is what you shoot. It's almost like seeing an advance proof. This allows you to concentrate on the most important part of plant photography—composition. Some models have a built-in exposure meter for added convenience. From my experience, that added expense is worth every penny.

These cameras are lightweight and, although not as light as 35mm cameras, they are easy to carry and simple to use.

For publication purposes, you will shoot mostly color transparencies rather than prints. A 6 x 6 cm color transparency allows you to view the pictures without using a magnifier or projecting them as you must do with 35mm transparencies. In fact, the picture area of a 6 x 6 cm transparency is almost three times the area of 35mm, and that goes a long way in influencing editors to choose your

work over a competing photographer offering 35mm slides. Where two pictures are technically acceptable, a picture editor will almost always choose the larger transparency for publication.

The square format of the 6 x 6 cm transparency is also advantageous because it allows vertical or horizontal cropping to fit page layouts. A rectangular picture—which may or may not be planned for cropping—is always shot either as a vertical or horizontal. Therefore, a picture editor usually has greater versatility with square-format pictures.

Medium-format cameras can be hand-held at waist level, allowing you to move quickly around your subject to get the right angle. Another important advantage is the positioning of the waist-level viewfinder—on *top* of the camera, so you look down into it. This permits you to photograph low-growing plants by simply kneeling or bending low. With most other camera systems, you'd have to lie flat on your stomach for the same shot.

"Camera shake," which shows up as a blur in the photo, occurs mainly at slow shutter speeds without a tripod to steady the camera. It is common at speeds slower than 1/50th of a second. I have found that with a medium-format camera and a good carrying strap around my neck, I can hold the equipment firm and steady without camera shake. Although it is not recommended, I have taken good hand-held medium-format photographs at 1/10th second.

The 6 x 6 cm medium-format camera produces 12 exposures per roll of 120 film and 24 exposures on 220 film. Originals of either size are large enough for quality reproduction, even in big enlargements. The square format allows for beautiful picture composition without worrying about vertical or horizontal composition; and if you plan to sell your photos, it is an advantage because photo editors like to work with it.

CHOICE OF FILM FORMATS

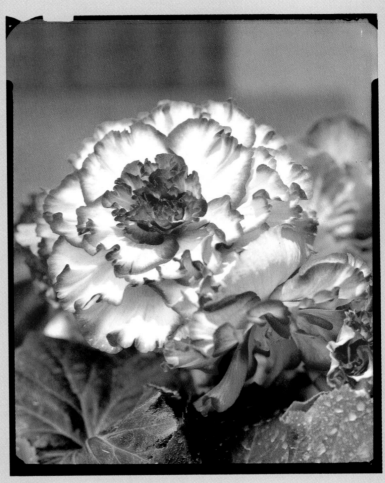

2-1/4 x 2-3/4

2-1/4 x 2-1/4

4 x 5

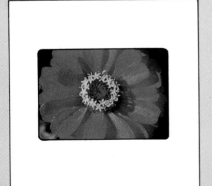

35mm

4 x 5-inch sheet film requires a large-format camera. Film is loaded into individual holders by hand, and the camera cannot be used effectively without a sturdy tripod.

2-1/4 x 2-3/4-inch rectangular format uses 120 or 220 roll film, 10 or 20 exposures to a roll. Camera is lighter in weight and easy to use without a tripod.

2-1/4 x 2-1/4-inch square format uses 120 or 220 roll film, 12 or 24 exposures to a roll. Camera is lightweight and easy to use without a tripod. This is the format most often used by professional plant photographers, and is preferred by publishers because the square format area can be used as is, or cropped to create a rectangular vertical or horizontal format without too much loss of picture area.

35mm rectangular format uses roll film, up to 36 exposures to a roll. Cameras using 35mm film are the most lightweight of all systems, and the most versatile. Image size is small and the slides must be seen through a viewer. When a publisher has a choice between 35mm and a larger slide, he will normally choose the larger format.

A basic question when buying a medium-format camera is whether to buy a twin-lens reflex or single-lens reflex.

A TLR—twin-lens reflex—camera has two lenses, one for viewing the subject and the other for taking the picture. These are the least expensive, but the two-lens system causes a problem called *parallax*, which is the difference between what the viewing lens sees and what the picture-taking lens records. Normally, the difference is so small it is hardly noticeable, but in close-ups the difference is indeed a problem. Most medium-format cameras now incorporate an automatic adjustment which eliminates the parallax problem. In plant photography, never use a TLR camera for close-ups unless it features *automatic parallax adjustment.*

An improvement over the TLR camera is the SLR—single-lens-reflex—which views and shoots through the same lens, thus eliminating the problem of parallax adjustment. However, they are considerably more expensive than the TLR cameras.

The only shortcoming I see with the 6 x 6 cm format is that color transparency film is available only in 12 exposure rolls, compared to 36 exposures on one roll of 35mm film. Changing film after every 12 shots can be time consuming. Also, many photo dealers will stock 120 roll film only by special order, so if you're in a remote area and run out of film, don't expect to be able to run into the nearest drugstore for a fresh supply. For color and black-and-white *prints*, you have a choice of 12 exposure rolls of 120 film or 24 exposure rolls of 220 film, thus avoiding the aggravation of many film changes during a busy day's shooting.

35mm SLR CAMERAS

These cameras are handy and easy to use. Many models have an extensive system of interchangeable lenses and other accessories, making them the most versatile cameras ever invented. They can take you beyond close-up photography into the world of photomacrography.

Just as medium-format cameras have their advocates, so do the 35mm SLR camera systems. If you want to hear an interesting argument, put two photographers with opposing viewpoints together and see how each defends his system. Although I am biased toward medium-format, I know at least three other successful professional plant photographers who use 35mm exclusively.

The 35mm SLR enthusiast will quickly point out that his camera is by far the most versatile, and the most lightweight—two very important considerations for plant photography. And, of course, with up to 36 exposures to a roll you tend to be more adventurous with your compositions and exposures. The film is relatively inexpensive and it doesn't matter much if you waste a few exposures trying some offbeat, creative ideas. A photographer using a medium-format camera, however, may be more conservative, more disciplined and reluctant to experiment because of fewer exposures per roll and higher cost per exposure.

For building up a picture library fast, you can work more rapidly with 35mm than any other camera

Cymbidium orchid, Sussex-variety *Laeliusassa,* showing the original picture taken on color transparency film and a black-and-white conversion, made by producing an internegative from the color transparency.

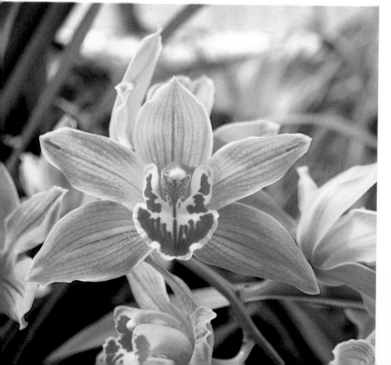
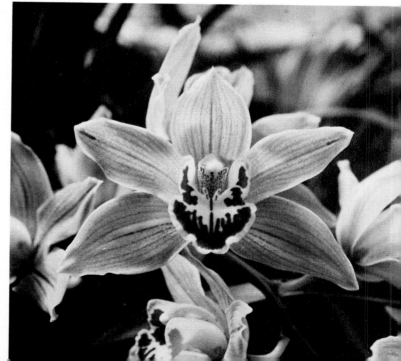

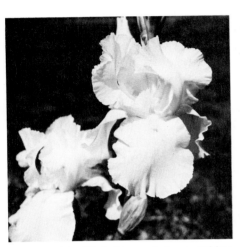

Bearded iris Rich Reward, is a golden yellow color and stands out well against a dark lawn background, requiring no special filter to achieve adequate tonal separation.

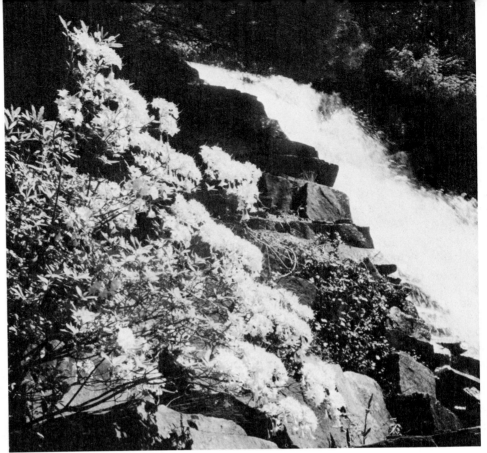

Rhododendron *lutescens* in a wild landscape. Color contrast is good between the yellow flowers and dark coloring of background rocks and foliage. No special filtration was used here.

system, but there are some important points to consider about 35mm.

The film size is small and color transparencies can only be appreciated through a viewer. I have found that some publications, such as *Architectural Digest*, dislike 35mm slides because they lose quality in blowups for double-page spreads. However, the prejudice among some publishers against 35mm seems to be disappearing. In fact, *National Geographic* magazine prefers 35mm.

Eye level viewing may be a handicap for close-ups, and camera shake is a common occurrence without a sturdy tripod. Although some 35mm SLR cameras do have waist-level viewing adapters, their light weight doesn't allow you to hold them as steadily as a medium-format camera.

All 35mm systems force you to choose between a vertical or horizontal format because the film image is rectangular. Although some medium-format systems also produce rectangular images, you do have the choice of a square format, such as the 6 x 6 cm, allowing picture editors greater freedom when selecting your work.

The viewfinder image is small, and important details of composition can escape the eye more easily with 35mm SLR cameras than with medium-format. Although many 35mm SLRs offer eyepiece magnifiers, you still have to look through a small eyepiece which is not nearly as comfortable as a medium-format viewfinder.

In spite of these considerations, there *is* definitely a place in the world of plant photography for 35mm, and many top-notch

professional photographers earn a good living using nothing else. *All of the techniques described in this book apply just as well to the 35mm format as to the larger formats.* The best of the 35mm SLR cameras are very, *very* good, and if you want to specialize in photo-macrography of plants, I feel it is *the* best system to choose.

I am doing an increasing amount of work in 35mm because of my lecture series and the universality of the Carousel projector for 35mm slide shows. Thus, some of the illustrations in this book were shot in 35mm.

Snapshot Cameras—Other camera systems are not recommended for plant photography. Neither Kodak nor Polaroid makes a camera sufficiently versatile for producing consistently reliable, publication-quality pictures.

KODACHROME VERSUS EKTACHROME

35mm enthusiasts are fortunate to have a choice between *Kodachrome* and *Ektachrome* film for color transparencies. In my opinion, Kodachrome is best for reds, yellows and orange colors, and Ektachrome is superior for blues and greens, as shown here. The brilliant coloring of red peppers is rendered accurately on Kodachrome film. Hawaiian maidenhair ferns with their exquisite green fronds are superb on Ektachrome. Except when shooting predominantly red subjects such as tomatoes and strawberries, I tend to favor Ektachrome over Kodachrome. Although Ektachrome gives acceptable reds, yellows and orange colors, Kodachrome's greens all too often show up muddy. Because green foliage is such an important component of most plant pictures, dull-looking greens can be objectionable.

FILM

The choice of film is vital in plant photography because it affects the final result in many ways. When choosing one type over another, you have to sacrifice something to gain something else.

The perfect film would give good tonal separation, fine grain, high speed and high resolution, but you cannot have high speed *and* fine grain, for example. Film just isn't made that way. Film speed is important because a high film speed allows you to take good pictures in poor light without flash, but fine grain is also important when you want to make enlargements without loss of detail. The best films for general use are a combination of the two—a film speed fast enough for normal day-to-day photography, and grain that doesn't ruin the picture in moderate enlargements.

There are three types of films you should be familiar with: *black-and-white*, *color negative* for color prints and *color transparency* for color slides.

Black-and-White Film—There is a moderate demand among publishers for black-and-white photographs of plants and gardens, but rates paid for black-and-white pictures tend to be low—so low that I rarely shoot black-and-white any more. I've concentrated on color because it is the more rewarding market. On the occasions that black-and-white pictures are required, some publishers are willing to accept a color transparency for conversion to black-and-white at their expense.

I have never understood why so many professional photographers charge lower rates for black-and-white pictures over color. In my experience, good black-and-white pictures are more difficult to shoot. Some kind of filtration is normally needed to produce acceptable contrast for publication-quality prints. This is especially true when dealing with plants where flower and foliage colors have a tendency to merge into the same tonal range. There isn't a great deal of difference in the processing cost when shooting roll film and, unlike color transparencies, publishers rarely agree to return black-and-white prints. Thus, each time you sell a picture you have to make a new print from the negative.

Kodak manufactures several popular black-and-white films with different film speeds, from ASA 32 to ASA 400. The choice depends on shooting conditions and how you plan to use the prints. I use Plus-X Pan for most situations. It has a film speed of ASA 125, suitable for most daylight conditions, and grain is fine enough for enlargements. Tri-X Pan, with a film speed of ASA 400, is better for low-light situations or where fast shutter speeds are required to stop movement. Both of these films are supplied in 120 and 35mm rolls.

Color Negative Film—Films producing negatives for color prints are rarely used when shooting for publication. However, for snapshots, exhibition work and framing for indoor decoration, color negative film is better.

FILTER SELECTION TO DARKEN SKIES WITH BLACK-AND-WHITE FILM	
To preserve original appearance	8 filter (yellow)
Mild darkening effect	15 (deep yellow)
Strong darkening effect	25 or 29 (dark red)

Advertising agencies also use negative film for making up advertisements and brochures where retouching is required to soften or highlight certain areas.

For sheet-film cameras, Kodak color negative film comes in two types—Vericolor II Professional Film Type S for fast exposures of 1/10 second or less, and Type L for longer exposures from 1/60 to 60 seconds. Type S film is made in medium-format and 35mm. Kodacolor is an alternate choice for color prints, but for publication quality, Vericolor II is more widely used.

Color Transparency Film— Although there are several brands of color transparency film, in my experience the most satisfactory are Kodak Ektachrome and Kodachrome. They are also the most readily available from camera stores.

I generally use Ektachrome for the best-looking blue skies and green foliage. Because green foliage is such an important part of most plant pictures, that counts for a lot. When your pictures show bright green leaves and deep blue skies, it impresses picture editors.

Kodachrome, on the other hand, is strongest in red, yellow and orange colors; so if you want the very best strawberry and tomato pictures with glowing deep reds, or superlative pumpkins with rich, deep orange coloring, Kodachrome is the better film. Unfortunately, only 35mm camera users have the privilege of choosing between these two films, because Kodachrome is not available in larger film sizes.

Ektachrome has long been a standard for large-format and medium-format cameras, and is also available in 35mm. In addition to a slow-speed type, there are several high-speed versions, up to ASA 400, available for daylight and tungsten lighting. Although Ektachrome can be processed at home, I never do my own developing because it is time-consuming. I prefer to send film to a good custom laboratory because their work is more reliable and consistent. However, they charge more than local labs for amateur processing.

For most of my plant photography, I use Ektachrome 64 Professional film. It gives excellent color reproduction and a clear, sharp image that can be enlarged considerably without loss of definition. It's a good policy to stick to one film for most of your picture-taking because it is easy to forget what kind of film you have in your camera. Also, familiarity with a particular film helps you to react instinctively to tricky situations.

I like to carry a few rolls of Ektachrome 200 daylight film. It comes in handy when shooting inside conservatories or greenhouses on cloudy days, and for outdoor scenes on dull days. The higher speed Ektachrome film is ASA 400 but, for my needs, color quality is not sufficient. Under normal daylight conditions it's hard to use it without bright colors such as white and yellow washing out.

If you want a photo album of prints showing travel scenes and family portraits as well as a color transparency library of your plant photography, it is best to stay with color transparency film all the way. You can make conversions to prints for the family album, rather than work with two kinds of film.

When choosing color film for

Windswept Monterey pines on the clifftops near Carmel, California, cast dense shade in contrast to the bright open sky. Film does not retain any detail in the shaded area because exposure was made to record the sky. The reverse situation from the Carmel shot: This is a scene in the Bowman's Hill Wildflower Preserve, Pennsylvania. I exposed to record areas of dense shade, leaving the overhead canopy of leaves and sky beyond the film's effective exposure range. In spite of contrast limitations in both these scenes, however, the results are pleasing.

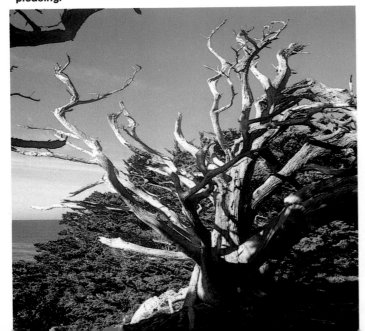

reproduction, it pays to buy the *professional* quality when there is a choice. Because film is manufactured in batches and color quality can vary from one batch to another, some users test batches and use film with the same batch number until another batch can be tested. Professional film is specially manufactured for good color stability but this stability is maintained only by storing the film at a low temperature. When left in a warm place, such as the glove compartment of a car on a hot day, the film will deteriorate. The vegetable bin of a refrigerator is a perfect place to store professional film. For carrying on long trips, I store it in a lunch box packed with canned ice—an ice substitute usually sold packed in a can or plastic container.

However, it's *important* to realize that cold film must be left in the factory package at room temperature for two to three hours before using; otherwise, moisture will condense on the film and spoil your pictures. Also, after exposure, *process* professional film *immediately* or store under cool conditions.

Film Contrast Limitations— Although modern films are versatile in capturing a wide range of tones, they cannot adequately record scenes having both very bright and very dark areas in the same frame. This is particularly true with color films. In a ten step scale from black to white, the tonal range of most color films is five steps, which means that if your lighting is fairly even—low-key, all dark; middle key, middle light; or high key, all bright—then the film can show acceptable overall detail. But in a high-contrast scene, you cannot expect to retain good detail in both dark and light areas.

Instead, you may have to make a difficult decision: Expose for the light and lose detail in the dark shadows, strive for a "middle-of-the-road" exposure or expose for the shaded area.

Color Changes in Natural Light—When shooting color pictures outdoors in natural light, light changes from hour to hour depending on the position of the sun. Late in the afternoon, for example, sunlight tends to have too much red in it, tainting the image with undesirable reddish hues. Color film is balanced for midday light; if you seek true colors, natural daylight between the hours of 10 am and 3 pm in summer is best. All my best close-up work, specimen shots and garden scenes are taken during those five hours of prime daylight.

Obviously, if you are shooting for artistic effect, light at other times of the day may be perfectly acceptable.

LIGHT METERS

When shooting color transparencies, accurate light readings are critical. Photo labs cannot make adjustments in processing to improve a poorly exposed transparency as they can with black-and-white or color negative film. Some cameras have built-in light meters, but I like to carry a separate one because there are occasions when I like to have a "second opinion." On at least two critical occasions, my built-in meter failed completely. When two independent light meters give two different readings, the question of which to believe arises. In this case, *bracketing* is recommended: Shoot three exposures— one for each light reading and one in the middle.

Independent light meters, or exposure meters, used to be costly, but in recent years many reliable inexpensive models have flooded the market. You may choose from two types: *Incident light meters* are pointed away from the subject toward the camera to measure the amount of light directed at the subject. *Reflected light meters* are pointed at the subject and measure the amount of light reflected from the subject to the camera. I prefer

Backlighted flowers present a difficult exposure problem. These White Emperor tulips, for example, are against a clear blue background. A light meter reading that includes sky will usually give too much exposure for the petal areas. In a case like this, hold the meter level with the petals or read off a gray card.

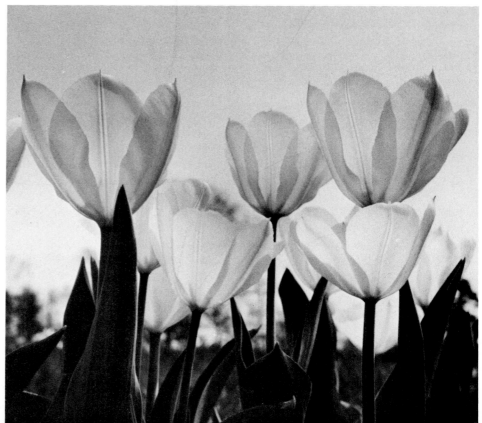

the reflected kind because it's a lot easier to make light readings from the camera position, and built-in light meters are all of the reflected type.

Although they may seem complicated, light meters are quite simple. Follow the manufacturer's instruction manual.

Using reflected light meters, such as those built into cameras, a darkly colored flower against a lawn background will need a completely different exposure than a brightly colored flower against a sky or white fence under identical light conditions. *Do* take a light reading before *every* picture.

Certain lighting situations can confuse your light meter. For instance, when photographing a tall flower on a bright day, be sure the light reading is of the flower petals and *not* the surrounding sky. In such cases, hold your light meter level with the petals or directed slightly down at foliage or lawn, not pointed up at the sky.

Consider metering on a *Neutral Test Card*, a gray board that you hold directly in front of your subject for an accurate light reading. Another good substitute metering surface is lawn grass in the same light as the subject. Also, bare soil, stone paving, foliage and gray rocks usually have a reflectance surprisingly close to a gray card.

Some cameras have through-the-lens (TTL) metering systems, but these are reliable only if the light sensitivity pattern measures light at the middle and lower half of the image area. When TTL meters respond equally to all portions of the frame, they often produce an incorrect exposure by measuring bright sky or some other bright area in the upper edges of the frame. Whenever you are in doubt about a light reading, it's a good policy to bracket three shots.

LENSES

Any photograph you make is controlled by the lens. There is no universal lens that functions like the human eye, changing focus

from extreme close-up to infinity, and recording a concentrated area or a large area in the flicker of an eyelid.

Most medium-format cameras have a standard lens that focuses from infinity to between two and three feet in clear detail; in 35mm, that distance is about 1-1/2 feet. To focus closer, you must equip yourself with the most important tool in plant photography—a simple close-up lens accessory that screws onto your standard lens.

Plant photographers use various approaches for close-up work, although you will find it best to master one technique and stick with it. More about close-up systems is in Chapter 8.

Accessories for the standard lens are close-up lenses, which usually come in sets of three, each lens taking you progressively closer to the subject, up to about nine inches; extension tubes, allowing you to move closer to the subject using these same close-up lenses, and a bellows attachment for photographing objects from life-size to 4X magnification. Rather than use these accessories, you might choose the ingenious macro lens that most closely matches the versatility of the human eye, focusing from infinity to extreme close-up by simply turning the lens barrel. One lens manufacturer, Nikon, calls this a *micro* lens.

The realm of close-up photography may sound complicated, but for the plant photographer it can be very simple.

I have discovered that the most frequently used close-up lens for plants is the #3 screw-on type. I carry it everywhere, and recommend that you do the same. With TLR cameras, close-up lenses come in pairs—one to fit on the viewing lens and one for the taking lens.

When taking close-ups, there is little depth-of-field. The wider the lens is opened, the shorter this depth-of-field becomes. In close-up plant photography, I make it a

general rule not to go wider than *f*-11. I use *f*-16, *f*-22 and even *f*-32 if light conditions allow it.

I would estimate that most of my outdoor color plant pictures were shot at between *f*-11 and *f*-16. In close-ups, I also prefer to sacrifice shutter speed for a high *f*-stop. It is better to shoot at *f*-11 at 1/50 or *f*-16 at 1/25 than to shoot at any of the lower *f*-numbers.

Wide-angle, telephoto and fisheye lenses are rarely needed in plant photography. To keep things simple, I will not comment on them here. For more information about depth-of-field, read *Understanding Photography* and *SLR Photographers Handbook*.

ACCESSORIES

Although I have stated that simplicity is the key to good plant photography, and that you really must have only the four basic items, there are other accessories you may want or need for special situations. These are optional, and should be considered only if you feel they are absolutely necessary.

TRIPOD

Although I prefer to work without a tripod whenever possible, many people have trouble with camera shake at any exposure longer than 1/100th second. Tripods are also good for low-light shooting, where slow shutter speeds are required to use small apertures. Most close-ups require a tripod for maximum sharpness when using relatively slow films.

I dislike tripods because they take time to set up and they're difficult to use at times, getting tangled up on plant stems and branches. The only good tripod is a strong, sturdy model that allows you to get the camera down to ground level for low close-ups. Inexpensive models are normally too unsteady to be practical, and impossible to use for low-to-the-ground shots.

CABLE RELEASE

A cable release allows you to trip the shutter and make the exposure

without touching the camera or tripod, thereby avoiding any movement which might blur the image.

FILTERS

There are more than two dozen different filters available for plant photography—but I rarely use them because filters are more important in black-and-white photography than color. Black-and-white film often records different colors such as red and green in the same shades of gray, and a filter must be used to induce tonal differences.

As a general rule, for black-and-white film, a filter lightens its own color. In other words, a color filter used with black-and-white film darkens every color except its own.

It is essential with black-and-white film to use filters to make clouds stand out against blue sky; otherwise the sky will look washed-out—almost invisible in the print. Yellow is the most common filter for emphasizing contrast between sky and clouds shot in black-and-white, although red and orange filters do it also.

For color photography, the most important filters to consider are a *haze* filter, *skylight* filter, *polarizer* and *soft-focus* attachment. Avoid the use of colored filters with color film unless special effects are required, because the filter will change the colors of the image.

Haze Filter—When shooting landscapes and scenic views, atmospheric haze can obscure the view. This is most often seen as a blue "mist." The problem is frequently encountered along the ocean, in mountains and in tropical climates. Use of a haze filter helps cut through the haze and allows the film to record a clear view. Ultraviolet radiation exposes film and gives the appearance of haze. The higher the altitude, the worse it becomes.

Skylight—When shooting in shade, natural light has too much

With a soft-focus attachment over the lens, you can shoot images with a diffused, dream-like quality. You can also make your own soft-focus effects by smearing petroleum jelly on a piece of clear glass held in front of the lens. Soft-focus effects generally work best on evenly lit close-ups of single blossoms, wildflowers and flower arrangements.

blue in it. Thus, light-colored subjects such as white flowers photograph with a blue cast to them. A skylight filter records truer colors in shade and also helps screen out ultraviolet radiation.

Polarizer—This filter eliminates reflected glare, and improves scenic views where water is the predominating feature. It removes surface glare so the film can record details deep into the water. Also, a polarizer improves the colors of dark green foliage when the film would otherwise show lush greenery in dismal dark tones. Its use normally produces adequate color saturation to brighten those shaded areas. Polarizers are also

good for darkening blue sky, an important consideration when shooting landscapes and scenic views for that "picture postcard" look.

Soft-Focus Attachment—Look at any greeting card display and you'll see that most of the photographic scenes are in soft focus. They have a diffused, misty look to them, creating a special romantic quality. This effect is achieved with a soft-focus attachment. If you are interested in the greeting card market, a soft-focus attachment is indispensable. It works best in an evenly lit situation, such as outdoors under a high overcast sky, and on close-ups of romantic

flowers such as roses or wildflowers.

Another type of soft-focus attachment offers *partial* diffusion, showing the subject at the center in sharp focus, but the surrounding area in soft focus, resulting in a dream-like quality. You can create this effect without a filter by smearing petroleum jelly around the edges of a haze or clear glass filter mounted on your lens, leaving the center area clear. To create a totally diffused effect, simply breathe heavily on the lens and shoot before the condensation disappears.

PORTABLE BACKGROUNDS

Artifical backgrounds are sometimes necessary when a plant is in an undesirable setting, or where you wish to shoot pleasing floral arrangements in the house or on your front lawn. You must be sure that the point of focus is on the subject, *not on the background.*

You can make these backgrounds easily from 2-1/2-foot square pieces of lightweight particle board or plywood. These will fit easily in the trunk of your car, yet are large enough for most close-ups and groupings. A matte rather than a glossy finish is best.

Basic backgrounds you might consider:

Sky—Light blue is excellent, streaked with white to simulate clouds. Sky is the most natural of backgrounds for most flowers.

Blue—Plain blue is good for extreme close-ups of yellow, white, orange, pink and green flowers.

Foliage—Use leaf-green paint, and then create a dappled effect with dabs and streaks of yellow, brown and darker green.

Green—Plain green is a natural background for most plants because it is the color of leaves and grass. It can be used well for extreme close-ups of yellow, blue, purple, red and white flowers.

Black—Use this for the most dramatic close-ups. A matte black is

effective with just about every flower color imaginable.

Red—Use sparingly. It's an unnatural background for most colors in nature, but can be used effectively with pale colors, such as yellow flowers and fruit.

Yellow—This is another color I rarely use because it is not often found as a background in nature.

Use it occasionally with dark colors, such as dark blue iris or deep purple tulips.

Rustic Fence—Creat a portable "stockade" or picket fence design, bamboo-type screen, or other style.

Lawn—When shooting down at certain low-growing plants, an artificial grass mat—the type used

CHOICE OF BACKGROUNDS

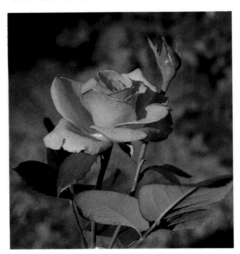 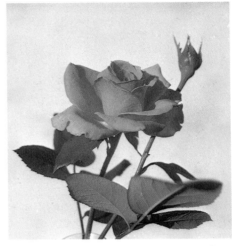

Two pictures of the same flower—rose Rosalyn Carter—show how important the choice of background is in plant photography. One has a natural background where foliage and lawn are out of focus. This natural look is one of the most pleasing and widely accepted. Sometimes a natural background is not possible, however, because of insufficient contrast or undesirable features such as bare soil, buildings or color clashes from other plants. In such cases, use an artificial background.

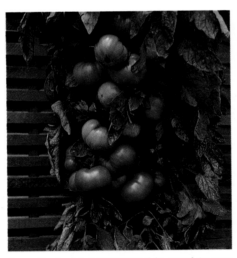 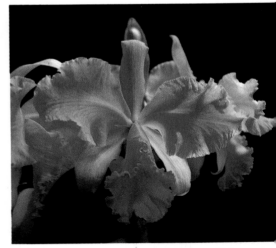

A rustic fence background is good to use with vegetables, such as this productive vine of Bragger tomatoes.

Most flowers, such as this cattleya orchid, are beautiful on a black background.

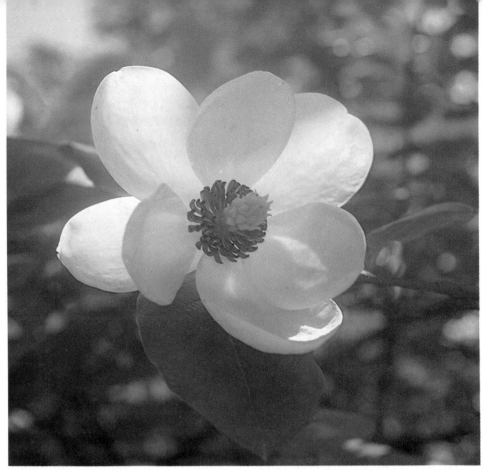
This is *Magnolia wilsonii*, backlighted by sunlight and photographed against the most pleasing of all backgrounds—out-of-focus natural foliage.

in florist shops—can be placed as a background to cover ugly patches of lawn or dirt. This should be well in the background, however, and out-of-focus; otherwise it may look artificial.

USEFUL AIDS

Following are some additional accessories you may find helpful when photographing plants:

Wind Breaks—A sheet of clear plastic acrylic makes a good wind break for shooting close-ups of flowers on a windy day because it will not throw a shadow or block off light from your subject. Clear plastic acrylic is available at glass dealers. Try a three-foot-square piece.

Rather than carrying another piece of equipment which would restrict my freedom of movement, I prefer to wait for a lull in the wind, shoot at a fast shutter speed to "freeze" the action, or just not tackle close-up photography on a windy day.

Reflectors—A sheet of stiff white cardboard can be used to reflect light into areas of dark foliage or shaded petals, or to produce an overall light balance. Backlighting plus reflected front lighting can create some beautiful effects with flowers.

I frequently use reflectors for close-ups of fruit such as eggplants, apples and tomatoes. When the sun is high in the sky, a shadow often darkens the bottom of the fruit. With close-ups of single fruits, you can eliminate the shadow simply by shining light from a small mirror onto the dark area. Also, a piece of cardboard with kitchen aluminum foil stapled to it will serve as a handy reflector.

Diffuser—Just as you need a reflector to bounce light into dark areas, you will sometimes need a diffuser to reduce glaring sunlight which can cause unsightly dark shadow areas or a washed-out effect. This is particularly true with close-ups. The best lighting condi-

tion for outdoor photography is high overcast sky, which is bright but not harsh, and produces beautiful color saturation on film. You can make an effective diffuser simply by stretching a light-colored cloth on a frame and using it to cast shade over your subject. Camera stores sell a variety of excellent diffusers in the form of white umbrellas.

Atomizers—A fine misty spray of water on certain fruits, vegetables, leaves and fungus can help bring out a more dramatic color. Spray carrots, radishes and strawberries, for example, and see how the colors improve. The mist must be fine enough so it does not form unnatural droplets.

Pocket Knife—I carry a sharp pocket knife everywhere I go with my camera. There are many times when I need to slice fruit, cut stems for arranging flowers and trim away obstructions such as branches and leaves. You may prefer to use a pair of scissors for the same purpose.

Notebook & Pen—On my photographic expeditions, I wear a jacket or shirt with a breast pocket to carry a pocket-size spiral notebook and pen. That way it's easy to make notes of every plant specimen I shoot. Don't depend on your memory to retain plant names; I always forget them no matter how hard I try. Jot down the name after each shooting, noting both the common name and Latin name when possible.

Florist Clay—This is good for posing and arranging flowers with stiff stems to create a close grouping or interesting composition.

Toothpicks—These are helpful to position fruit and vegetables in tight arrangements. Also for repairing flower clusters where several flowers may be blemished. Groups of crocus, for example, can be tidied-up by replacing faded blooms with fresh ones stuck into the soil on toothpicks.

Artificial Lights—Flash and other means of artificial lighting are covered separately in Chapter 9.

Garden Flowers

Many people may feel that flower photography *is* plant photography. That's not so, of course, because trees, shrubs, vegetables, foliage plants and many other forms of plant life can be stimulating subjects for *plant* photography. Because most plants—even foliage plants—have flowers at some stage of their life cycle, flowers are likely to command most of your attention. They are the most photogenic and colorful subjects in the fascinating world of plants.

In my view, the test of a really good flower photographer is his ability to photograph flowers as they grow in nature. Their natural beauty and surroundings are usually so breathtakingly lovely; it irritates me to see the efforts of some plant photographers who pose plants awkwardly against artificial backgrounds, or flood their interesting forms and delicate textures with artificial light. Catalog pictures are often the worst offenders, showing graceful flowers stiffly arranged against alien backgrounds. Ugh!

There is no substitute for natural light and backgrounds when photographing flowers. There are many who scoff, pointing out that there are numerous occasions when flowers simply cannot be photographed that way. True, but to show nature at her best is the ultimate challenge. The greatest animal and bird pictures are not taken in zoos, or with the animal tethered against an artificial background. The same holds true with flowers—and with flowers there is less excuse for falsity because your subject will pose for hours, whereas bird and animal

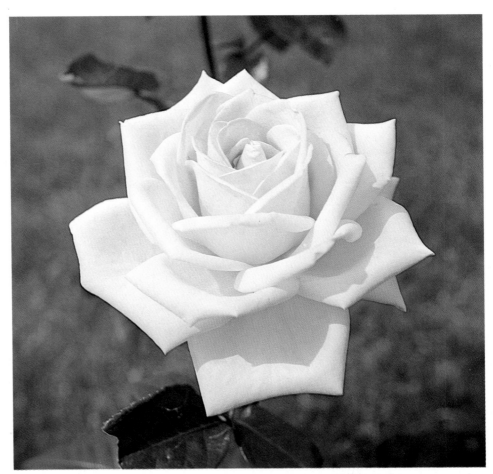

One rose in a million: Royal Highness displays perfect form and delicate, blemish-free color against a contrasting lawn background. It can take years of searching through acres of rose gardens before you find a rose flower to equal this specimen. The picture was used in a Burpee Seed catalog.

photographers must sit for endless periods in concealment for one split-second opportunity.

WHERE TO BEGIN

One of the delights of flower photography is that your subjects are easily accessible. A worthwhile investment for a flower photographer is to join a state or national horticultural society. Consult your local library, county agricultural agent or a local botanical garden for information about horticultural organizations. Modest membership fees include bulletins giving valuable information about tours to many locations where flowers are grown in ideal surroundings. Private and public gardens are perhaps the most likely locations for outstanding flower pictures,

FLOWERING TIMES OF 30 PHOTOGENIC FLOWERS

Class	Jan	Feb	Mar	Apr	May	June	July	Aug	Sep	Oct	Nov	Dec
African Violet (inside)	X O	X O	X O	X O	X O	X O	X O	X O	X O	X O	X O	X O
Amaryllis (inside)	X O	X O	X O	X O							X O	X O
Asters							X	X O	X O			
Begonias					X	X	X O	X O	X O	X	X	
Cactus	X	X	X	X	X	X O	X O	X O	X O	X	X	
Camellias	X	X	X	O							X	X
Chrysanthemums									X O	X	X	
Clematis			X	X	O	O						
Daffodils		X		O								
Dahlias					X	X	X O	X O	X O			
Daylilies				X	X O	X O						
Geraniums				X	X O	X O	X O	X O	X O	X	X	
Gladiolus					X	X	X O	X O				
Gloxinias (inside)	X O	X O	X O	X O	X O	X O	X O	X O	X O	X O	X O	X O
Hibiscus			X	X	X	X	X O	X O	X	X		
Iris (Bearded)			X		O	O						
Lilies (Lilium)						O	O	O				
Lotus					X	X	X O	X O				
Magnolias			X	O	O							
Marigolds					X	X	X	X O	X O	X		
Orchids (inside)	X O	X O	X O	X O	X O	X O	X O	X O	X O	X O	X O	X O
Peonies (Tree)			X	O								
Petunias					X	X	X	X O	X O	X O		
Primulas	X	X	X		O							
Rhododendrons		X	X	X	O							
Roses					X	X	O			O	X	X
Sweet Peas		X	X			O						
Tulips			X	O	O							
Waterlilies					X	X O	X O	X O	X O	X		
Zinnias				X	X	X	X O	X O	X O			

X indicates flowering time in Southern California, Gulf States and other frost-free areas of the South and West.

O indicates flowering time in the Northeast, Midwest, Northern Pacific Coast and other areas with frost or snow cover in Winter.

18

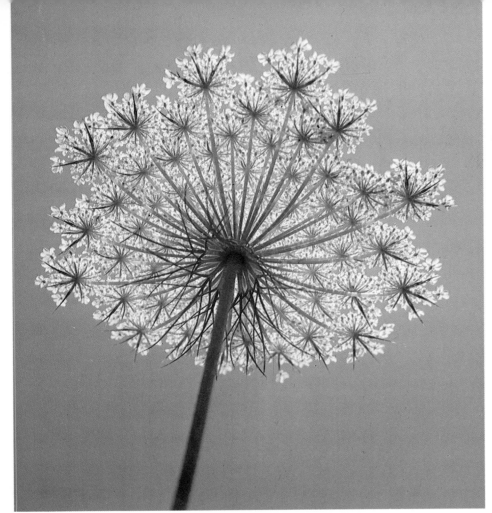
Meticulous searching through a field of Queen Anne's lace rewarded me with this magnificent flower cluster, backlighted against a clear blue sky. I got a crick in my neck from looking up at countless other mediocre plants, but the perfection displayed in this picture was worth it. *Plants Alive* magazine used it in an article on wildflowers.

cessful nature photography of any kind—patience. The outstanding flower photographer searches for perfect blossoms or groupings of flowers devoid of any blemish or imperfection. When I enter a garden looking for flowers to photograph, I feel as though I am searching for precious stones. The excitement of finding a perfect specimen in peak condition, in a stimulating setting with the light falling just right, and with the background showing off the bloom to absolute perfection, is like discovering a vein of silver. It's the same thrill a bird photographer experiences when, after waiting all day, the eagle finally returns to her nest and strikes a majestic pose that could never be imitated in captivity.

You may find an interesting cluster of flowers past its prime, perhaps blasted by the wind, shredded by the rain or bleached by the sun. Remember the spot, make a note of the date and return the following year to try again. Or you may discover a glorious flower in peak condition, but in the wrong light. Return several times during the day to see if the sun is in the right position.

Patience rewards the flower photographer who meticulously searches through an acre of roses seeking the one rose that outshines all the rest, ruthlessly disregarding hundreds of possible mediocre pictures.

The successful flower photographer is one who stands for endless moments, waiting for a brief lull in the wind, so he can shoot a poppy head using a slow shutter speed and a small lens aperture to gain maximum depth-of-field.

FLOWER SHOWS

In my opinion, flower shows are generally the worst possible places to take good flower pictures. My advice is to attend flower shows, but leave your camera at home. More film is probably wasted at flower shows than any other event I know.

although arboretums and parks are also good places to begin.

Don't overlook the many local garden centers, nurseries and commercial greenhouses—especially in spring. Garden centers at that time of year often have a profusion of photogenic material. Many also have greenhouses full of interesting indoor plants, and the owners usually do not mind a photographer taking pictures.

In arboretums and parks, respect the work gardeners have put into preparing the ground and border plantings. Tread warily, obey regulations and ask permission when you wish to enter areas normally out-of-bounds. Also, don't litter the grounds with empty film cartons.

In some of the larger gardens and estates, there is too much to take in during one visit. Most large public gardens have a conservatory with colorful material that has been forced into bloom to create a spectacular display. This is usually the best place to begin. If the light is not quite right, you can remember to come back later in the day at a time you judge to be more appropriate. Then it is best to look at some of the other specialized areas in the facility, such as rock and water gardens, annual and perennial borders, vegetable gardens, fruit tree orchards, herbs and heather gardens and nature trails. Each merits special attention, depending on the time of year. These subjects are covered in detail in subsequent chapters.

The secret of successful flower photography is the same as suc-

There are several reasons: The light is usually inadequate, there are too many people and distractions and the flower material is usually very difficult to get at, especially for close-ups. It's surprising how ugly a flower show garden can look on film, no matter how good a design job has been done. Flower shows are invaluable to the flower photographer for other reasons, however—mainly *ideas*.

When I visit a flower show, I usually like to tour the exhibits with program in hand and make a note of the outstanding exhibits. For instance, if there is a striking orchid exhibit, I'll make a note of the exhibitor and his address. Then I'll speak with the individual and ask permission for some after-the-show photography.

At each outstanding display, I speak to the exhibitor and ask about photography at a later time. Gardeners and greenhouse owners are usually very cooperative. They like people to appreciate their skill and work in raising prize exhibits, and will also advise you about the best time of year to photograph the material.

A notebook and a pencil at flower shows are worth far more to you than your camera. Don't waste your time and film. Of course there are exceptions to this generalization, such as flower or harvest shows held in the open air. Among these, some good pictures may be possible. To find worthwhile shows, consult your local county agent, listed in the telephone book under Cooperative Extension Service or County Agent.

PHOTOGENIC GARDEN FLOWERS

In my experience, certain groups of flowers are distinctly more photogenic than others. Most flowers certainly are beautiful, but some are more beautiful than others. That's because flowers appeal to different pollina-tors for fertilization, some attracted by color and others by fragrance. For example, aspidistra flowers appeal to snails for pollination, skunk cabbage to flies, bird of paradise to hummingbirds, moonflowers to moths, and zinnias to butterflies and bees.

I've established a "Top 20" selection of favorite photogenic flowers from personal experience. Each of these groups contains so many beautiful and distinct varieties, you could spend an entire lifetime finding and photographing the different kinds. Here they are, with special comments and how to photograph them for best results:

AFRICAN VIOLETS

It's an incredible fact, but there are more African violet enthusiasts in the United States than orchid or rose enthusiasts, and the African Violet Society claims more members than any other plant organization. As a result, magazines are constantly trying to find new ways to present these flowers.

One of my best African violet features appeared in *Popular Gardening Indoors*. I visited a husband-and-wife team of African violet specialists, Frank and Anne Tinari, at their commercial greenhouses just north of Philadelphia, and decided to make my story more of a personality piece, reporting the advice of these two experts.

Before 1945, when the Tinaris decided to specialize in African violets, the plants were mostly confined to botanical gardens and were considered difficult to grow. The violets were discovered in 1892, growing among pockets of leaf mold on cliffs in the rain forests of the Usambra Mountains in east Africa. After German and later, California nurserymen, developed some beautiful cultivated varieties from the wild species, the full potential for these plants was realized. At first the color range was restricted to shades of blue. Although blue is still a popular color, coral-red is now more popular. Generally speaking, the Tinaris recommend double-flowered varieties over singles because the double blooms last longer; but for photography, the singles seem to make better pictures.

I photographed Anne and Frank together and made notes of their recommendations. After the interview, Anne made up some composite arrangements using different colors of African violets, placing them flat on a leafy background. I shot these with a close-up lens. They were published full-page, with a key showing their names.

Another good way to photograph African violets is as specimen plants, simply showing a tidy, dome-shaped plant covered with flowers. You can shoot these two ways—against a plain background such as a dark-colored or blue sky, or as a table centerpiece, with a table lamp and table ornaments to emphasize a room environment.

When photographing African violets, look for good flowering specimens with blemish-free foliage and as many flowers as possible. Leaves with curled brown edges should be removed. Both of these images were made in daylight. The close-up of African violet Blue Fairy above shows a pleasing symmetry of flowers and leaves. It was photographed on a slatted bench inside a greenhouse. Specimen pictures like these are widely sought by catalog houses. The arrangement of various African violet varieties on the opposite page shows a range of colors. It was used in *Popular Gardening* magazine with a key to identify the names of each variety.

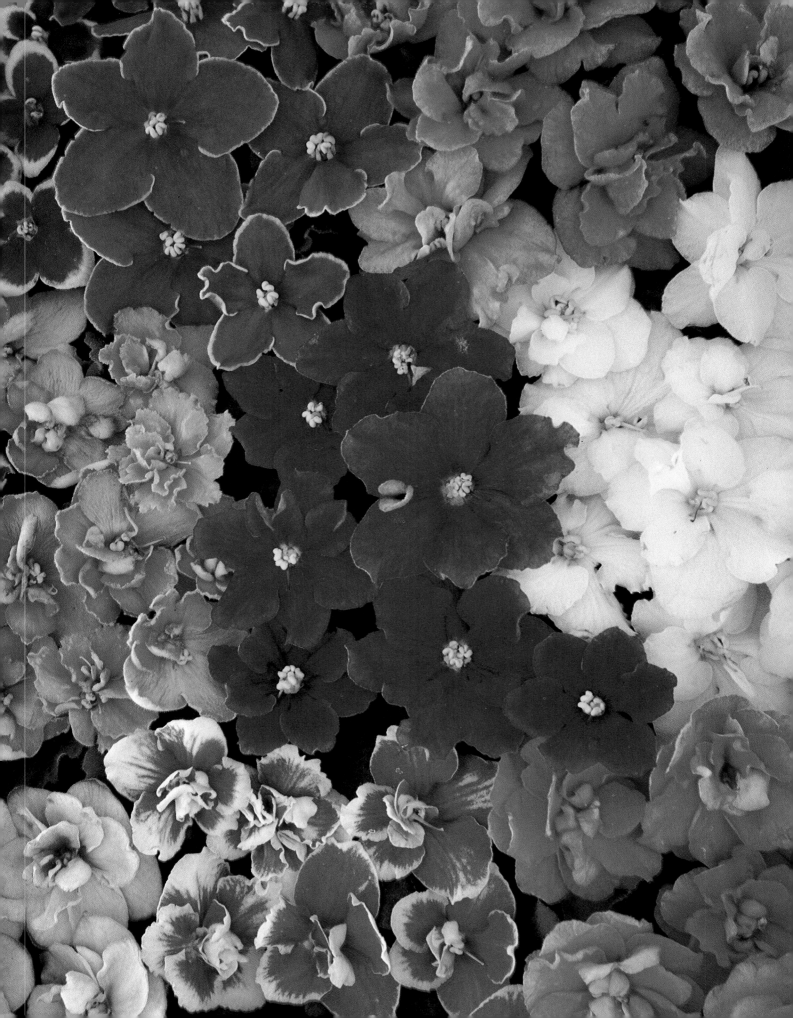

In recent years, plant breeders have been able to create new forms with variegated leaves, so you should try to ensure that interesting leaf shapes and colorations show clearly in any of your specimen pictures.

Application shots—showing the plants in a special situation rather than in a plain setting—are also popular; for example, shoot miniature African violets in dish and bottle gardens. Also, pose them in creative containers, such as driftwood or lava rock planters, and under indoor light units.

AMARYLLIS

Very few spectacular indoor plants are foolproof to grow. Most of them need greenhouse conditions to be "happy." Adequate amounts of light, moisture and food are usually essential for satisfactory blooms.

The amaryllis is a glorious exception!

Growing from an enormous bulb with its own built-in reserve of energy, amaryllis can be forced into flowering within four weeks after watering the bulbs. The reward is massive trumpet-shaped blooms measuring up to ten inches across, clustered four to a spike. When the first flower cluster dies, another will grow to take its place and sometimes even a third flower spike will appear.

Because certain hybrids—such as the brilliant red African amaryllis—can flower in time for Christmas, the amaryllis is becoming as much a part of the holiday season as holly berries and mistletoe.

The most commonly grown kinds of amaryllis, besides the African hybrids, are the Royal Dutch hybrids. Only slightly smaller in size, the color range of the Royal Dutch is more extensive, including red, white, pink, orange and candy striped—and they are later flowering, usually February at the earliest. Both the African and Royal Dutch hybrids can be induced to flower again the following year simply by transplanting the bulb to a shady part of the garden after all danger of frost, feeding it with 5-10-5 fertilizer and bringing it indoors in fall when frost kills the leaves. The bulb will be unharmed and should be stored in a dark, cool place at 40-50°F for eight to ten weeks, then potted-up, watered and transferred to a bright, warm place such as a living room window.

The best picture is a close-up of a single bloom against a black background. A distinctive feature of all amaryllis is the pistil at the center of the flower, which projects far forward. Below the pistil is a cluster of bright yellow stamens.

When the flower is young and at its vibrant best, the stamens are powdery and buttercup-yellow, but after a few days they discolor, turning brown. The rest of the blossom usually stays fresh for a week longer. For the picture-perfect result, however, always photograph amaryllis with the stamens bright yellow rather than brown.

One problem with African amaryllis is the long flower stem which makes it difficult to shoot a complete plant without having too much wasted space on each side of the frame. This is best overcome by "posing" the plant on a table, and showing it as part of the room decor.

Another good composition is a group of different colors of amaryllis. To do this, you may have to arrange the pots on different levels, perhaps creating three tiers of plants so you can present six or more separate colors in the frame.

African amaryllis are extremely popular as cover subjects for garden magazines, especially in Christmas and New Year issues. One year I sold the same picture twice to the same magazine.

Because of the unbelievable size of the African amaryllis, consider shooting some specimens with a child or attractive model to show scale.

BEGONIAS

This is an enormous family of plants from tropical humid climates. Some are grown for their exotic flowers and others for the ornamental value of their textured leaves. The three most photogenic groups are tuberous begonias, which have individual blooms measuring up to eight inches across; fibrous begonias, with lots of smaller flowers; and rex begonias, displaying colorful leaves with prominent contrasting veins.

One of my most colorful photo features was about begonias for *Woman's Day* magazine. The article told readers how to grow the

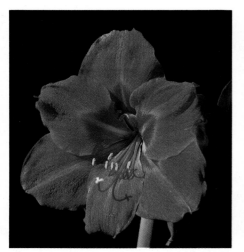 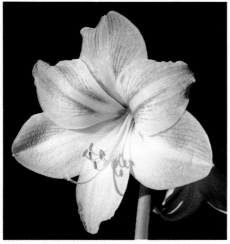

African Amaryllis—Christmas Red and Apple Blossom—showing how well a black background displays the petal colors. These pictures appeared as a pair in *House Plants & Porch Gardens* magazine.

three main groups, and a double-page color spread showed examples of each type.

Tuberous begonias are among the most spectacular flowering plants. The size, substance, texture and pastel-colors, combined with a long flowering period, make them ideal subjects for dramatic photography. Young plants produce the best flowers because older tubers have less vigor. It's also important to know that tuberous begonias usually produce three flowers in a cluster. The central flower, whether single or double, is the male and the side flowers are females, growing slightly smaller.

To produce a larger and better central flower, the female flowers should be removed in the bud stage so all the plant's energy goes into growing a truly spectacular main flower, offering the best opportunity for a dramatic close-up photo.

Tuberous begonias are normally at their best when grown in shade or in greenhouses covered with shade cloth. Outdoors they look good about mid-summer, but after that both leaves and petals can become badly blighted by sunscorch or disease.

CACTUS

Most people think of cactus as an uninteresting, undemanding, spiny plant that squats in a pot of dry soil and grows so slowly it hardly seems to grow at all. We see rows of them in the dime store happily nourishing themselves with their own built-in reserves of moisture, waiting patiently for someone to buy them. Actually, cacti are quickly losing their dusty old dime-store image. Many are so elegant in form that they are valued as highly as pieces of fine sculpture; others produce such spectacular blooms that they will outshine even orchids and water-lilies in sheer brilliance.

Most photogenic of all cacti and succulents are the epiphyllums, or orchid cactus, with some individual flowers measuring ten inches across. Hybridizing of these has produced some beautiful varieties in many brilliant colors, especially shades of red.

Closely related to the orchid cactus is the night-blooming cereus, which opens its white blooms only at night. Flowers begin to open around 6 pm, reach peak bloom by midnight and die by dawn. You can easily tell when the plant is ready to bloom: A large bud will form at the end of a leaf segment, and in the morning you can see the folded white petals ready to burst open that night. Flash lighting is essential. It's a good idea to photograph the flower in the bud stage, half open and fully open. The blooms open so quickly, you can actually see them move. August is the month when cereus normally bloom, and once you've been caught up in cactus photography, you won't rest until you have spent a night photographing cereus in full bloom.

You can do the same with moonflowers, which are related to morning glories and bloom at dusk to be pollinated by night-flying moths.

Epiphyllums and cereus grow mainly in the crotches of trees. They are jungle cacti, not desert cacti, and black or deep shadow makes an excellent background for close-ups of one or several blossoms.

There are literally thousands of varieties of desert cacti which produce glorious flowers. Surviving in arid lands, they attract attention with a vivid display.

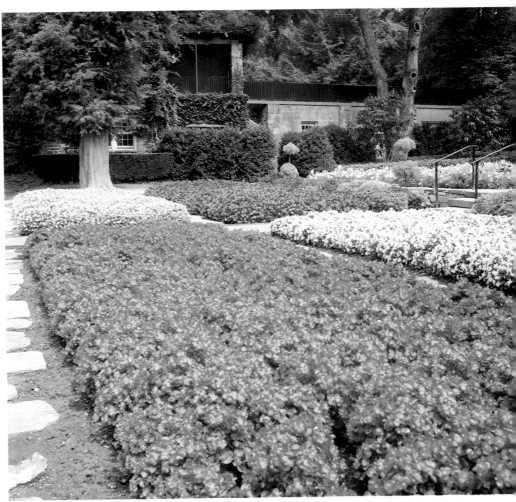

Red Scarletta and white Viva hybrid wax begonias create an unusual checkerboard design in this spectacular mass planting at Longwood Gardens, demonstrating how effective these plants are for outdoor bedding displays. This picture was used as a double-page spread with an article on wax begonias in *Plants Alive* magazine.

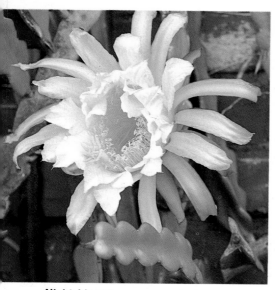

Night-blooming cereus starts opening at about 6:00 pm, reaching peak bloom by midnight, and fading by dawn. The petals open with such speed you can actually see them move.

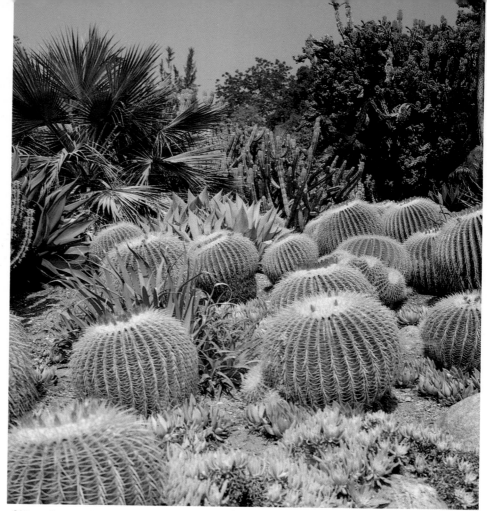

Although many beautiful cactus pictures can be made indoors in greenhouses and conservatories, no indoor photo can compare with an outdoor scene where several varieties of cacti are combined in a natural landscape. The ball-shaped cacti in this planting are golden barrel cacti, *Echinocactus grusoni.*

Most cactus flowers make magnificent close-ups, with the viewer looking directly down on the blossoms. Natural desert and rock are excellent backgrounds, although these are often better in slight shadow, with the flower in good light to show the colors more dramatically. Flowering cacti in clay containers make excellent pictures, but nothing quite compares with a full-blooming group of cactus in its natural habitat of sand, accented with gnarled tree shapes, bleached bones and stark rock formations. However, for the majority of photographers, lengthy trips into remote desert areas make this type of shot difficult to obtain.

Many varieties of cacti are beautiful to photograph even without flowers, and these are best seen in the wild or in specially landscaped desert gardens which cactus enthusiasts create under glass in non-desert areas. The spiny-barrel cactus, living stones or lithops, and rattail cactus are

examples of cacti with interesting shapes.

Among the giant varieties, such as the enormous organ-pipe cactus and prickly pears, it is their shape and form which make spectacular pictures. The more grotesque and bizarre they are, the better your chance of pictures with impact—especially when you can photograph them contrasting with rock formations or silhouetted by a desert sunset.

Some cacti have white flowers. White flowers make beautiful pictures, especially if you remember a few important points: White flowers are rarely all-white. They usually have a distinctive contrasting feature, often a cluster of golden stamens at the center of the flower—this is where you should concentrate your efforts.

White flowers should also have a sufficiently dark background—green foliage is generally best. Correct exposure is critical with white flowers. The slightest overexposure will lose all texture and delicate petal shadows, while underexposure will dull the whole effect. When photographing white flowers with artificial backgrounds, you must take care that the background color does not reflect in the white petals.

The white petal color will also change according to the sunlight. In late afternoon sun they may reflect an undesirable reddish tinge. I've never taken a good white flower picture in bright sunlight. My best results have always been on slightly overcast days before 3:30 pm, or on sunny days using a diffuser screen.

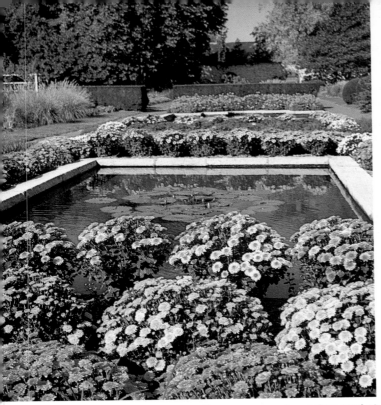

This display of cushion chrysanthemums around a sunken pool at the Missouri Botanical Garden, St. Louis, shows an effective use of mums for fall bedding displays.

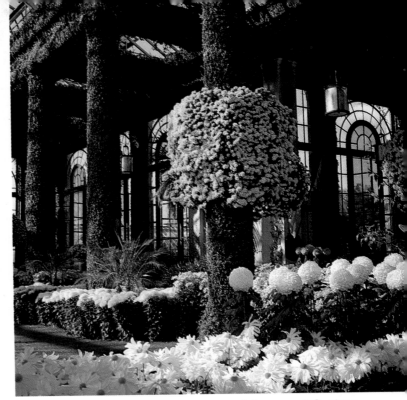

One indoor display of chrysanthemums at Longwood Gardens focuses on a cascading display completely encircling a vine-covered pillar. Bedding varieties and show chrysanthemums fill the flower borders.

CHRYSANTHEMUMS

Although just about everyone is familiar with the big round "football mums," few people realize that the chrysanthemum plant group is one of the largest in the world, with many hybridized forms. In addition to the big bold rounded types, there are spider, spoon, button, cushion and other classifications, each photographing best in a different way.

For example, the large-flowered football mums are mostly grown for indoor display. Forced in greenhouses, they are trained to a single stem by pruning of side-shoots so all the plant's energy is directed into one magnificent bloom on a tall stem. These are best photographed as close-ups of one perfect specimen against a dark background like black.

Spider and spoon mums have smaller flowers. The distinctive feature of these is an unusual petal shape. Spiders have curled petals that stand out in all directions. Spoons are also curled, but with a flattened tip. These are best photographed as a group of flowers on the same plant, against dark backgrounds.

Cushion mums are low-growing, with so many flowers the foliage is often completely hidden. The plants themselves are mound-shaped. The more perfectly shaped the mound, and the more densely covered with flowers, the better it is as a specimen. These are best photographed showing one complete plant. They are also effective when photographed in massed beds, particularly as a colorful border.

One autumn at the Missouri Botanical Gardens, I was able to capture a beautiful massed planting around a sunken pool. On another occasion at Longwood Gardens, Pennsylvania, I photographed chrysanthemems trained into different shapes, some like balls four feet or more across.

Yellow, white, bronze, orange, purple and red are the most common chrysanthemum colors. You'll see these blooms on greeting cards, usually shot with a soft focus attachment, and on a lot of magazine covers.

CLEMATIS

Of all hardy flowering vines, clematis are the most showy and largest flowered. Flowers of some hybrids measure eight inches across. Some bloom so profusely, they are dazzling in their floral effect. White, blue and red are the principal colors, although Nelly Moser, a pink variety with red petal stripes is the most popular in the magazines.

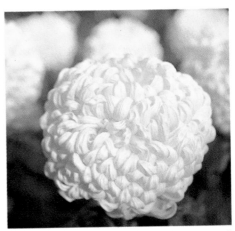

Perfect shape and flawless in-curved petals make this single Yellow Show chrysanthemum blossom an excellent close-up subject.

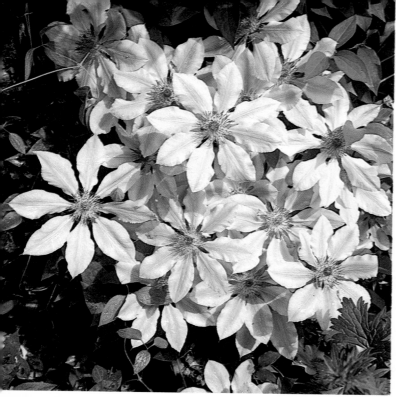

Clematis Nelly Moser, a spectacular free-flowering, striped variety, shows how effective clematis can be in group close-ups. Clematis deserve to be much more widely photographed for artistic compositions because their appealing beauty compares with tulips and roses.

Shooting straight down on a young plant to emphasize the intricate multicolored pattern around the leaf veins is illustrated with this picture of coleus Rainbow Salmon Lace. I used leaves from other plants as a background to cover up an ugly cement floor.

Clematis photograph well up close, particularly as group close-ups with one perfect specimen in clear focus and two more in the background slightly out of focus.

Pictures of an entire vine covered in flowers are also effective. When shooting clematis as specimen vines, try to show what the vine is climbing on, such as a trellis, lamp post or mailbox. Your picture will be improved by showing the support.

Clematis are also spectacular when photographed against old stone walls and old brick.

One of the biggest problems in photographing clematis is accurate reproduction of the blue color of such types as Jackmanii. Light blue and sky blue clematis have a tendency to photograph pink or mauve. This is known as the *ageratum effect* because it is most noticeable when photographing blue ageratum flowers—see "Problem Flowers" at the end of this chapter. To reduce this effect on clematis, shoot on slightly overcast days.

COLEUS

Although coleus are flowering plants, they are grown mostly for their leaf colorings. The brilliance of coleus leaves can outshine even the most colorful flowers. Color development in the leaves occurs soon after the seeds germinate, intensifies as the plants mature, and lasts a long time.

Classified as a tender annual in flower catalogs, coleus are really perennial. If grown in a greenhouse, it's possible to keep them colorful all year round, year after year.

In some cases the leaves display four distinct colors—bronze, red, yellow and green. Depending on variety, leaf shapes can vary from long and slender to broad and arching, some with deeply scalloped edges like an oak leaf, and others delicately fringed.

Out in the garden, coleus are used extensively for summer bedding displays. They tolerate shade, and you will find them mostly used as a border planting or massed together in a single bed.

Coleus also make excellent indoor plants. In the home they are often seen as magnificent hanging baskets.

It's good to shoot pictures of coleus in garden settings and container plantings, but for the best color effect, try close-ups of a single leaf or a portion of leaf, allowing the intricate leaf patterns to fill the frame. I can guarantee you'll never tire of photographing coleus. Color variations are endless, and breeders add new varieties every year.

DAFFODILS

Daffodils are one of the easiest flowers to photograph effectively. You may think they don't offer enough variation, but they do. Each spring I find myself taking new and more spectacular daffodil pictures, and I have sold numerous features on them to *Architectural Digest, Plants Alive, Flower & Garden*, the *Philadelphia Bulletin* and others.

I suppose what I like most about daffodils is that they are the earliest showy flowers to bloom in the

spring. They bloom ahead of the great tulip displays, and this enables you to concentrate on them without being distracted, as more and more flowers compete for your attention during late spring and early summer.

Daffodils are not blemished easily by the weather. They stay bright and colorful for a long time and pose beautifully even in wind. Basically, you have to watch for only two things: Blooms must be symmetrical and they must be well-placed in groups and clusters.

The best background for daffodils is clear blue sky, followed by green lawn or shrubbery such as rhododendrons and evergreens. The predominating yellows and whites also stand out well against a dark background. The trumpet blossom of a daffodil sometimes causes a focusing problem. With a long trumpet, the best place to focus is on the anthers situated about mid-way down. This general rule-of-thumb applies whether you are taking a direct head-on shot, a half profile, or if you are looking down or up at the flower.

If you can fill the frame with a tight cluster of shapely blooms in the same plane, you'll rarely take a bad daffodil picture. Naturalized plantings of daffodils also make exquisite scenic pictures. A classic setting for these flowers is a sunny bank bordering a lake or stream, or they can be used as a ribbon of color at the edge of lawn or woods.

Backlighting of daffodils is effective. Look at a daffodil against the sunlight and see how it glows.

DAHLIAS

These colorful summer-flowering plants are grown mostly from tubers planted in the garden after danger of frost is past. They grow rapidly and flower until fall frost. The most spectacular kinds are the "dinner plate" dahlias, growing massive flowers up to ten inches across in a beautiful color range, including yellow, orange, red, pink and bi-colors.

The best pictures are those showing a single blemish-free bloom and a bud, with clear blue sky or natural foliage for the background.

Dahlia enthusiasts are in all areas of the United States. To discover a garden planted almost exclusively with exhibition-quality dahlias is an uplifting sight, and the source of a lot of good pictures. Try shooting some of the romantic colors—the deep reds and clear pinks—using a soft focus attachment, with green shrubbery or other foliage as a background.

DAYLILIES

Daylilies grow wild along the waysides of most states, and you would think they are native to the United States. Actually, they came originally from China and have made themselves totally at home in North America, thriving in poor soils where few other flowering plants will grow. Several specialist breeders of daylilies have made some remarkable color breakthroughs: The two original colors, orange and yellow, are now accompanied by pink, white, peach, mahogany and shades in between. However, it is difficult to find any of the newer colors unless you visit a botanical garden featuring an up-to-date collection. Generally, you will find orange and yellow, but the most used colors in magazines are pink and mahogany, both of which photograph quite faithfully on color film.

The classic arrangement for daylilies is a grouping of three perfect blossoms of the same color shot against either a contrasting background or an out-of-focus natural green background. The blossoms should be turned to face the camera. This is the way catalog houses like to show them.

Daylilies photograph well as a mass planting, in a perennial

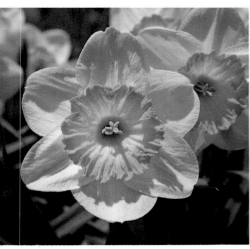

This illustration of daffodil Roulette shows how perfect specimens can make dramatic close-ups; modeling from shadows in the white petal areas is essential.

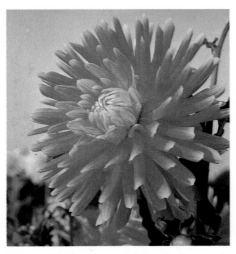

This exhibition-type dahlia, Radiance, is grown from tubers and produces some of the largest flowers to be found in home gardens. Notice how blue sky complements the rose-pink petals.

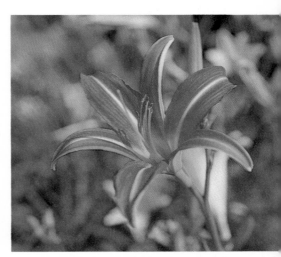

This unnamed bronze variety of daylily with yellow petal stripes contrasts effectively with a natural background of yellow daylilies that are well out of focus.

Ivyleaf geranium Balcan Imperial, cascading over the edge of a sunken pool. Pictures showing the use of plants in landscaping or decor are very popular in publications.

There isn't a month when you cannot photograph geraniums. Outdoor varieties bloom non-stop until fall frosts, and indoor varieties flower throughout the year.

The most widely grown outdoor geraniums are the zonals, so-called because of a dark brown horseshoe zone on the leaves; the regals, also called Lady Washington; and the ivy leaf, which is spectacular in hanging baskets, containers and climbing up trellises. Best for indoors are the scented leaf and the fancy leaf types, although these are sometimes encountered outdoors during frost-free months.

The dark horseshoe area on zonal geranium leaves is considered a decorative feature, but not all geraniums have it. In close-ups, when trying to document different types, it is important to show a specimen leaf so an observer can judge whether the variety has a prominent leaf marking or not. Zonals have globe-shaped blooms, generally red, pink and white, with the reds far more popular. Close-ups of a single bloom are effective, especially if a bud is included in the composition; I feel that a better presentation is two perfect blooms and a bud.

Garden scenes featuring bedding geraniums are in demand, especially those showing mass plantings and container plantings.

The regals are an extremely colorful class of geranium, but they do well outdoors only in cool climates. Even in greenhouses the blossoms do not last long. The best pictures are close-ups of a single flower head because many of the regals have intricate petal markings, some resembling pansy faces.

Ivy leaf geraniums are widely grown as hanging baskets. The best picture is a healthy cascade of foliage smothered in blossoms.

Fancy leaf geraniums usually have small flowers, but colorful leaves. In my experience, the most

border, for example. If you can find some unusual wild plantings, with a rustic bridge, waterfall or some other romantic feature in the background, you may be able to compose a picture suitable for a calendar or greeting card.

Although daylily flowers last only a day, there are sufficient numbers on each stem to ensure a succession of blooms for several weeks during the summer. The trumpet-shaped flowers open at dawn and close at dusk, and the leaves form thick arching sword-shaped clumps that stay ornamental all season.

GERANIUMS

Believed to be the most popular flowering plants in the United States, it is estimated that 40 million geraniums are purchased each year as ready-to-bloom plants for outdoor garden display and indoor

decoration. Home gardeners grow millions more from seed. New hybrid varieties are capable of flowering within 14 weeks from sowing.

Geranium photographs in my library have been one of the biggest money-making groups. In addition to illustrating an entire book about growing geraniums, pictures from my files were used by *Woman's Day* magazine for a special photo feature showing the most popular kinds.

Some geraniums are such prolific bloomers that they can be kept in flower every month of the year. They are second in popularity to African violets as indoor flowering pot plants, and second, after petunias, as outdoor bedding plants. Their popularity as both indoor *and* outdoor plants makes geraniums the most popular plant.

popular pictures are those showing both the colorful leaf and a flower, no matter how inconspicuous the flower may be.

Similarly, there is a group called scented leaf geraniums, grown for the beautiful aroma of the leaves. Some have perfumes as delicate as rose petals, while others are pineapple, peppermint and lemon scented. The scented leaves are usually decorative—either deeply serrated or heavily textured. A good picture shows a close-up of a single leaf for identification. Some of the scented leaf types also have big, bold flowers. The best picture features the leaves in clear detail, with a flower or group of flowers.

IRISES

One of the most enjoyable assignments I ever undertook was to photograph an iris garden for the *Philadelphia Bulletin* Sunday magazine supplement. It included writing a story about the owner of the garden who sold healthy clumps of iris in full bloom for $1.00 per clump. I wrote this up as one of the biggest plant bargains around and advised people: "Don't ask the price—everything's a dollar."

As a result of the article, which was illustrated with color pictures showing the iris garden, the grower was inundated with visitors. Hordes of people descended on him, arriving by the bus-load from as far away as Washington, D.C. and Maryland. In two weekends he sold every plant, and when I visited him the next year to find out how he liked the article, he scolded me for the publicity, saying he hoped he'd never see crowds like that again! We had a good laugh, and we're still good friends.

In my experience, irises are among the most difficult flowers to photograph effectively, particularly the tall bearded iris. The main problem is the intricate shape and petals that flop all over the place. It is sometimes extremely difficult to find some form of pleasing symmetry.

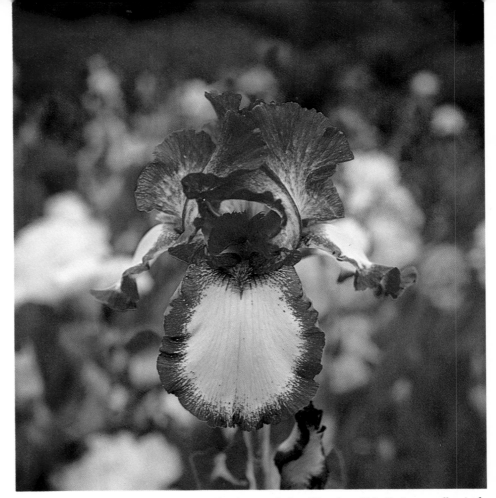

Bearded iris Tollgate against a natural background of multi-colored iris that are well out of focus. Notice how the broad front petal is perfectly placed in relation to the arching side petals and overhead petals. This pleasing symmetry is important when photographing close-ups of the iris, and is not easy to find.

Another big problem is color. They predominate in shades of violet, lavender and blue, the most difficult flower colors to capture successfully on film.

Japanese and Dutch irises are not so difficult to photograph. With Japanese iris, the best picture is a grouping of several well-formed blooms, looking down on the flowers at a slight angle. With Dutch iris, group close-ups of mass plantings are lovely, and clusters of the blue kind photographed against a background of white azalea blossoms are especially beautiful.

Bearded irises are more challenging. Close-ups of single blooms and groups of two or three tightly placed flowers can make effective subjects. The big challenge is to find blooms with good shape and form. Each

bearded iris flower has a set of three upward arching petals called standards, and a downward facing set called falls. Shooting a single iris close-up should be done head-on to one of the falls in such a way that the other two falls are shown in profile—like wings—and the standards sweep upward in a perfect arch. I have never found any other angle to be satisfactory with bearded iris. Focus should always be on the top of the "beard," which is usually a contrasting color of yellow, tangerine or white.

The best backgrounds for iris are sky and shrubbery. Artificial backgrounds of black, blue and pale green are also acceptable alternatives.

Massed beds of bearded iris are effective in photographs, especially a rainbow planting of contrasting colors in solid clumps.

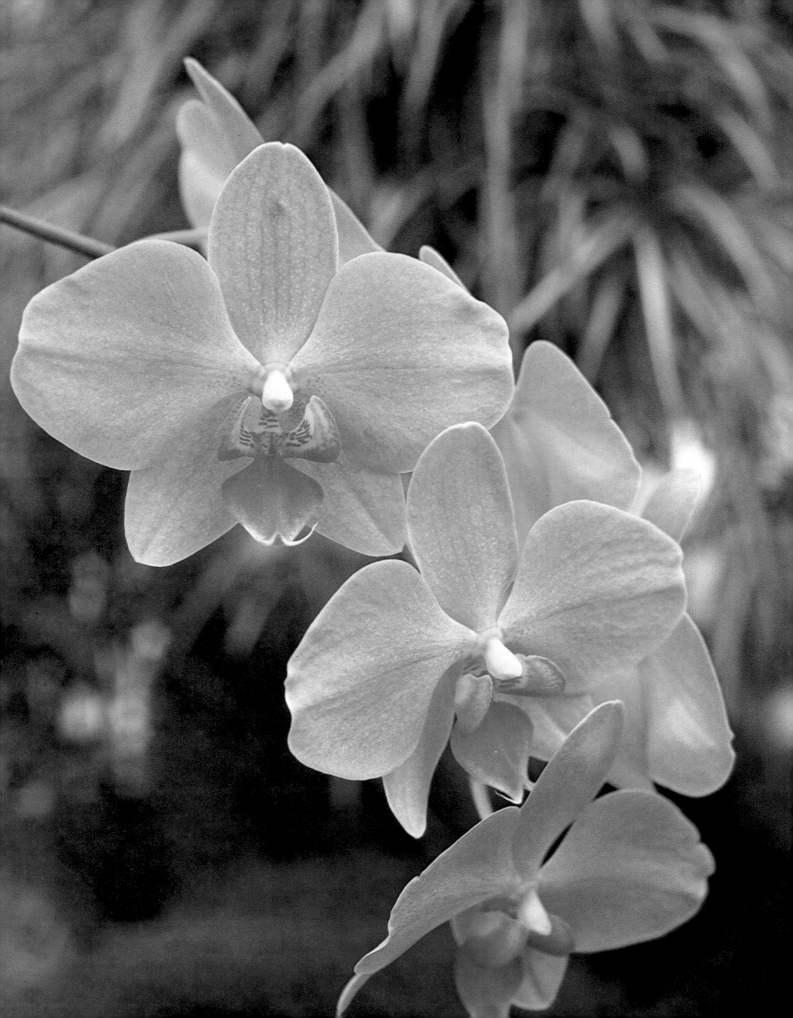

ORCHIDS

These mysterious plants have compelled men and women to risk life and limb in the jungles of the world, fighting cannibals, wild animals and fever in search of new varieties. Considered to be the most complex of all plants, their fascinating forms and near-human characteristics are a flower photographer's delight. More than 35,000 named varieties exist today, and

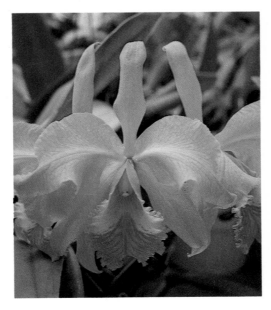

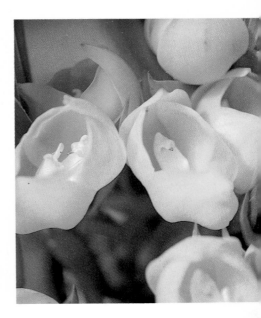

For good orchid pictures, *get close*. Orchids have evolved sophisticated methods of pollination, mostly to attract flying insects such as moths and bees. Thus, the flowers themselves are beautifully colored and the intimate parts often have bizarre markings. Most of these pictures were taken at Waldor Orchids, a commercial orchid greenhouse in Linwood, New Jersey.

Facing Page: Phalaenopsis orchids, or moth orchids, have graceful arching stems with flowers resembling a flight of moths or butterflies. The original background to this spray was an ugly greenhouse structure which I covered with some hanging baskets of foliage plants.

Top Left: Cattleya orchids are the most striking, and natural green foliage backgrounds are excellent for close-ups. A picture similar to this was used by Encyclopaedia Britannica for *Britannica II*.

Top Right: Resembling Dutch clogs, these two flowers of an *Anenloa clavesii* orchid make a matched pair. When two perfectly uniform blossoms present themselves like this, they almost always make a better picture as pairs than a single close-up of one flower.

Center Left: There's only one better grouping than two perfectly shaped blooms—and that's three. This trio of laelia orchids, with foliage to provide a contrasting background, resembles trumpet daffodils.

Center Right: Orchid flowers last a long time, so it's not unusual to find a whole stem covered with blemish-free flowers. Complete flower stems like this vanda orchid make good pictures with a jet black background, or a natural foliage background as seen here.

Bottom Left: Orchids photograph well when posed against a black background. This variety of ladyslipper orchid is named Albion.

Bottom Right: Ladyslipper orchids have a prominent lower lip that protrudes forward a long way and forms a slipper shape. Sometimes there isn't sufficient depth-of-field to get the entire flower in sharp focus. The best place to focus is the center of the flower petals at a slight angle as shown here. The variety is Maudiae.

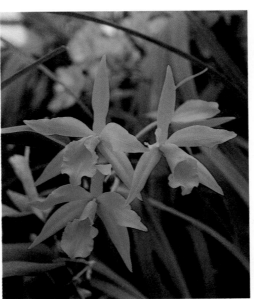

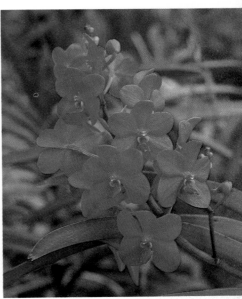

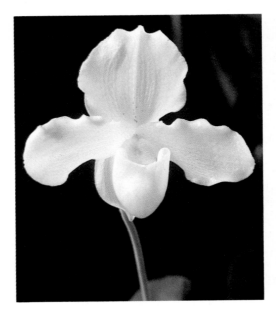

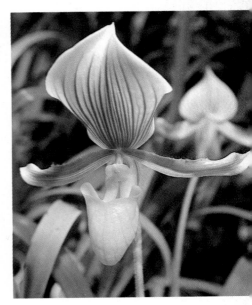

31

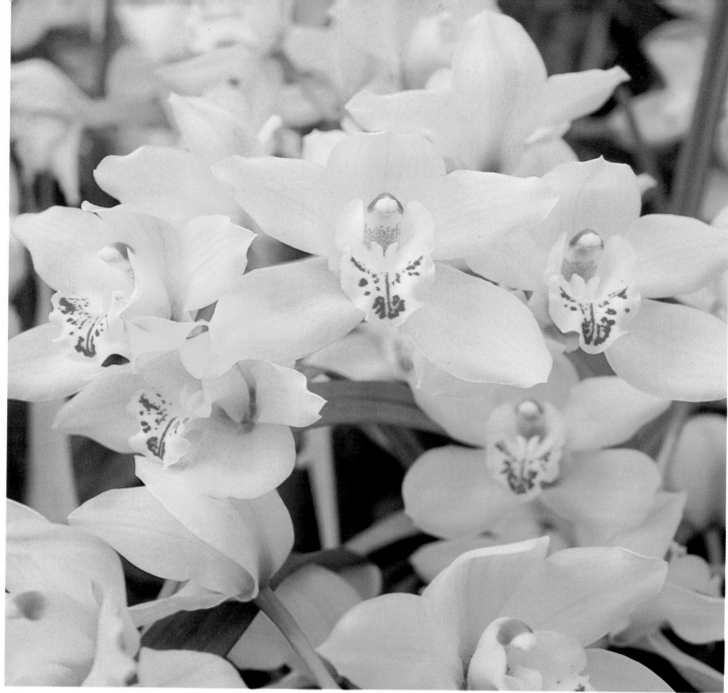

Sometimes you will find a spray of orchids that allows you to fill the entire frame with flowers. Although the flower at the center of this spray of cymbidiums is good enough for a single close-up, it makes a far better picture when seen with its companions, with their petals "bleeding" off all edges of the picture frame.

distinct new forms are being created every year. It's hard to take a really bad orchid picture. Once you get in close to them, it's easy to understand why they are held in such high esteem.

Single and group close-ups of orchids are sensational. Good backgrounds are ferns, foliage or shadowy darkness. Artificial backgrounds of blue, dappled green and black are acceptable substitutes.

Focus is a problem with many orchids. Members of the popular *Cattleya* species, for instance, have graceful petals that arch back, and a frilly lip projecting forward. Depth-of-field is normally insufficient to keep the whole flower sharp and clear. To gain as much depth-of-field as possible, use a small aperture—f-11, f-16 or f-22—if you can. Then decide what is the most distinctive feature of the flower. It could be a splash of

yellow on the inside lip, a group of purple blotches intended to attract insects, or the lip may be distinctively frilled. Focus on that important feature and let the lesser background go out of focus.

In orchids, the male and female parts of each flower are fused together in a single column, which is usually a distinctive feature. This is particularly true with the *Cymbidium*, *Phalaenopsis*, *Miltonia* and *Paphiopedilum* species. In

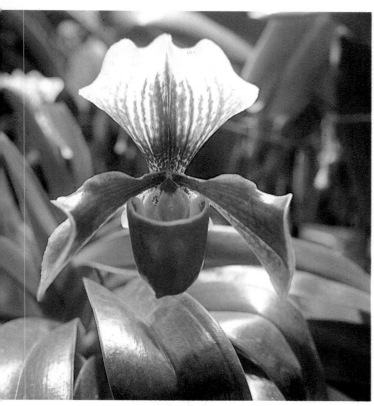

Like some exotic bird in flight, this ladyslipper orchid is back-lighted by the sun to create a dramatic close-up.

Dancing doll orchids, *Oncidium flexuosum*, get their name because the lower lip resembles a flared skirt. Although a single flower makes an especially dramatic close-up against a black background, this picture of a complete flower spike gives a better idea of the true flower form.

This head-on close-up of cattleya orchid Golden Sands Elizabeth Strauss would not be so beautiful without the second flower, half-turned, in the background.

There's a tendency to shoot all close-ups of orchid pictures head-on, but here's an example where a single cymbidium bloom shot at a slight angle produced a much better picture.

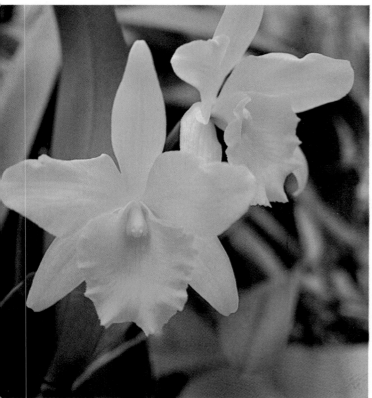

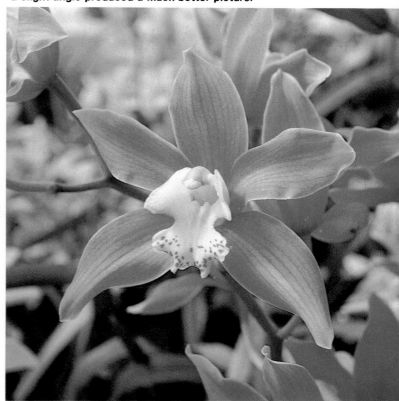

paphiopedilum, a bucket-shaped keel projects forward of the outstretched spotted petals, and the column at the center of the flower is shaped like a bullseye. Ignore the keel and keep the bullseye in sharp focus—that way you'll never take a poor paphiopedilum picture.

Orchids are excellent subjects to practice backlighted shots, particularly the yellow cattleyas and the spotted paphiopedilum.

The best time of year for orchids is just before Easter, when most commercial growers have them in full bloom. Locate the main orchid growers in your area, and ask permission to take pictures. There are also amateur orchid fanciers who love to have their prize specimens captured on film. Locate the local orchid society and contact orchid fanciers by attending their meetings. Soon you may be an orchid addict yourself, and that'll leave you little time for photography!

PEONIES

Peonies can be classified into two groups: The old-fashioned herbaceous peonies bloom mainly in early summer, and the more spectacular tree peonies, originating from China, bloom several weeks ahead of the earliest herbaceous peonies.

Most herbaceous peonies are white, pink and red, in double and single forms. Best shots show a plant covered in blooms and single blooms with a bud. A border planting can also be sensational.

Tree peonies grow huge flowers, up to ten inches across, with petals so delicate they resemble fine silk. A perfect tree peony will outshine an entire border of herbaceous peonies, and some of the best pictures are close-ups, against a natural green background. At the center of every tree peony is a dome of brilliant yellow anthers. Try focusing on them.

In addition to red, white and pink, tree peonies also come in yellow. In the world of plants there are very few giant yellow flowers. For this reason, giant yellow tree peonies can make stunning pictures, especially with one flower pictured alone in clear close-up.

The pinks and deep reds among tree peonies make excellent greeting card subjects, especially when a soft-focus attachment is used over the close-up lens to create a dream-like, romantic quality.

RHODODENDRONS

Although rhododendrons are really shrubs, they are principally grown for their beautiful flowers. Because they make some of the most spectacular flower pictures, they are included in this "Top 20" selection.

Modern rhododendrons have been hybridized successfully and improved from the original wild species, largely as a result of the

This hybrid tree peony displays a profusion of blooms, like a line of chorus girls, exactly as nature presented them. A spray of such large perfectly-formed blooms is extremely rare among flowers, and reinforces my opinion that tree peonies are the most photogenic of all flowers—easily surpassing orchids, roses and rhododendrons in sophisticated beauty.

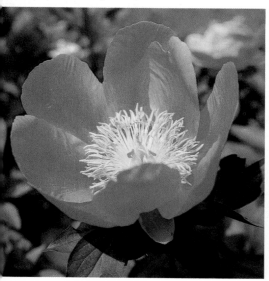

Peony Bowl of Beauty, in a pose perfectly illustrating its name. Very often the name of a flower is a clue to how it should be photographed, as it is here. Shooting to show the bowl effect, I focused on the prominent yellow stamens at the center of the bowl. A natural foliage background provides a perfect contrast for the delicate pink petals. I have a framed color blow-up of this in my office.

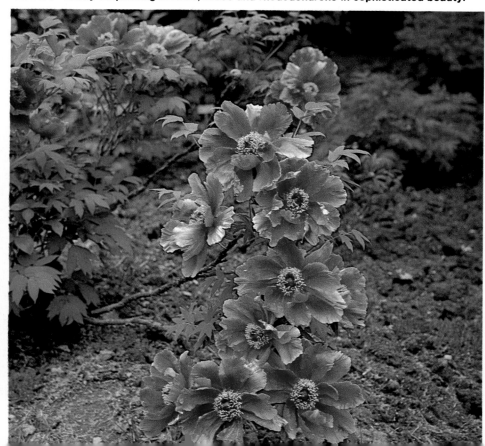

fanatical activity of a small group of enthusiasts. The most energetic and most famous of these was Lord Lionel de Rothschild, of the famous English banking family. At his beautiful country estate known as Exbury, he made the most significant improvements to rhododendrons and azaleas, employing hundreds of gardeners working with thousands of crosses. The famous strain of Exbury azaleas resulted from this work along with many fine rhododendrons, including my favorite, the Bud Flanigan.

The most spectacular rhododendron pictures are those of well-established plants in a naturalized setting. At the edge of trees, bordering a manicured lawn, massed near a lakeside and as part of wild gardens—these are all classic settings. The individual flower clusters can be equally spectacular, either singly or in groups. Foliage, trees, sky and even the forest floor

when you get an angle shooting down, are excellént natural backgrounds for rhododendrons. For close-up photography, the best blooms are dome-shaped with individual flowers set close together in perfect symmetry. Pay as much attention to the leaves as the flowers because the collar of leaves is an important part of any rhododendron picture. These should be healthy, dark green, well veined broad and pointed— not shriveled, burned or chewed by insects.

An often asked question is, "What's the difference between a rhododendron and an azalea?" No difference, because all azaleas are really rhododendrons; but it has become customary among nurserymen to refer to the smaller-flowered, fine-leaved rhododendrons as azaleas.

Some of the large-flowered azaleas like Mollis and the Exbury

hybrids can be treated like rhododendrons for picture purposes. The smaller-flowered azaleas, however, are better as part of a landscape.

Rhododendrons in the wild make spectacular pictures, and many wild species are native to the United States—mostly in the Northeast. One of the best places to see naturalized stands is along the Blue Ridge Parkway which runs from West Virginia to the Smoky Mountains. The Himalaya Mountains in northern India are also rich in rhododendrons. Although I have not photographed them there, it is an ambition I hope to fulfill one day.

ROSES

Without doubt, roses are *the* most photographed flowers in the world. Although sales of these flowers have been declining in the United States during the past ten years, they are a romantic flower,

One of the most famous rhododendron gardens in the world is Savill Gardens near Windsor, England, where both these pictures were taken. *Rhododendron kaempferi* Kathleen and a yellow hybrid rhododendron in full flower beneath a canopy of towering pine trees. *Rhododendron loderi* King George, so heavy with the weight of its own blossoms, that branches are touching the ground as though burdened with snow.

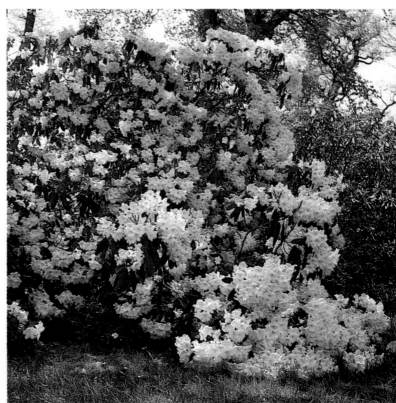

associated with love, tenderness and caring.

The problem in a warm climate is that roses bloom well only a few weeks in early summer and a few weeks in autumn because they cannot tolerate hot summers. So if you are eager to shoot some good rose pictures, you must plan in advance to visit rose growers and rose gardens at the right time, although cut roses grown in greenhouses are available from florists all year.

Each year I try to visit England, where the climate is ideal for growing roses. Roses bloom there continuously from early summer until autumn, and I've never seen such large flowers anywhere else!

One of my more interesting assignments was from an advertising agency that required a large number of rose pictures for a client's rose catalog. I contacted a wholesale rose grower and spent an entire day in his rose fields gathering different kinds of blooms. Some were in the bud stage, some were half-open with a high center and others were fully open. I collected together all the main color groups—white, yellow, pink, coral, red, crimson and orange—and made tight arrangements, showing these three different stages of flower development in each picture.

Almost daily we see rose pictures on greeting cards, in calendars and on candy boxes. Roses are illustrated in countless different ways—on pillows, in vases, through frosted glass, against artificial backgrounds, plus a multitude of other fine and fancy variations. Many of these are creatively inspired and artistically done; but to me, a truly *natural* rose picture outshines them every time!

In spite of the vast number of rose pictures published each year, they are not the easiest flowers to photograph. Finding unblemished blooms is the big problem because roses are so susceptible to petal damage by wind, sun, rain, disease and pollution. These are imperfections you hardly notice until you try to photograph the flower. The best time to shoot roses is when flowers are young and freshly open; then again when cool fall weather brings in a new flush of good blooms.

To build a good collection of rose photos, you should take pictures of the major rose types: hybrid teas, which have the largest flowers; floribundas, with smaller flowers, but more of them; climbers, which are both large and small flowered; and miniatures, with tiny flowers.

Hybrid tea roses make the most spectacular pictures; a classic arrangement is a cluster of two perfectly formed blooms—one fully open, one half-open—and a bud. Lawn and foliage make attractive backgrounds. Keep a sharp eye open for leaves eaten by caterpillars or stained by chemical or water spray.

After taking hundreds of rose pictures, I've realized that each rose has a different stage of its development when it is most photogenic. Some roses such as Tiffany have their best form and color in the bud stage. Others such as Circus and Chrysler Imperial seem more beautiful when fully open. Catch Peace and Royal Highness in between. When photographing individual blooms, focus on the very center.

Floribunda roses look best as a cluster of up to half a dozen blooms, as do some climbing and hedging roses. Blue sky is almost always a good background. There are many interesting pictures to be taken of roses—a rose arbor in full bloom, or roses in containers or cascading over walls, for example.

For photographic purposes, my favorites among roses are the vivid reds and the clear yellows, and also the delicate pinks and the coral colors. Roses with a high center, like Royal Highness, are especially lovely, but I've yet to see a really outstanding picture of the new lavender roses. Sterling Silver and Angel Face are examples of lavender roses which are impossible to photograph true to color. To my mind, roses were never meant to be blue, and these man-made lavender forms are not the prettiest of flowers.

Walk into a rose garden during peak bloom and your eye will register a delightful mass of color. On film it will invariably turn out disappointingly colorless unless you learn to compose for maximum color effect. One technique is to find a corner where the roses are massed closest together. Shoot looking down at such an angle that you bring the individual rose blooms close together, and the wide vistas of foliage and empty space drop out of sight. Too high an angle and you'll show too much foliage, garden soil or just plain

Here are three perfect rose pictures. Top: Miss All-American Beauty, an attractive hybrid tea showing two perfect blooms in close-up. Bottom: Floribunda Fire King, with a cluster of flowers typical of the variety. Facing Page: The romantic rose garden at Lyndhurst Castle, New York, photographed to emphasize an all-white theme.

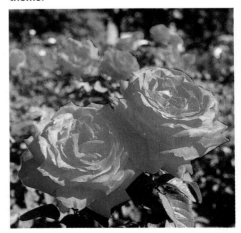

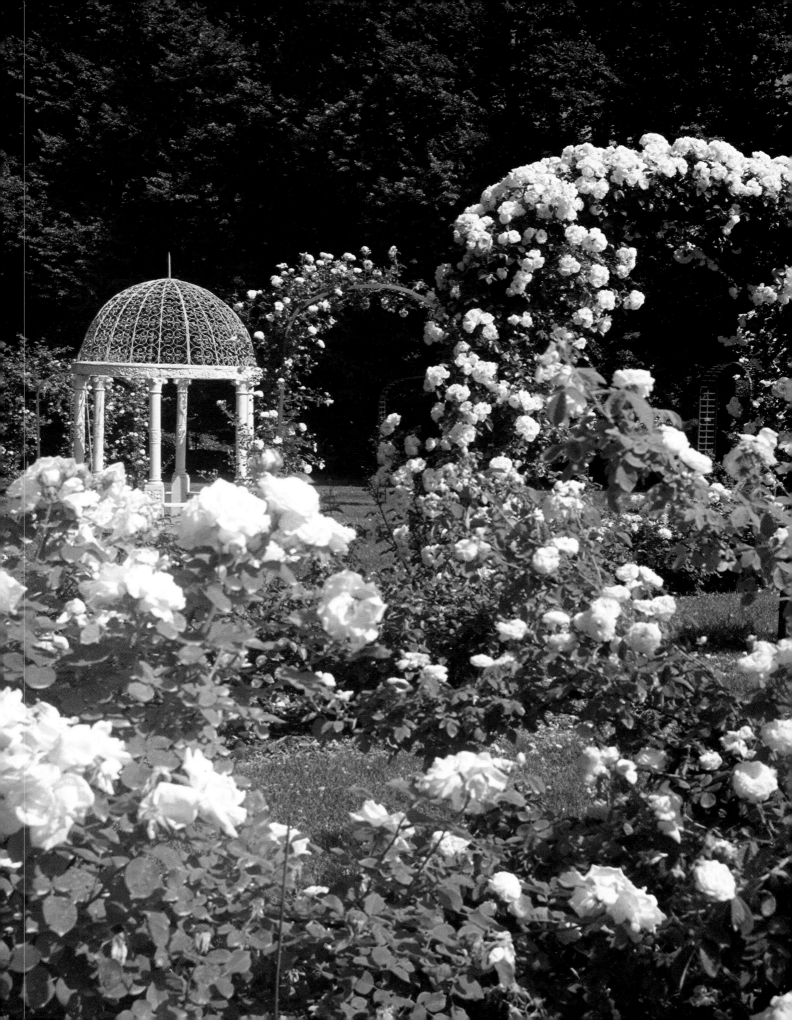

gaps which tend to separate the colorful blooms into insignificant islands of color. Too low an angle and you won't show enough blooms.

Another technique is to find a bright cluster of blooms to fill the foreground of your picture. This splash of color up front will help frame the background blooms and overpower any dull gaps caused by foliage, soil or lawn.

An old photographer's trick with roses is to show them sparkling with drops of dew. Sometimes they are real, but usually they are added by the photographer by spraying with an atomizer or other device.

The lengths some individuals will go to make rose pictures "different" is incredible, and maybe you can think of some new tricks yourself. One photographer has taken some unusual pictures of roses immersed in soda water, showing bubbles of effervescence clinging to the petal edges. Another smears petroleum jelly around the edge of a filter mounted on the lens to create a special diffused effect. Yet another shoots through an aluminum foil tube for extreme close-ups so the petal color bleeds softly into every corner.

LILIES

The true family of lilies is probably the most confusing in all the botanical world. Among the many imposters are lily of the valley, sacred lily of India, canna lilies, daylilies, plantain lilies and spider lilies. *Lilium* species, the true lilies, are the most showy, and modern hybridizers such as Jan de Graaff of Oregon have created some sensational new varieties—notably the Imperials and the Jamboree strains.

Lilies have such interesting shapes and radiant petal colors that they are the most beautiful of all flowers in single close-ups. Another striking feature in close-ups is the prominent arrangement of male and female organs. The female stigma is normally long and

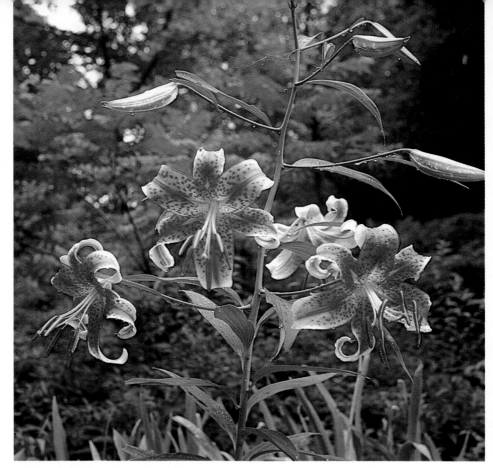

Lily Imperial Crimson, showing a magnificent flower spike with fully opened flowers and buds. Although close-ups of a single flower would be spectacular, never overlook the impact of a full flower spike like this. Norcross Inc., a Philadelphia greeting card company, bought this picture.

slender, topped by a large round ovary surrounded by a cluster of colorful male anthers loaded with dusty pollen. In photographing lilies, it is essential to catch the anthers at the peak of ripeness; they discolor in old flowers and spoil close-up pictures.

Because of the intricate form of lily flowers, it's sometimes difficult to know where to focus—on the distinctive anthers or lower down at the center of the flower petals? With lilies, there is no general rule; each flower must be considered individually. Normally, if the petals are distinctively marked toward the center, it's a good policy to focus at the center of the flower petals. If the anthers are distinctive, it's better to focus on these.

The best backgrounds for lilies are clear blue or shades of blue. Some lilies hang their flowers

down and present the petals in shadow. A reflector such as a white card is good for bouncing light up into the shadow area. Clumps of lilies photographed against a rock garden, pond, waterfall, stream, woods, rustic fence, hedge, gateway, perennial border and fernery make lovely garden scenes.

TULIPS

Alexander Dumas' classic adventure story, "The Black Tulip," told of intrigue, drama and tragedy surrounding attempts to possess a unique black tulip developed in 17th century Holland. Today, black tulips are common, but the story was written of an era when tulip mania swept the continent of Europe and high prices were paid by tulip fanciers for new forms of this enchanting flower. Discovered growing in the gardens of Constantinople, tulips

were introduced into Europe by a Flemish diplomat. The Dutch developed a fanatical interest in them and built a flourishing industry that grows and breeds tulips to supply the world.

Tulips come in a variety of shapes and sizes. Some look like peonies, some like waterlilies, some like poppies. Others are fringed, laciniated (fringed segments) and striped. The new Darwin hybrids are particularly photogenic because of their huge flowers and shimmering colors.

Picture variations with tulips are endless—in massed beds, group close-ups, single close-ups, backlighted, naturalized, flower arrangements and countless other situations. Depending on the variety and color, just about any background is fine. Blue sky makes a gorgeous background; so does a green lawn, shrubbery or a rockery. Avoid bare soil, however. Except for some of the low-growing rockery tulips such as the Kaufmannianans and Dasystemons, bare soil is an unattractive background.

My favorite tulip varieties are Gudoshnik, a bizarre, peach-colored Darwin hybrid; Pinkeen, a shimmering flaming red Fosteriana; Stresa, a rich yellow and red Kaufmanniana; and Texas Flame, a massive yellow-streaked-red parrot tulip.

Most tulips are best photographed in good sunlight because the blooms close up in poor light. Kaufmanniana, or waterlily tulips, are especially sensitive to light. Always try to photograph them wide open, not closed as you see in so many catalogs. They are more beautiful wide open, and it is the only way you can observe the similarity to a waterlily. Also, choose freshly-opened blooms. When over-mature, they are easily distorted by inclement weather. The petals develop ugly marks and the anthers discolor.

Some tulips have a distinctive marking inside the cup-shaped bloom. Jewel of Spring, a Darwin

hybrid, for example, has a beautiful black base inside the sulphur yellow petals, and so does Gudoshnik. When taking group close-ups, try to show these distinctive features by tipping a bloom forward or photographing from a sufficiently high angle.

Other tulips such as the bouquet flowered and the parrot group look best photographed from below, against a clear blue sky. In doing this, be sure that your light meter reads the flower and not the bright sky. By holding the meter level with the blooms rather than aiming it upwards, you will get a more accurate reading.

Tulips don't have to be urn-shaped, as these two tulip pictures demonstrate. Above: This mass planting of Kaufmanniana tulips shows why they are often called waterlily tulips. Below: The Fosteriana Pinkeen is backlighted by the sun against a clear blue sky.

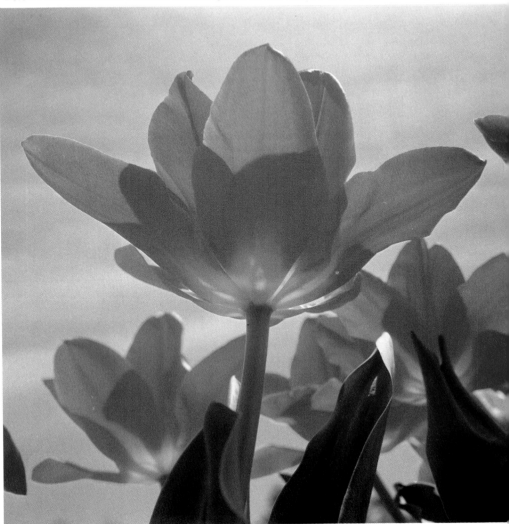

WATERLILIES

Basically, waterlilies fall into hardy and tropical groups. The hardies are mainly white, yellow and shades of red, and are day blooming. The tropicals are more unusual, with larger leaves and much larger flowers. They bloom in a wider range of colors, including blue, and all are fragrant. Some waterlilies are day blooming and others are night blooming, although the night bloomers usually carry their flowers until noon the following day.

By far the most spectacular waterlily is the Victoria waterlily, *Victoria regia.* It grows huge round lily pads up to six feet across. The leaves have upturned edges and a single leaf can support the weight of a child. The large white waterlily flowers open at night, last two days and change color to pink. Although native to the Amazon, the Victoria waterlily is grown extensively outdoors in northern botanical gardens. One of the finest displays I have ever seen is at Longwood Gardens, where a

This photo of Victoria waterlily, *Victoria regia,* shows its large white fragrant flower surrounded by massive round leaves which will support a child's weight. Although the large leaves are dramatic in themselves, I made them appear even more spectacular by having them "bleed" to all four corners of the frame.

I shot this waterlily Persian Lilac in a heated greenhouse on a cold day through a steamed-up lens. The condensation resulted when I moved from the cold outdoors to the warm, moist indoor environment.

This is waterlily Attraction, perfectly lighted from a slightly overcast sky, against the only background suitable for waterlilies—leaves and water.

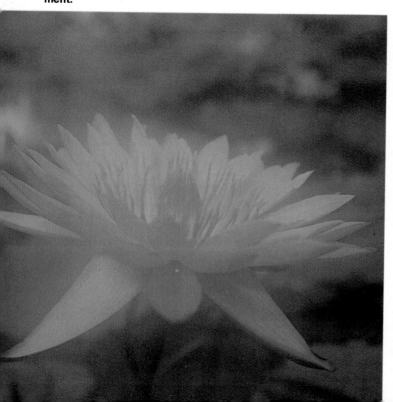

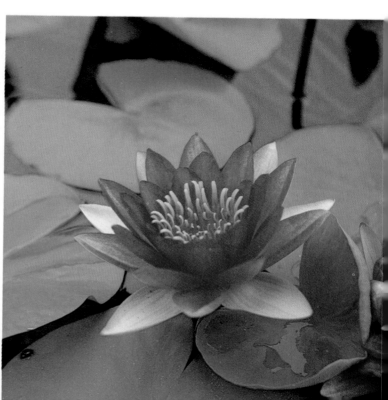

special hybrid with a red leaf rim has been developed.

Lotus blossoms, closely related to waterlilies, are another breathtaking sight in the water garden. Held sacred in the Orient and the Middle East, they were symbols of fertility in ancient Egypt. The blossoms measure up to 16 inches across on nine-foot stems. The leaves look like parasols, the fragrance is haunting, and there is something "prehistoric" about the gigantic seed pods which rattle when shaken. Indeed, lotus seeds hold the record for longevity. Three lotus seeds, discovered near Tokyo under an ancient canoe which proved to be 2,000 years old, were tested for germination. Two of the three sprouted.

Most waterlily blues are hard to photograph true-to-color because of the *ageratum effect*. See the section on "Problem Flowers" at the end of this chapter. You will see a beautiful sky-blue waterlily, but when the film is developed, chances are it will be mauve. The problem is most pronounced on a bright sunny day, less so under an overcast sky.

When photographing waterlilies in greenhouses, watch for condensation on your lens, especially during winter months. Condensation will always happen when you move suddenly from a cold environment into a warm one. You'll have to keep wiping the lens clean until it has warmed up. You can avoid condensation by placing your camera in a bag while you walk from the car to the greenhouse or conservatory.

There are times when you can use condensation to good advantage. I once accidently took a waterlily picture through a steamed-up lens, and the surprisingly pleasant result was a flower with a diffused "humid" look similar to the effect of a soft focus attachment.

With waterlilies, your choice of backgrounds is easy. You're automatically restricted to just two

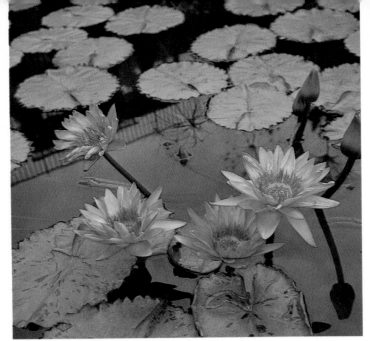

The railing on top of a nearby building is reflected in the water of this waterlily close-up, and spoils the composition in my opinion. The variety is Director George T. Moore, a beautiful blue which is highly subject to the ageratum effect, whereby the blue petal color actually photographs red.

alternatives—water or lily pad foliage. A combination of the two is really the best.

Mature, fully open flowers make the best pictures, and it's advisable to shoot in good sunlight because the flowers have a tendency to close or distort in poor light.

Focus should always be at the very center of a waterlily, with the conspicuous ring of stamens in sharpest focus. Avoid extraneous reflections in the water. Clouds or trees and anything else natural will help your picture, but buildings, park signs or pool railings will spoil the composition.

This butterfly spent a while in my refrigerator—just long enough to slow its metabolism down so I could pose it where I wanted it on a zinnia. When it warmed up, off it flew.

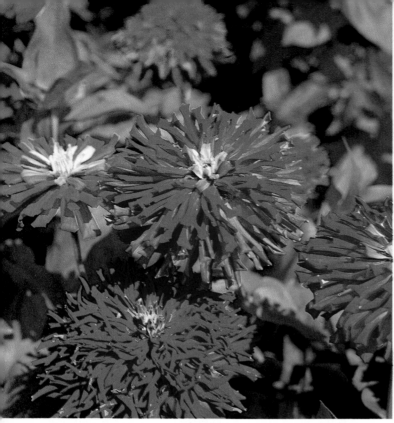

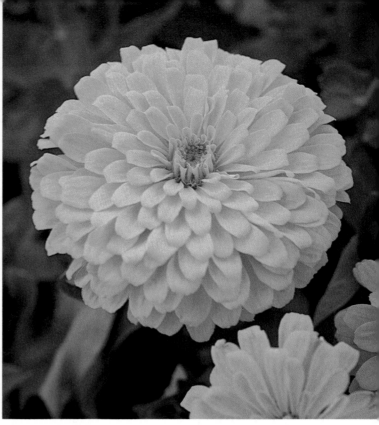

Here is one perfect cactus-flowering specimen, zinnia Purple Giant, at the peak of perfection, surrounded by more flawless flowers at different stages of development. Green foliage is the perfect background.

These flowering hybrid zinnias, giant dahlia, make excellent single-specimen close-ups. This variety is Gold Sun, on a simple background of contrasting green foliage.

Single blooms are exquisite, and it's easy to fill the frame because they are large. Groups are also impressive, particularly groups of three or four when they stand up several inches above the water.

To get close enough to water-lilies without a telephoto lens, you have two choices: Wade out to them, which is not permitted in public gardens, or lean out over the pool—something you'll have to learn to do without falling in!

ZINNIAS

Most annuals make spectacular flower pictures. Marigolds, asters and petunias are spectacular during summer with their mass displays and vibrant colors, but zinnias are at the top of my list of photogenic annuals.

Over the past 50 years, zinnias have been improved beyond recognition. In the old seed catalogs you'd have to search hard to find them, but today they are among the most popular flowers grown at home in America. Native to the deserts of Mexico, nothing among the popular annuals quite equals their color range, from white, cream and yellow through green, orange, pink, red and lavender—plus combinations of these colors.

The large cactus-flowered zinnias are particularly beautiful as close-ups and in groups of two and three. A bed of mixed colors or a single color en masse is a stunning effect. Zinnia borders combined with petunias or gloriosa daisies for contrast are also a glorious sight.

After the giant cactus-flowered class, dahlia-flowered zinnias are most spectacular, magnificent in close-ups of one flower or a grouping of flowers. They have flat, rounded petals, rather than curled, pointed petals like the cactus-flowering types.

When making flower arrangements with zinnias, put the stems into water immediately after cutting. Otherwise, the beautiful stiff petals go limp very quickly.

Lush green foliage is a good background for zinnias, although it may be necessary to "tidy-up" the plants to remove faded flowers and signs of wilt or mildew.

Butterflies and zinnias make a beautiful combination, and you normally won't have to wait long before one flutters to your group of flowers. Even so, you have to be patient and alert to get good butterfly pictures. There is a special trick you can use to ensure a greater chance of success: Catch the butterfly and place it in a jar in the refrigerator for a few hours. The cold will slow down its metabolism, and soon you'll be able to pose it any way you wish. Afterwards, the butterfly is free to fly away, unharmed.

OTHER PHOTOGENIC GARDEN FLOWERS

Deciding on the 20 most photogenic garden flowers was quite a job. The selection is in no particular order of importance. I certainly considered many more for a "Top 30," including alpines, rather a general group, and magnolias, rather a small group; also, gladiolus, but the exotic types are mainly show flowers, and the same is true of gloxinias. Hibiscus are beautiful garden subjects that make spectacular close-up pictures, and they would have been number 21. Camellias would have been high on the list also, but they are not hardy in the North and therefore not readily available to many photographers. Petunias and marigolds are beautiful subjects for flower photography, too.

One of the keys to successful flower photography is knowing the flowering dates for the most photogenic flower classes. By knowing ahead what is coming into bloom, you can catch the flowers early and at their most beautiful stages. The chart at the beginning of this chapter lists 30 flowers and their approximate blooming dates.

Flower photography can be a busy pastime—a year-round activity, with something new coming into bloom all the time. Flowering times in the chart are for outside blooming, except where stated otherwise. Many of the subjects listed are available for photography all year when grown indoors or in greenhouses. Tropical hibiscus, for example, blooms all year when grown under glass, and the same holds true for roses, waterlilies and others.

PATTERNS WITH FLOWERS AND LEAVES

Whenever I see a mass of flowers or leaves, I instinctively look for patterns. You see them used photographically as covers for books and garden magazines. Patterns are most often formed by petal shapes and leaf configura-

A leaf pattern formed by lace-edged leaves of coleus Fiji Scarlet, growing in a flower bed.

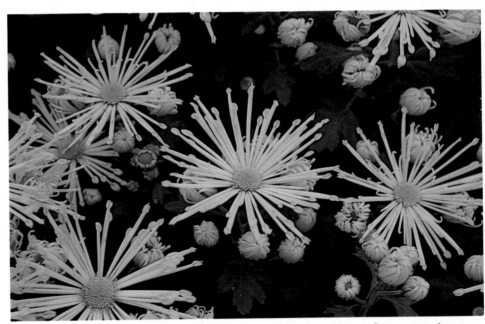

Another floral pattern formed by flowers of chrysanthemum Yellow Spoon, growing on a greenhouse bench.

A floral pattern formed by flowers of dwarf zinnia Rose Starlet, growing in a flower bed.

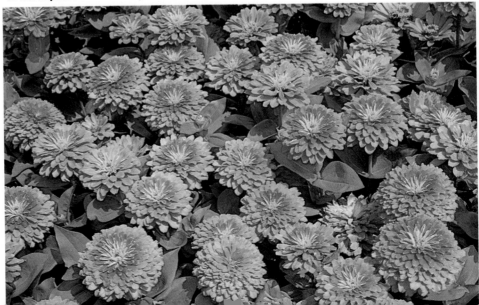

tions, and when you discover an interesting one, it's generally best to shoot it so the design extends to all four corners of the frame, and "bleeds" off at the edges.

I have also found patterns in a grove of trees, the fronds of ferns, grass stalks covered in hoar frost and the tracery of exposed roots— but nothing beats flowers and colorful leaf formations for dramatic impact.

One of my favorite patterns was a mass of coleus leaves found growing outdoors in a flower bed. It was a young planting of a fringed variety, Fiji Scarlet, with all the plants the same height, their leaves intermingling at the same focusing distance. Each red leaf had a delicate golden edge, presenting a beautiful contrast and a bizarre pattern.

On another occasion, in a greenhouse, I discovered a planting of yellow spoon chrysanthemums which resembled a colony of sea anemones or exotic starbursts when looking directly down on them.

Yet another pleasing pattern in my collection is a planting of dwarf Peter Pan zinnias, their rosy-pink flower heads competing for attention against a contrasting background of glossy green leaves.

None of these pictures required any special arrangement to achieve the pattern effect. They simply needed an alert eye to recognize that the pattern was there, and a special angle to dramatize the effect.

These floral and leaf patterns are not common. They always fill me with wonder when I see them because several special elements have to be right to produce the pattern, including perfectly symmetrical flowers or leaves, a spontaneous design quality, and the flowers or leaves must usually be on the same plane so the total area is in sharp focus. In many cases, diffused, even lighting is also important, although I have created some appealing pattern pictures with backlighting.

PROBLEM FLOWERS

Some flowers are easier to photograph than others. The big, bold, colorful flowers of zinnias, for example, stand stiffly erect. Even in a slight breeze, they pose perfectly. The color range is extensive, and all the colors seem to reproduce faithfully on film.

Tulips, too, are a joy to photograph. The color range is even more extensive than zinnias, predominating in easily reproduced reds and yellows, and they are photogenic whether you are shooting a close-up or an extensive massed planting.

Certain flowers, however, do present problems, and one of the interesting aspects of plant photography is the challenge presented by some notoriously difficult flowers.

First, let's talk about flower colors. Color photography is a miracle of technology. With the use of just three basic dyes, color

Blue hyacinths are difficult to photograph true-to-color because of the ageratum effect. The picture below shows blue hyacinths in bright sunlight. At right you can see the same flowers in shade, photographed through a haze filter, thus achieving a much closer rendering of the true color.

transparency film produces a remarkable rendering of most colors, providing the film is correctly exposed and has not been abused through incorrect storage or improper processing.

However, certain films are more accurate in recording specific colors than others. *Kodachrome* film, for example, is best for photographing *reds and yellows*, and *Ektachrome* is superior for *greens and blues*. No matter what type of film you choose, you will find that none can match the color sensitivity of the human eye over the entire color spectrum. In my experience, the most difficult colors to record are greens and blues.

Green and blue are the least common flower colors in the plant world—other than black—because flowers must generally contrast with green foliage and blue sky backgrounds in order to be attractive to pollinators such as bees and butterflies.

Green used to be a big problem. Often it would photograph too dark, as though it had a lot of black in it, but ever since I've used Ektachrome Professional film, I've been pleased with the rendering of natural colors such as green gladiolus, green orchids, bells-of-Ireland and green zinnias. Blue flowers still present a serious problem.

BLUE FLOWERS AND "ANOMALOUS REFLECTANCE"

When photographing blue flowers, you will encounter one of the great mysteries of plant photography: *Why do certain blue flowers photograph true-to-color, while others photograph red?* For example, it's fairly easy to photograph a forget-me-not and a delphinium with the right shade of blue, but ageratum, morning glories and lobelia show up with reddish tones of pink, mauve, lavender and purple.

This is known among plant photographers as the *ageratum effect* because it is most commonly encountered with flowers of blue ageratum. In the world of film technology, it is known as *anomalous reflectance*. Regardless of what it is called, it is not easy to correct.

The problem stems from the fact that film sees colors differently from the human eye and is more

These are the blue flowers presenting the biggest problems:

Ageratum	Lobelia
Asters	Morning Glory
Anemone	Pansy
Aubretia	Petunia
Campanula	Phlox
Cineraria	Scabiosa
Clematis	Stokesia
Hyacinth	Tradescantia
Iris	Viola
Larkspur	Waterlily

A cluster of cineraria flowers illustrating the ageratum effect: The image above, produced in bright sunlight, shows a purple coloring not representative of the true color. On the facing page is the same cluster of flowers photographed in shade with a haze filter, showing a blue coloring much closer to the true color.

sensitive to the far red and infrared end of the spectrum where the human eye has little or no sensitivity. The difference is most noticeable in bright sunlight and less in diffused light such as overcast sky. However, even under these diffused light conditions, you will still have difficulties photographing ageratum and lobelia.

Advice for photographing difficult blue flowers:

1. Use a haze filter, such as a Wratten #2B, over the lens or light source. This offers a slight improvement even in full sun.

2. Shoot in shade or under an overcast sky. On some flowers, such as cineraria and iris, this can make a dramatic improvement.

TALL TAPERING FLOWERS

Gladiolus, foxgloves, delphiniums, hollyhocks and snapdragons are examples of tall tapering flowers that can present problems of a different kind. This doesn't apply so much to 35mm camera systems because they have a rectangular format for framing the subject vertically. With a square-format camera, you have the choice of moving far enough back so the entire flower is framed as a weak streak of color down the middle of your picture with wide

gaps on both sides, or getting in very close and cutting large portions from the top and bottom of the flower.

When tall tapering flowers are in close groups in an attractive garden setting, there's no problem. You simply compose a picture with the group across the full width of the frame—but a single stem is another matter. The best course is to get in close until you fill at least half the width of the frame with the full width of the flower spike, and aim to include the top half or three-quarter portion of the flower in your picture.

With gladiolus, for example,

cutting off the bottom and a little of the topmost unopened buds will not normally harm your picture. As long as you can show a tapering effect, it usually doesn't matter how many topmost unopened buds you must cut off. The problem is reduced when you can group more flowers in the picture. Three or more spikes alongside each other will usually allow you to fill the width of the picture and show all or most of the height of each flower spike.

FLOPPY FLOWERS

Pansies, petunias, cannas, nasturiums and bearded iris are included in my definition of "flop-py flowers." It is difficult to achieve some sort of symmetry for good picture composition with these flowers. The floppy characteristic gets even more pronounced as the flowers age, and after rain has fallen.

When shooting these flowers as a garden scene, in a massed border or as a container grouping, the problem is not so apparent; but when you wish to photograph them close-up to show their colors, texture, shape and form, your only chance of success is to seek out young plants with freshly opened flowers. You have to concentrate on good symmetry. It sometimes takes a lot of searching—it took me five years, for example, to take a picture of cannas to my satisfaction.

Another category of floppy flowers includes poppies, lupines and snapdragons. As soon as you cut them, they flop. To me, there's nothing worse than a droopy lupine or a sagging poppy. So, if you wish to compose a tight grouping using these flowers, it is best not to cut them—dig the plants up, root and all, place them in pots, and arrange them that way. When you've finished, simply transfer them back into your garden.

3
Gardens

Visiting a beautiful garden without your camera is like planting a vegetable plot and failing to harvest the crop. Beautiful gardens "plead" to be photographed.

Great gardens are full of many exciting gradations of beauty, some subtle and sophisticated, others blatant and domineering.

Every garden offers a constantly changing scene that differs not only from season to season, but even from minute to minute when the light and mood become an integral part of their composition.

Naturally, there are many kinds of gardens—rose, rock, aquatic, herb, vegetable, heather, desert and wild. There are gardens which reflect a particular cultural or ethnic influence—French, English, Japanese, Italian and American colonial, for example. Each has a style and character all its own.

When you visit any garden for the first time, don't expect to take award-winning pictures right away. There's always a good chance of getting excellent close-ups and groupings, but for the best general garden scenes and overall views, you have to know a garden well. Beautiful gardens have their moods, their moments of infinite beauty and their moments of depression.

Start by choosing a beautiful garden estate near your home. Visit it often—on misty mornings, at noon, at dusk, on rainy days, cloudy days, sunny days, snowy days, bleak days, bright days, humid days—and during every season. Tour every corner, take every walk, look at the garden from every angle and examine every planting scheme. Look at interesting shapes, buildings and landscape features. Most important, look at everything through your viewfinder and "compose, compose, compose."

This tiny hillside meditation garden at the Temple of Chisaku-In, Kyoto, Japan, is composed entirely of clipped evergreen shrubs, rocks and running water. The picture was taken from a viewing balcony adjoining the temple, where Buddhist monks would sit cross-legged in quiet contemplation, facing this idyllic scene. Even today the garden evokes an atmosphere of peace and tranquility despite its proximity to busy streets and highways.

After visiting traditional gardens in Japan, imitations of Japanese gardens usually leave me unimpressed. However, the Japanese Garden at Huntington Botanical Gardens, famous for its moon bridge, is a delightful exception. I like this picture because it contrasts the brilliant red color of the bridge with the dark green coloring of a grove of sago palms.

When I enter a garden for the first time, I instinctively look for several basic types of pictures— close-ups of single specimens and groups, whether they are flowers, shrubs, trees or fruits; pictures showing imaginative interplantings; and overall scenes showing a beautiful panorama, often with part of a house, castle or lake in the background. Sometimes it is possible to shoot these three distinctly different compositions from almost the same position by merely altering your aim and area of focus. For example, you might find yourself looking at a magnificent view with a glorious clump of flag iris in the foreground, behind which is a small stream with primulas and a rustic bridge and, in the background, a lake bordered by tall trees and rhododendrons.

Your first shot could be a lovely close-up of the iris alone. You might even shoot two types, one an extreme close-up of perhaps two perfectly-formed blooms using a close-up lens, the other a group close-up of the whole clump using your standard lens. The next shot might be of the iris combined with the primulas and the rustic bridge. Your final shot could be a panorama showing the iris and primulas, the bridge, the lake with the tall trees and the rhododendrons, all creating an idyllic scene.

Shoot flower borders at an angle rather than as a straight ribbon of color across the middle of the frame. By shooting at an angle you'll fill the picture with more color and more depth. After all, who would *ever* approach a perennial or annual border head-on?

When photographing overall garden scenes, focus on a special feature of the garden, such as a pool, an arbor or a pagoda. More often, you will get a better picture when photographing this kind of garden feature if you have a splash of color in the foreground—a clump of peonies or roses, for example. When you can do this, it is usually better to keep the

Branches of an azalea bush have been pruned carefully and trained to frame a stone lantern, although the effect looks natural. Backlighting highlights the artistic form of the branches.

foreground subject in sharpest focus and allow the background to be in soft focus.

Avoid photographing landscapes or large garden areas when they are flooded with light; they will appear flat and lifeless like a theater set. Instead, try to shoot them with slanting light during mid-morning or mid-afternoon so deep shadow areas give the landscape body and depth. Particularly beautiful pictures in gardens can be created between the hours of 6 and 9 a.m. when the light is soft and dreamlike.

LAWNS & GROUNDCOVERS

Sales of lawn grass seed and lawn grass products is a huge industry, and pictures of showcase lawns are in constant demand for advertisements and package designs. O. M. Scott & Sons, the lawn grass experts, uses dozens of lawn pictures each year in their publication, *Lawn Care*, distributed to millions of homeowners. This is an excellent place to see good lawn photos. Most common are bluegrass lawns, the most popular type for the Northeast, and zoysia, a popular southern grass. Where grass has difficulty growing, in heavily shaded areas, for example, other forms of groundcover can be used, such as pachysandra, English ivy and myrtle; and pictures of these are useful.

Photogenic lawns should be even in color, trimmed short and free from blemishes such as brown patches and weeds. They usually look best when photographed at an angle, with a colorful flower border along one side. The background should end in a definite feature, such as a suburban home, a rustic fence or a hedge of evergreens. Grass should occupy

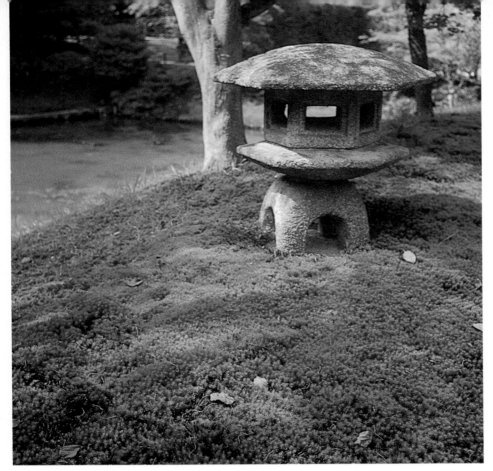

Moss is used widely in traditional Japanese gardens and is pampered to make it grow luxuriantly where Western gardens would normally use grass. This stone lantern surrounded by moss was photographed at the Katsura Imperial Villa.

at least three-quarters of the picture area, and no asphalt from driveways or roadsides should show in the foreground, because it is too distracting.

ORIENTAL GARDENS

When I first visited Japan and Taiwan, I was unprepared for the beauty of their gardens. Although I had visited a number of Oriental gardens in other parts of the world, very few came close to capturing the exquisite beauty and peaceful atmosphere of a genuine Japanese or Chinese garden. The best imitations I have encountered are at the Huntington Botanical Gardens, San Marino, California; the Missouri Botanical Gardens, St. Louis, Missouri; and Cypress Gardens, Winter Haven, Florida.

The Japanese gardens I visited around Kyoto are beautiful and filled me with awe and respect. Every stone, tree, trickle of water,

texture, and ground contour is shaped or placed with such infinite care that I can only describe them as the greatest works of art ever created by man. If you find that hard to believe, look through a copy of *Imperial Gardens of Japan* (published by John Wetherhill, Inc., New York) with photographs by Takeji Iwamiya, and you will understand.

One classical Japanese garden I visited was the Katsura Imperial Garden, one of three very large gardens planned by members of the Imperial Court. It is reputed to be the oldest Japanese stroll garden, dating back to 1620, and is not an easy garden to visit, requiring a special permit good only for an appointed time. You are given a guide and, in the company of a small group of similarly privileged people, you stroll through the garden just as the emperor and his

guests might have done hundreds of years before.

The stroll begins at a sheltered glade bordered by sago palms, and the guide tells us September is the best time of year because the fall colors have not yet started, and the spring blossoms are long since past. Thus, there is nothing to detract from the essential beauty of the garden, which relies on three simple elements—stone, water and trees.

The path twists and turns, presenting an ever-changing scene as it skirts a large irregular pond or small lake. The path itself is a work of art, portions of it made from stone paving, then stepping stone, next cobblestones, then gravel, zigzag stone slabs and tiers of stone steps. The varying textures and uses of stone are wondrous.

Out in the lake are manmade islands consisting of granite rocks hauled from the nearby mountains. They are specially positioned to look natural and harmonize with the surroundings.

Evergreen azaleas and pines are used extensively. The azaleas are neatly clipped, and the pines meticulously pruned and sculptured like giant bonsai to create a weathered effect. Moss grows abundantly everywhere, and is used wherever a shady ground cover is needed. Stone lanterns peek from glades and headlands, adding unobtrusive highlights. Humpback bridges cross numerous rocky streams that thread into the lake. Not one flowering annual is used anywhere, and the only perennial plantings are permanent clumps of Japanese iris and waterlilies. I am sure if a petunia or a delphinium had raised its head anywhere in the garden it would have been pounced upon and eradicated like a weed.

Even in spring, color is dignified, coming mainly from ornamental cherries, azaleas and wisteria. In fall, the maples turn blood red, and the ginko spreads a mantle of yellow leaves over the

While visiting Cypress Gardens, I was impressed with an Oriental garden featuring a stone Buddha. The approach to the garden was through an immense bamboo thicket which cast deep shadows and gave the impression of a secret garden. Framing the scene with the arching bamboo branches, I created the effect of looking out of a cave to establish the secluded feeling I wanted to portray.

ground. It is a sophisticated beauty.

The Katsura Imperial Garden is large as Japanese gardens go, occupying 11 acres. However, the path twists and turns through so many miniature valleys that it seems much larger. Manmade hills, moon-viewing verandas and tea houses strategically placed around the ponds heighten the illusion of immense size, and a thick bamboo hedge screens out the noise from passing traffic on nearby roads.

At the other extreme is the tiny temple garden of Chishaku-in, also in Kyoto. Its beauty literally takes your breath away. Designed not as a "stroll" garden, but more as a "viewing" garden, Chishaku-in sits on a steeply sloping bank, and once served as a place for meditation and devout religious contemplation.

The temple itself has an observation deck that juts out over a

small pond looking directly at the sloping garden. A waterfall tumbles down its side, while boulders and clipped dwarf evergreens cling to the hillside to create a magnificent rocky landscape with tiny paths, stone steps and stepping stones threading through the boulders and greenery.

I sat cross-legged on the observation deck for nearly an hour, spellbound at the scene, and wondered what kind of person had inspired such a unique and lovely landmark way back in 1670. It is the most beautiful patch of earth I have ever visited.

After Japan, the gardens of Taiwan were something of a disappointment, although some of the natural scenery is more lovely, and compares favorably with the best Hawaii has to offer. Taiwan is tropical, and every inch of level ground is cultivated with pineapples, sugar cane, rice and tropical fruits. The mountainous western coastline has jungles and highlands yet to be botanically explored, yielding exotic orchids and tree peonies. In fact, the island is so rich in floral beauty that the Portuguese named the island Formosa, meaning Island of Flowers.

Taiwanese gardens are mostly arranged around lakes, and they tend to be more like sprawling parks, with temples, pavillions and pagodas connected by walks that skirt the lake or detour to ponds planted with lotus and waterlilies. The Chinese adore zigzag bridges that cross rivulets or the narrow corner of a lake, and also neatly sculptured trees in the form of topiary.

At Kaohsiung, in the southern section of the island, I toured the Chenegehing lake and gardens. To explore the park on foot would take more than a day, but one of the local seedsmen provided a guide and a car so we could drive to portions of it. Somehow, one pagoda looks like another, and the climb to the top of these is grueling in the tropical heat, although the surrounding scenery is

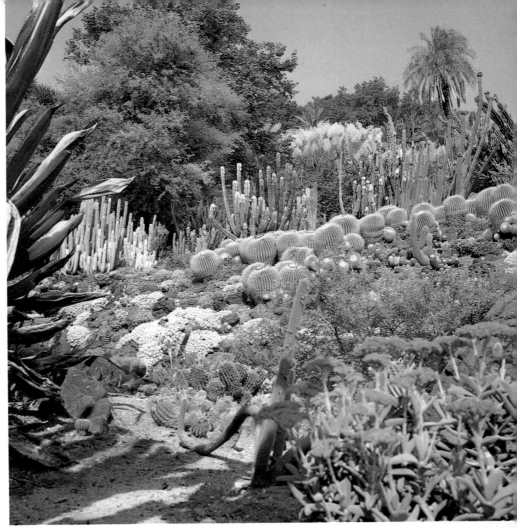

To show the true scope of the plantings in the 12-acre Huntington Desert Garden, I wanted scenes with a wide range of cacti and succulents. This vantage point overlooking a richly planted ridge provided exactly the composition I needed for an impressive general view.

generally beautiful. I soon yearned for the greenery and intimate atmosphere of a Japanese garden.

MY FAVORITE GARDEN FEATURES

Over the past 15 years I've visited many well-known gardens, and some that are not so well-known. Each presented a different challenge to photograph. With famous gardens, my goal is to shoot pictures better than other professional photographers have already published. "Unknown" gardens can be a gamble, sometimes yielding scenes that can outshine the better-known locations, and other times turning out to be disappointingly unphotogenic.

When asked which I prefer to photograph—a famous garden known to be beautiful, or an unknown garden that might turn out to be a dud—I find it a tough decision. In my experience, only one in ten unknown gardens is exceptional; but what a thrill it is when you do finally discover ·a garden with "star" qualities! When you do, keep it a secret as long as possible, because other photographers will descend on the discovery like a plague of locusts.

Beautiful gardens are not hard to find. Every state has its own gems, and the best news is that many public gardens are free. To find out about public gardens in your area, obtain a copy of a useful 120-page directory entitled "Guide to Public Gardens," available by mail from Garden Club of America, 598 Madison Avenue, New York, NY 10022.

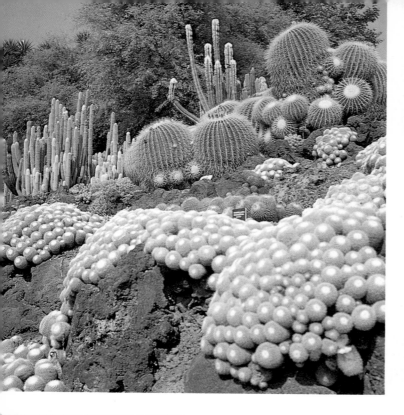

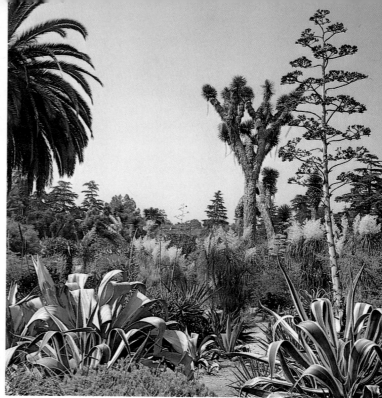

Upper Left: This effective combination planting, showing a rocky slope of lava boulders planted with golden barrel cacti and silvery mammilaria cacti, illustrates the special care taken to produce texture, shape and color contrasts.

Upper Right: The heart of the Huntington Desert Garden resembles a desert wilderness, and this scenic view captured that feeling to perfection. The flowering century plant on the right will die after setting seed, while a towering Joshua tree in the background dominates the landscape.

Left: It's important to show paths when photographing gardens because they have an inviting quality and help draw people into the picture. In gardens deliberately landscaped to create a natural effect such as this one, paths help to show that the area is cultivated and not a wilderness.

Following are some examples of both famous and unknown gardens I have visited, and how I photographed them. Some, like Nemours, required just a few hours of shooting time, while others, like Winterthur, demanded frequent visits over several years to capture their unique qualities.

HUNTINGTON'S FANTASTIC DESERT GARDEN

Gardens owned by wealthy people tend to reflect a special interest of the owners. Sometimes it is a particular plant group, such as rhododendrons, camellias or wildflowers; other times it is the person's heritage, such as a French Renaissance garden, an Italian water garden, an English natural garden, or an Oriental stroll garden. When I visit gardens, I immediately look for a theme or an ethnic feeling. When I detect it, I like to show it in my photographs so people can sense the atmosphere of a garden as the owner himself might have most wanted to project it.

Nowhere have I seen such a diversity of interests than at the Huntington Botanical Garden, just 12 miles from downtown Los Angeles. Created by railroad tycoon Henry E. Huntington on 130 landscaped acres, there are no less than a dozen independent areas, including a camellia garden, a palm garden, a water garden, an Australian garden, a rose garden, a Shakespeare garden, a Japanese stroll garden and a desert garden. It is an area of incredible contrasts. Although I did shoot scenes in the different theme gardens to dramatize this unique aspect of the facility, I decided to concentrate my photography on the most unusual area—the hot dry Desert Garden.

The Desert Garden occupies 12 acres, mostly on flat ground mounded into hillocks and ridges to resemble an arid desert. Paths meander through the area, where more than 2,500 species of cacti and succulents have been planted, including towering Joshua trees, coiling serpent cacti, statuesque

The Huntington Desert Garden is filled with exotic textures and strange forms. The striped arching leaves of this variegated century plant create a beautiful pattern effect. Sometimes it is easy to forget general scenes and concentrate on dramatic close-ups like this.

column cacti and other strange desert plants.

It is the largest collection of cacti and succulents in the world, and was the first major botanical collection conceived for the estate. Although it was a favorite project of horticulturist William Hertrich, who Mr. Huntington hired to supervise the landscaping, the owner himself was at first sceptical of its value.

When I entered the Desert Garden, the scene was almost overwhelming and I hardly knew where to begin—everything seemed so photogenic. I wanted to photograph every plant, every companion planting and every scenic view—a task that would take years to accomplish.

To portray the Desert Garden, I took overall scenes, showing many different plant species, particularly seeking out areas where I could include as many distinct shapes, colors, textures and landscape features as possible. Then I sought out combination plantings, where two or more different plant forms made a dramatic contrast through their distinct shapes, colors and textures. The best example was a grove of golden yellow barrel cacti surrounded by mounds of silvery-white *Mammilaria* cacti.

Nowhere have I seen such a diversely planted area as the Huntington Desert Garden or found so many possibilities for good garden photography.

LENTENBODEN—BEAUTY FROM BULBS

It is not easy selling pictures of spring-flowering bulbs. The Holland Bulb Institute maintains a large file and works mainly with one photographer who goes on assignment to Holland every year. The Institute makes his pictures available to editors free of charge. In spite of this tough competition, I've been able to sell my bulb pictures steadily. One of my bestselling garden features shows a small, intensively planted bulb garden located just six miles from my home in Pennsylvania.

Charles H. Mueller, the owner, is one of a handful of men responsible for bringing to America the latest and best in spring flowering bulbs. His business of supplying bulbs to home gardeners could be many times bigger, but he works more for the fun of it than the money, and prefers to keep it as a modest one-man operation with just a few part-time helpers during the busy season.

His home and place of business is an old Pennsylvania Dutch pink-plastered fieldstone farmhouse called Lentenboden. It's north of New Hope, overlooking the Delaware River, and dates back to the 1700s. Surrounding the house are nine acres of trial gardens where more than 1,300 varieties of tulips, daffodils and other spring-flowering bulbs are on display.

Mr. Mueller calls it his living catalog because the public can wander through at flowering time in spring and choose the varieties they wish to grow, for delivery in fall at the proper planting time. Each year the search for new and more spectacular flowers takes

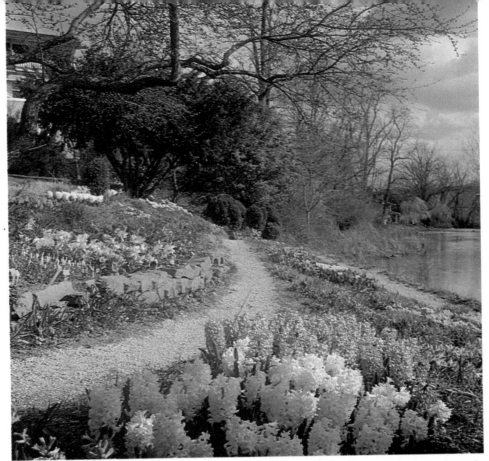

A south slope planted with different kinds of flowering bulbs, including hyacinths and tulips. The path leading through the plantings has an inviting quality and provides a sense of direction. The pond, just visible at the right, is also an important feature of this composition.

The Lentenboden bulb garden, with the still light of early morning producing a soft dream-like quality to the scene. I found the house to be an interesting architectural feature with an almost haunting quality, so I photographed the tulips as a broad sweeping curve leading the eye to the mysterious house.

him to England, Ireland and Holland, the world's major bulb breeding and growing areas. With the eye of a connoisseur, he picks out new varieties exhibiting exceptional merit for American conditions, and tests them at Lentenboden in small beds that any home gardener could emulate.

Mr. Mueller is usually on hand to dispense reliable advice about planting bulbs. He recommends lots of organic matter in the soil and applications of superphosphate fertilizer in spring before the flowers bloom and again in fall after frost.

The bulb gardens at Lentenboden are a sea of color in April and May. Tiers of tulip beds and woodland walks banked with clumps of naturalized daffodils create an idyllic scene. My pictures of the garden have been featured in the *Philadelphia Bulletin* Sunday supplement, *Flower & Garden* magazine and other publications.

I never fail to pay a visit to Lentenboden in spring. I prefer the small, intimate flowerbeds over the gawdy, massive park-like plantings of more formal bulb gardens such as Keukenhoff, the Dutch bulb industry's official display garden in Holland.

My favorite pictures of Lentenboden are scenes showing the bulb plantings as though they could be in anyone's garden. The best of these includes the old house in the background. One is a curving bed of tulips in the early morning with mist from the nearby river diffusing the light. Another shows groups of hyacinths planted on a bank, and a third dramatic shot focuses on a vivid clump of Orange Emperor tulips. All have the house in the background to give the scenes a sense of "place."

The diversity of small-scale plantings using top quality varieties makes this bulb garden so unusual.

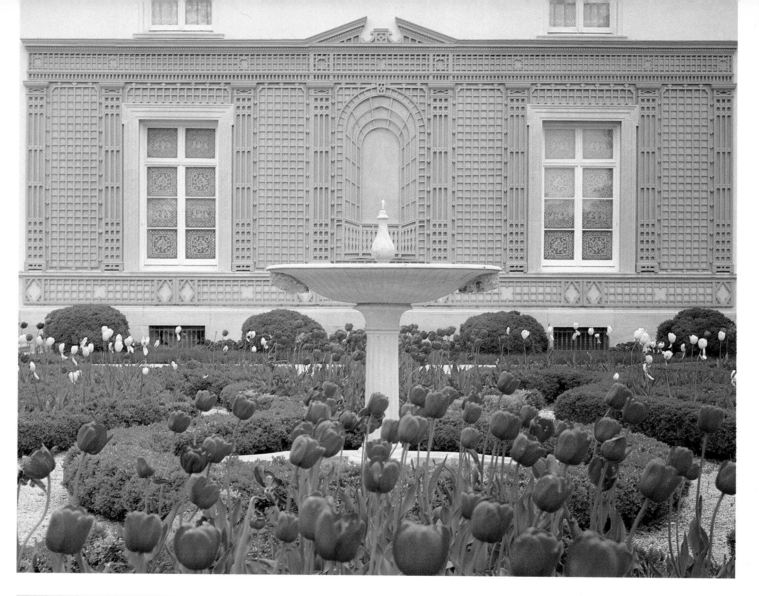

Top: Blood red Darwin hybrid tulips contrast with the light pastel green back-drop of French trelliswork here. Note the distinctive pattern in the middle, giving it a feeling of perspective. I composed this picture so the fountain spout is centered in the trelliswork.

Left: This colonnade overlooks a sunken garden with a fountain of cherubs. It marks the halfway point along the vista, intersected by free-form lakes and bordered by natural woodland. Balustrade and steps at bottom right help frame the scene.

NEMOURS—FRENCH FORMAL & ENGLISH NATURAL

In the world of business and high finance, the industrial empire forged by the duPont family of Delaware is one of America's oldest and best-known examples of free enterprise. In the field of horticulture, the magnificent gar-

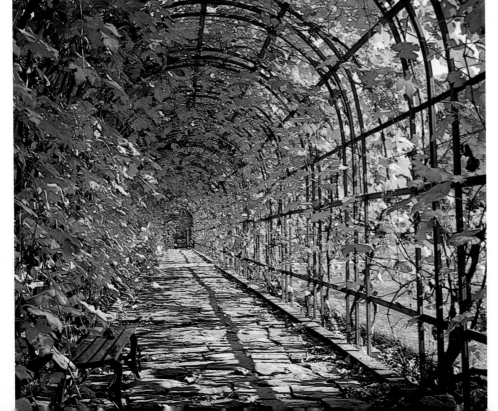

Left: Overlooking the vista in front of the mansion is this cast iron deer, one of a pair flanking a flight of stone steps leading to a French formal *allee* extending one-third of a mile into the distance. I photographed the deer from several angles, but this shot portrayed both the power of the sculpture and the spaciousness of the garden.

Bottom: This 250-foot long grape arbor creates a tunnel of gold in fall when the leaves change color and the grapes fill the air with a heady aroma. The backlighting of the leaves presented a tricky exposure. After taking a light reading, I exposed at one stop lower than indicated to brighten-up the darker areas, focusing on the gate at the far end of the tunnel.

dens created by prominent members of the duPont family are also world famous.

Winterthur, a vast woodland garden near Wilmington, Delaware, and Longwood, a sumptuous display garden near Kennett Square, Pennsylvania, are thronged by thousands of visitors each year. There is also a third duPont masterpiece, generally unknown, hidden behind a sinister stone wall embedded with broken glass. Nemours, near Wilmington, Delaware, resembles the gardens of Versailles Palace, and is named after the duPont ancestral home near Paris, France. It was built by Alfred I. duPont.

Although the overall effect is predominently French renaissance, the garden is actually a successful blend of two distinct styles, French and English, conceived by the owner following extensive trips to Europe.

At Nemours, Alfred I. duPont led a secluded life and discouraged visitors. Even now that the estate is administered by a foundation, only a trickle of visitors is allowed through the grounds by prior appointment. I was the first professional to photograph the gardens for publication. My article appeared in the September 1979 issue of *Architectural Digest.*

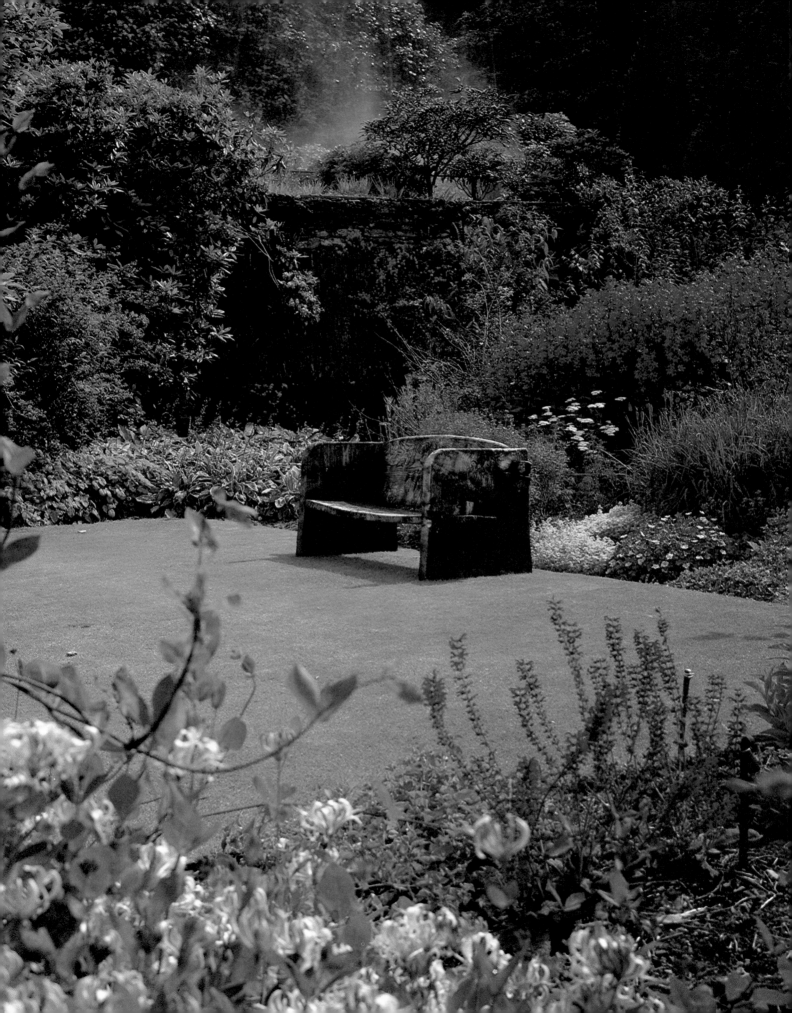

The Versailles effect is created by sweeping lawn vistas, wide tree-lined avenues, or *allees*, intricate clipped-hedge *parterres*, baroque sculptures and gushing fountains. These French formal gardens stretch for one-third of a mile, sloping away from the main house, surrounded by natural woodland and intersected by free-form lakes reminiscent of an English country estate. It is that intricate marriage of styles—the geometric shapes of French formal design softened by the free-flowing lines of English natural landscaping—that I sought to portray in my photographs of this garden masterpiece.

I went there in the spring when everything was fresh and green, but I couldn't get one particular special effect at that time of year. So, I returned in the fall to shoot a 250-foot-long grape arbor. The arbor was a monotonous green color in the spring, but by fall it had transformed into a tunnel of gold, contrasting with clusters of ripe grapes.

Another sophisticated garden feature at Nemours is a fascade of French trelliswork, or *treillage*, mounted on the south wall of the house as a background for a boxwood garden. This delicate trelliswork is extremely rare in garden landscapes today. It is even more unusual to see it creating an illusion of perspective. For one of my most satisfying springtime pictures at Nemours, I shot the pastel green trelliswork with a planting of blood-red tulips in front, and composed my picture with a small fountain positioned at the very center of the trelliswork, where the perspective came together.

The Garden House is the most beautiful private garden I have ever visited. Greenery surrounding the massive oak seat captivated me. By partially framing it with the flowers of a honeysuckle vine, I managed to capture a feeling of seclusion and tranquility.

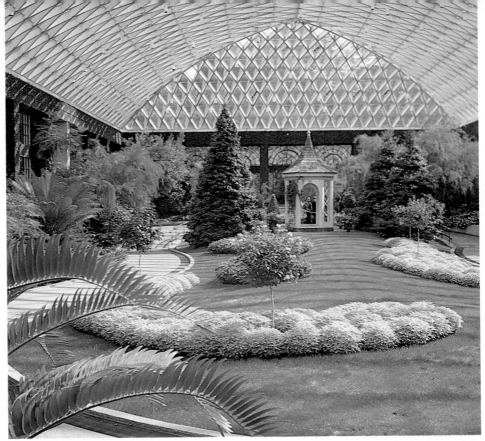

The Azalea House at Longwood Gardens is one of the largest greenhouses in the world. Using the gazebo as my focal point, I framed the scene with the arching fronds of a cycad palm. I also aimed for a balance between the unusual roof pattern and the plant material.

THE GARDEN HOUSE—AN ENGLISH COUNTRY GARDEN

I am often asked which is the most beautiful garden I have ever photographed. Without hesitation, my answer is The Garden House in Devon, England. I am not alone in my opinion. Patrick Synge, an eminent British writer and horticulturist with the Royal Horticultural Society, declared, "Never have I seen such a rich few acres."

The Garden House is a walled garden on the edge of Dartmoor, a barren windswept plateau associated with tales of murder, mystery and the supernatural, and where Britain's top-security prison is situated. Just 15 miles from the castle-like prison, the garden sits hidden in a sheltered valley, behind a 12-foot medieval stone wall. You enter the garden through a gothic archway, and a long grassy path leads to an ancient tower in the center of the plantings. Terraces full of beautiful ornamental shrubs and flowering perennials climb the slope. A spiral stone staircase inside the ruined tower leads to a door which opens onto a secret garden with a beautiful lawn surrounded by perennial borders, and a massive wooden seat at one end. This was the heart of the garden, creating an atmosphere of peace and tranquility, and where I had the distinct feeling that a friendly ghost was watching me.

The sensation of being watched by something invisible was so real that I literally tiptoed through the garden, not even daring to whisper for fear of shattering the peace and breaking some magic spell that seemed to be making the flowers grow so profusely. I took pictures of the old tower and a thatched barn covered with flowering vines, and got a spectacular bird's eye view of the garden from the top of the tower. I had a feeling, however, that none of these was more important than a picture of the secret terrace garden with its oversized garden seat, seemingly built for a giant.

The pictures on this page were taken at Longwood Gardens, Kennett Square, Pennsylvania. Right: Adjacent to the Azalea House is the main conservatory, with borders of flowering plants that change with the seasons. This is one of the spring displays. Several factors combine to make this a dramatic indoor scene, and the tall tapering foxgloves provide an interesting and unusual focal point. The pink hydrangeas help frame the scene with a bold splash of foreground color, and the golden border of daffodils provides an essential contrast of bright color.

Lower Right: The Tropical House is never more beautiful than when the banana trees are in fruit. When a garden or conservatory scene features such a dominant feature it pays to make it your focal point.

Below: Wall-to-wall angel's trumpets. The sheer size of this planting and the quality of blooms are portrayed effectively by getting in close and shooting along the vine at a sharp angle. When in doubt about the best angle, simply walk around your subject looking through the viewfinder until the best composition presents itself.

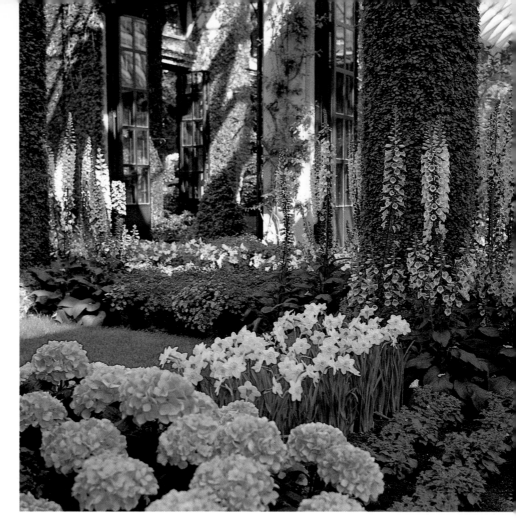

I concentrated my attention on the seat, half expecting to hear the ground tremble, with a giant booming "fee-fi-fo-fum." I finally obtained a composition that, for me, captured the ethereal beauty of the garden. I stepped back as far as I could go, right up against the tower wall, and had the enormous garden seat framed entirely by flowering perennials, retaining walls and high hedges. I also had a suitable expanse of velvet green lawn to contrast with the darker hues of the garden seat and its surroundings.

I subsequently sold the pictures to *Architectural Digest* as a feature in their April 1980 issue and, although all the pictures were beautiful in their own way, I have a feeling that the one picture which clinched the sale—the one picture the magazine felt they *had* to publish—was the picture of the secret area and its oversize garden seat that added an air of mystery and romance to the garden.

In spite of its beauty, however, the garden is difficult to photograph effectively. It is relatively small, crowded with plants, and hemmed in by tall trees and high hedges. It's on a steep slope with very few vantage points to gain an unrestricted view of special landscape features. The garden is owned by Mr. and Mrs. Lionel S. Fortescue, a retired couple who started the present plantings in 1945. The walled area, however, had been cultivated as an orchard and vegetable garden since medieval times when an abbot came to live at the property after King Henry VIII closed down a nearby monastery in 1536.

LONGWOOD—A GARDEN UNDER GLASS

Longwood Gardens, located at Kennett Square, Pennsylvania, is the world's finest display garden. Its more than 1,000 acres serve as a rich source of outdoor garden scenes and greenhouse plantings. Wealthy industrialist Pierre S. duPont founded Longwood as a country estate in 1906, but before

his death in 1954 he turned it into a foundation for the enjoyment of visitors. Today, Longwood receives more than 500,000 visitors annually, and you might think that such a well-known garden would offer few opportunities as a garden feature; but I did a picture story for *Plants Alive* magazine, concentrating on the appeal of Longwood during winter, with special emphasis on the conservatory displays—almost five acres under glass.

I instinctively look for one special picture that will make a viewer stop and look in every garden I visit. You cannot do it with close-ups—it has to be a general garden scene a person can project himself into. One of the

editors I work for summed it up exactly when he said close-ups are useful as fillers, but for every garden he needed one picture with a special inviting quality to make a reader "want to croak with delight." In a garden such as Longwood, scenes of this caliber are commonplace. This makes it a little easier to choose that super-spectacular breathtaking scene to lead off and dominate a feature article.

The conservatories are all connected at Longwood, and each area has a controlled environment for growing plants from different climatic areas, including humid jungles and dry deserts. There are houses devoted to palms, ferns, orchids, bromeliads, begonias,

To me, this picture exemplifies Winterthur more than any other—a quiet woodland glade adjacent to the main house, with a frog pond and a rustic garden seat. It is a garden for meditation. Notice how I balanced the reflections of the pond with the green canopy of trees, and how the reflected blue sky in the water helps to frame the view.

hibiscus, the desert and the tropics, and other specialized areas.

In the main conservatory, the emphasis is on floral displays that change with the seasons. This offered my first possiblity for the BIG picture. Leading from this is the azalea house, another large area, where fully mature trees and shrubs grow with a spacious lawn area in the middle, bordered with flowering plants. It is landscaped with some interesting features such as a gazebo, waterfalls and pools. The roof, the largest expanse of glass I've ever seen, creates an unusual diamond pattern, and because of its sheer spaciousness, I instantly realized this was the location for my most important picture.

I walked around the edges of the conservatory, seeking as much depth as possible to my picture, at the same time noting the placement of plants, their relationship to lighting conditions, and trying to locate a focal point in the distance. Finally, I found the perfect spot at the top of a flight of stairs, with the arching fronds of a cycad palm in the foreground and a long vista ending in a gazebo—like the cake at the end of a sumptuous dessert table. And the lighting was perfect!

When shooting in greenhouses and conservatories, the best lighting condition is a bright, but slightly overcast sky. Under these circumstances, the light inside the buildings becomes diffused and even, causing harsh shadow areas to disappear. On sunny, cloudless days, it's often difficult to avoid shadows from struts, glazing bars and pillars.

The rest of my pictures came easily—a display of flowering bulbs and spring annuals in the main conservatory, a banana tree in full fruit in the tropical house, a wall of angel's trumpets in the hibiscus house, and others.

WINTERTHUR—A NATURAL GARDEN

One of the most photographed gardens in the world is Winterthur, a woodland garden near Wilmington, Delaware. It was conceived by Henry F. duPont, another member of the famous duPont family.

It is an outstanding natural garden, created as a work of art, using wildflowers and naturalized plantings in bold strokes of color across hillsides, woodland and meadows. The gardens are vast—almost 500 acres—and winding paths lead to many different areas of botanical interest.

Dozens of colorful books and articles have been published about the Winterthur Gardens. Before entering to take my photos, I spent a quiet hour in the garden's bookstore, carefully examining each volume to see the picture possibilities. Because I was planning to sell my photos, I wanted to avoid the cliche shots, those that are too well known or have been widely published and don't warrant duplication. You might want to do this also, to find points of view for your own work. Winterthur has been featured in *National Geographic* and *Readers' Digest*, so the prospect of finding anything visually different from what had already been published seemed unlikely.

Although part of the appeal of Winterthur is its spaciousness—open areas of rolling hillside, and some formal gardens—by far the most visually exciting places are the naturalized plantings. Thousands upon thousands of

This landscape scene combines two elements of dramatic pictorial impact peculiar to Winterthur—the spaciousness of open meadows and rolling hills, and an extensive naturalized planting, in this case autumn crocus. Most visitors I saw photographed these flowers facing uphill, a much less spectacular angle of view.

Bluebells by the thousands light up the woodland floor in spring. The tree trunks help to provide a good focal point and add scale to the scene. Mass plantings like this one are an important part of the garden's unique appeal.

Azaleas are planted in great quantity at Winterthur, and even though they are spectacular at ground level, nothing quite portrays the dramatic effect of their blossoms better than this picture obtained by climbing to the top of a wall bordering one of the woodland areas.

bluebells, primulas, daffodils, colchicums, trilliums, ferns, azaleas and other colorful plant species flower *en masse* in broad sweeps across the woodland floor and on grassy hillsides. During my visit I became obsessed with one purpose—to photograph the natural plantings and to show the extent and diversity of those plantings.

Wherever I walked I searched for the natural effect in a landscape setting, ignoring close-ups, specimen shots and formal gardens until I felt satisfied that I had examined every inch of the property for the mass planting scheme. What an uplifting experience it was to find several dramatic scenes I had never seen published before, to sense that perhaps I had beaten some other professional photographers to *the* picture.

Never have I been more satisfied with my efforts as a plant photographer than the pictures I have of this remarkable garden. The most pleasing images were obtained where I least expected to find them.

For example, I stopped at the garden with a friend one afternoon in fall, too early for autumn hues, realizing that little color would be seen at that time of year. However, when we rounded a cor-

Above: Few gardens combine garden ornaments and natural plantings as effectively as Winterthur. When I spotted this sundial overlooking a sunken pool bordered with the glaring colors of Japanese azaleas, I searched for a composition that would keep the sundial centered. I finally found the right angle by standing on top of a stone balustrade.

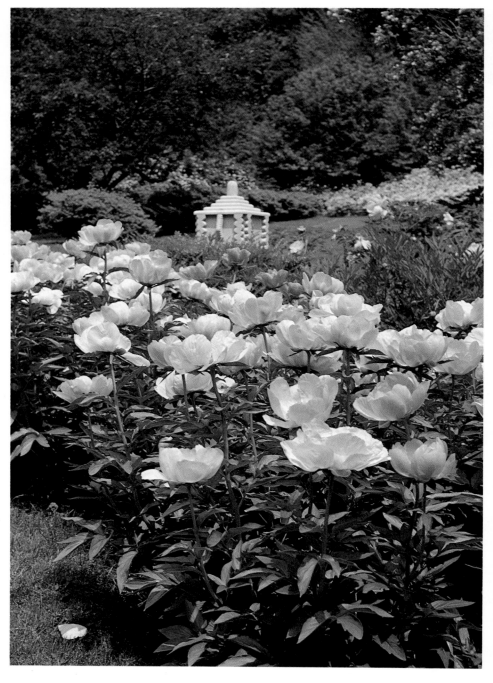

Right: This is a small secluded peony garden with an ornamental beehive. Shot at an angle, the flower border helps fill the frame with color, and the beehive is an unobtrusive decorative central feature. This picture was used as a full-page illustration for a Time-Life book in their gardening series.

ner, we saw an astonishing number of pink-flowered autumn crocus, colchicums, contrasting delicately with the surrounding greenery of a grass-covered valley. Almost every passer-by took pictures of the scene *uphill* with the hillside and a grove of trees in the background—this is how it was pictured in a book. I shot from the *opposite* angle, looking down on the planting, with the valley stretching out into the distance. This produced a much more spectacular picture and a truer image of the spaciousness of Winterthur.

Visitors in spring are drawn to areas of the woods with dazzling azalea plantings, but I found myself exploring a dark area where nobody ventured. There were no colorful azalea blossoms—just a frog pond with a garden seat and green leaves all around. Yet here I had a feeling of unearthly peace and seclusion, and composed one of my favorite natural landscape pictures—a scene of utter tranquility that never fails to have a soothing influence on my senses.

4
Fruits & Vegetables

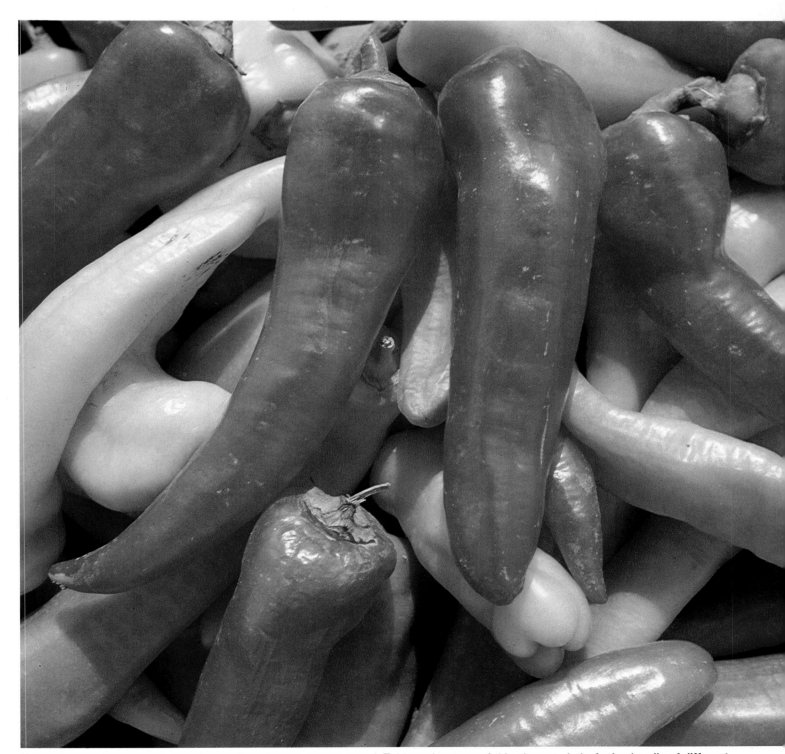

Hungarian wax hot peppers ripen from yellow through orange to red. Taking advantage of this characteristic, I mixed a pile of different colored peppers together, arranging two perfectly-shaped, fully-ripe specimens at the center as the focal point.

This picture of asparagus spears striking through the soil on a warm spring day has produced more than $1,000 in revenues, having been used in nursery catalogs, gardening books and garden magazines. Its appeal is the totally natural composition, as well as the symbolism of energy and growth it portrays.

On the surface, fruit and vegetable gardens can appear to be colorless and offer few opportunities for exciting plant photography—but that really depends on how good an observer of nature you are.

The size and brilliance of a squash flower can outshine the beauty of many exotic hibiscus flowers, and the bright red and green skin colorings of a Turk's Turban gourd will make many garden flower pictures seem pale by comparison.

Most pictures of asparagus show them cut and bunched, or served on platters with great gobs of butter. What more glorious sight is there in spring than thick, succulent spears of asparagus striking through the soil? They are easy to photograph and are as symbolic of spring as daffodils and tulips.

I classify vegetable and fruit pictures as two types—on the vine and off the vine. With few exceptions, a well-composed shot of any fruit or vegetable on the vine, in my opinion, outclasses any off the vine picture.

Ripe apples, pears, peaches, gooseberries, strawberries, grapes, raspberries, blackberries and tomatoes can indeed look beautiful arranged on a dinner table by a gourmet, but Mother Nature has millions of years more experience, and good wholesome, unblemished sun-ripened fruit, still clinging to the vine, will give you better pictures every time.

Naturally, there are exceptions, and these are easy enough to determine: Any fruit or vegetable that looks more beautiful on the inside than the outside should be removed from the vine, cut open and arranged in a pleasing composition showing cut and uncut fruit together. Examples are melons showing their orange, green and red flesh; papayas and acorn squash showing their brilliant orange flesh; and pea pods showing the neat interior rows of succulent round peas.

Look for interesting fruit tree varieties. Many people are now growing dwarf peach trees and nectarines in tubs, and these make unusual pictures, especially if you can photograph them in a patio setting. Specimens of dwarf apple and pear trees covered in fruit are good pictures to take, and espalier forms of apples and pears, trained to grow in a flat plane, often symmetrical, will add variety to your fruit tree pictures. Similarly, grape arbors offer exciting picture possibilities.

Vegetables that grow well in pots will add further interest to any vegetable collection you decide to build. Parsley not only makes a beautiful potted plant, it does well as a hanging basket in a well-lit room. Cherry tomatoes are picturesque when you can show them growing in containers on a patio or in a sun room.

It's surprising how beautiful even a common green cabbage will look when it is a fine specimen. Cut open a head of red cabbage and see the intricate design it hides inside. It makes beautiful close-ups. Even plump Brussels sprouts and cauliflower, free from blemishes and photographed as they grow, will give you a pleasant surprise when viewed through a close-up lens.

In melon, squash and pea pictures, where flowers and fruit appear together on the vine at the

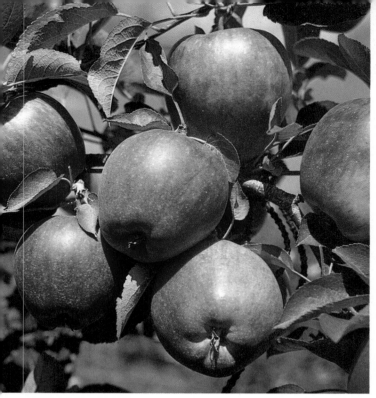

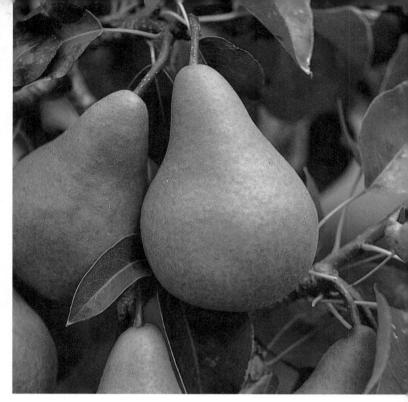

These Red Delicious apples on the tree were featured in the Miller Nursery catalog. Appealing qualities of this picture are the completely blemish-free handsome fruit cluster and the even lighting of the fruit.

Here I concentrated on one perfectly-formed, evenly-lit pear, variety Beurre Bosc, on the tree. Many catalog editors like single fruits that they can silhouette—a publishing technique whereby all of the background is left out, showing only the fruit itself highlighted on a white background.

same time, it's a good idea to include a flower and an arrangement of leaves in your composition. In strawberry pictures it's possible to show flowers and fruit together on the vine; and with okra, ripe pods and flowers can be photographed together.

Root vegetables are another problem. These include radish, celeriac, turnip, beet, carrot, salsify, rutabaga and parsnip. Because you cannot see them in the soil, they must be uprooted and made into a pleasing arrangement. Take a tip from the harvest shows and arrange them carefully on wicker platters, reed mats or bunches of healthy foliage. Clean the roots by gently brushing away the soil and use only well-shaped, uniform roots. Avoid divided roots, and turn any blemish such as worm holes and cracks to the underside. Then dip the roots in clean water or spray them with a fine atomizer. You'll be amazed how the color will brighten up and make a much better picture. If you spray water on other vegetables

and fruit, including tomatoes and strawberries, this will work wonders, too.

When photographing apples and pears on a tree, the colors will be brighter if you gently polish the fruit before taking the picture. Chemical sprays and dust accumulate on the skin and can considerably dull the color.

Certain other fruits form a bloom on the skin, a dusky, powdery covering. Grapes, plums, damsons, blueberries and even pea pods are examples. This bloom is natural, and should *not* be removed. Nor should you overhandle this kind of fruit because fingermarks and shiny patches will show up and spoil your picture. In harvest shows, judges give extra points for grapes and plums showing a healthy bloom. You should remember this when making your photographs.

VARIETY SELECTIONS

There are many occasions when a magazine or book publisher wants to show a large selection of *varieties*. I constantly receive

requests like this for apples, pears, lettuce, peppers, melons, gourds, tomatoes, and fall and Oriental vegetables. If you decide to market your photos, the wider the selection you can offer, the better your chances of multiple sales.

The demand for apple pictures has become so consistent that I have made a special effort to photograph not only the four main varieties—Red Delicious, Golden Delicious, Winesap and McIntosh—but also some old fashioned varieties, such as Grime's Golden, Winter Banana and Cox Orange Pippin.

A good selection of lettuce varieties would include both loose-leaf types—Grand Rapids, Salad Bowl and Oak Leaf—and head lettuce—Iceberg, Buttercrunch and Boston Bibb—plus unusual kinds such as Cos, Ruby and Tom Thumb.

Pepper pictures should include both sweet and hot kinds, including bell, Hungarian wax, jalapeno, cherry, banana and cayenne.

Among Oriental vegetables,

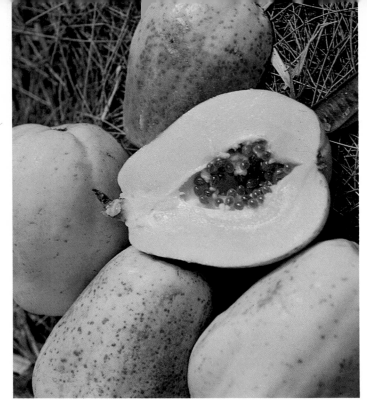

I found these papayas lying on the ground in an orchard on the island of Oahu, Hawaii. I gathered them together, arranged them on the ground on a covering of pine needles and obtained a pleasing picture of these beautiful tropical fruits, with one sliced open to show the attractive interior flesh color.

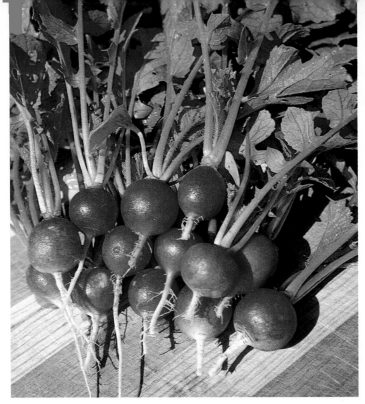

Root crops such as the radish are best arranged in a neat pile with the tops left on and roots trimmed. To bring out the color of this variety, Champion, I sprayed them with a fine mist of water from an atomizer.

there is a steady demand for the white eggplant, Chinese cabbage, yard-long beans and cucumbers, snow peas, and spaghetti squash.

In addition to photographing these varieties individually to show their distinctive shapes and textures, also consider arranging them together for a composite shot.

Collect an assortment of sprouting seeds and see what interesting compositions you can make. In addition to the familiar mung beans, there are sweet-flavored alfalfa sprouts, curry-flavored fenugreek and sweet crisp bamboo bean sprouts, each with a distinctive color and texture.

Arrangements with different kinds of melons are fun to make. I select my subjects for skin texture, shape and interior flesh color, and arrange them against a natural garden background.

Gourds make colorful arrangements, especially if you can place them against an autumn background of corn shucks or fallen leaves.

When *Time* magazine decided to do a story about the development of a new vegetable called a snap pea, possessing both plump edible peas and edible pods, I was the only photographer able to satisfy their request for a black-and-white picture showing the shelled peas on a natural background. All other pictures submitted by competing photographers showed the peas unshelled as table arrangements.

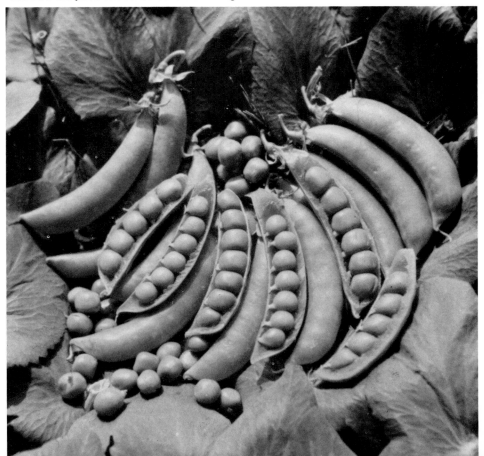

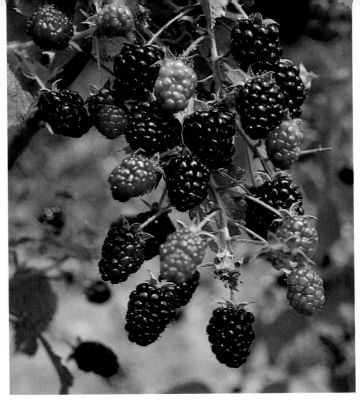
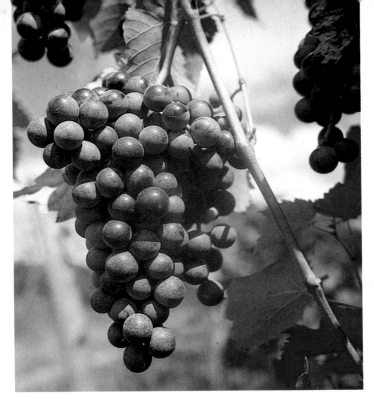

A handsome cluster of blackberries, exactly as nature presented it. Although I have dozens of blackberry shots on file, none is more widely published than this group pictured on the vine.

This Steuben grape has a dusky, powdery bloom that should be left untouched for the best-looking grape pictures. This photo has been published many times, most recently in *Plants Alive* magazine.

Dried sunflower heads, Indian corn, pumpkins and squash also make colorful autumn groupings. You will often find these ready-made for you to photograph at roadside stands, garden centers and farmers' markets in the fall.

When photographing shiny fruits such as eggplants, peppers and tomatoes, be wary of "hot spots" caused by reflections from an intense light source, such as the sun. Sometimes this shiny spot on the fruit is desirable, but for catalog pictures and specimen shots, the glare should be eliminated by shooting the fruit on an overcast day or by using a diffuser to cast a light shadow on the fruit.

The two most important fruits are tomatoes, classified as a vegetable fruit, and strawberries, a berry fruit. I'm sure it is possible to earn a comfortable income by specializing entirely in the photography of these two plants. Here's how I have photographed them for the best results:

Tomatoes—There are many different kinds of tomatoes, from the small "cherry" varieties to the giant Beefsteak types. Not all tomatoes are red, either; some are yellow, orange, white or striped. There's even a variety that stays green.

I started off my collection by trying to photograph all the different kinds, from large to small, concentrating primarily on showing them "on the vine" in beautiful clusters, and with natural foliage as the background.

Next, I photographed the most popular varieties, such as Big Boy, Supersonic, Beefsteak and Red Cherry. I have photographed these in different ways: In addition to showing them on the vine in their natural condition, I've arranged them on plates and displayed them cut open as slices—this is how the catalog companies like to illustrate tomatoes. When dealing with the big fruited varieties, such as the Beefsteaks, it's important to show scale, so you should introduce something into the picture to indicate relative size, such as a knife, salt and pepper shaker or slice of bread. One of my most popular tomato pictures is a Beefsteak with one slice of tomato completely covering a slice of bread.

When photographing arrangements, a question to consider is whether to have the tomatoes with the blossom or the stem end facing the camera. In my experience, they always look better with the blossom end showing.

Tomatoes are grown both staked and unstaked. Pictures of tomatoes with large quantities of fruit clusters hanging down the side of the staked plant like a curtain are most popular. Inspect the foliage carefully and take out any leaves hiding the fruit clusters. Also remove any diseased or mud-splattered leaves. Sometimes you'll find fruit covered with stains from a pesticide; these marks must be removed by gently rubbing the fruit with a damp cloth.

When photographing giant-sized tomatoes, take this opportunity to introduce the human element. Make a pile of tomatoes and

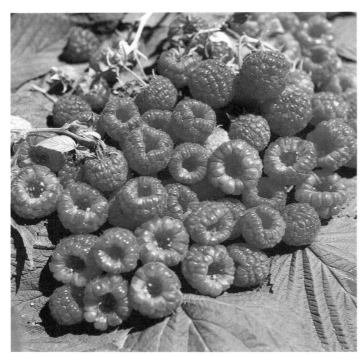

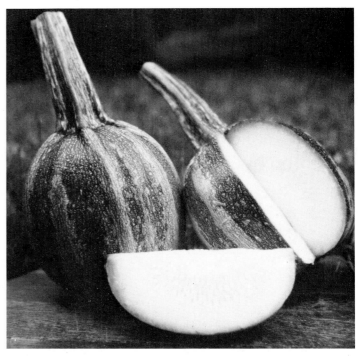

Sometimes it simply isn't possible to obtain an outstanding on-the-vine picture. Berries may be widely scattered or leaves blemished, so an arrangement has to be made from picked fruit. These giant raspberries were the best of the crop. By selecting unblemished leaves for a background, I was able to create a large pile of the berries on the ground. *Mother Earth News* published this picture.

Both of these vegetables are types of summer squash. The white is a scallop variety, photographed on the vine because the creamy-white color of the fruit contrasts well with the soil and foliage background. The mottled variety is called an apple squash because it can be eaten raw like an apple. I decided to photograph it as a table arrangement because the predominantly green fruits offered poor contrast on the vine. Notice how I left a good deal of stem attached to the fruit and sliced one open to show the creamy-white interior.

show a smiling child or attractive model.

With staked tomatoes, it's often difficult to take the picture without showing some undesirable background feature. Problem backgrounds I can recall include an ugly greenhouse wall, a clothes line with wash hanging from it and a pile of old rubber tires. Use a portable background showing a rustic fence or stockade design to screen out extraneous background objects.

I always find time each summer to shoot new tomato pictures, and generally will visit an experimental farm where many different varieties are grown for evaluation. State universities and commercial seedsmen normally plant extensive tomato trials.

Strawberries—By far the most popular dessert fruit, strawberries are most plentiful in June. That's when I usually find time to take as many different kinds of strawberry pictures as possible because they

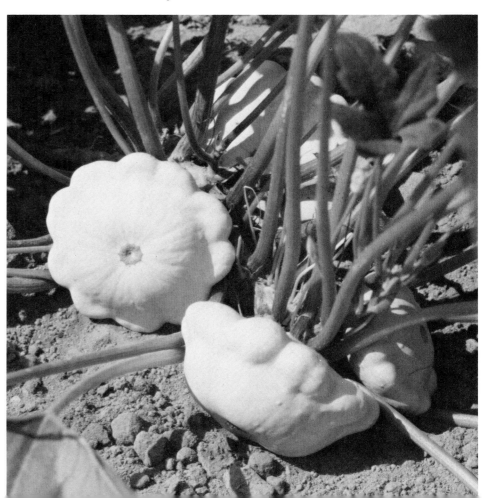

These are examples of lettuce varieties often requested by publishers for identification: Above left is Salad Bowl, a popular loose-leaf lettuce with a frilly leaf edge; in the center is Great Lakes, a head lettuce with a crisp texture similar to Iceberg; on the right is Black Seeded Simpson, a loose-leaf variety that is one of the most popular in the home garden; and at left is Paris White, a leading cos lettuce that keeps its leaves clear of the soil.

are popular with publishers and catalog houses.

Each year I drive to a strawberry growing area in Maryland, near the ocean. Strawberry picking time comes early in Maryland— generally before Memorial Day— and there are lots of operations where you can pick quarts of fruit at minimum cost. Take my advice and get there on the first day of picking so you can quickly tour the rows of plants to select the biggest and best berries before the crowds of visitors strip the vines.

I had enormous fun one year, photographing strawberries in a field of early morning pickers. When a picker found a really big and beautiful specimen, it would be brought over to me for inspection and photography.

The best pictures show strawberries on the vine with lots of fruit arching out from all sides of the plant and a covering of clean straw on the ground. After taking lots of on the vine pictures, I then create some arrangements, photographing a solid mass of berries to all four edges of the frame, making sure that the sharpest focus is on a perfectly shaped, blemish-free berry in the middle.

I then photograph different types of berries as arrangements, perhaps six to eight berries on a plate, and make a note of their variety names. I also determine whether the variety has any distinctive feature which must show in my picture. For example, Fairfax is famous for its deep-red color while Guardian has a high percentage of "cockscomb" fruits, a term used by strawberry growers to describe a berry broad at the base rather than pointed, or cone shaped.

Next, I find the biggest berries I can, and photograph them with a person holding them between the forefinger and thumb. Strawberry specialists love to use this kind of picture in their advertising and mail-order catalogs.

Another good shot is of a child or attractive woman with her mouth open and her hand poised to pop a big bright berry into her mouth.

Strawberries are classified as June-bearing and everbearing, so it's best to get pictures of both kinds. June-bearers produce a large crop of berries only in June— these are also the biggest—while everbearers normally produce a moderate crop in June and another moderate crop in September, as cool weather returns.

There are also alpine strawberries which resemble wild strawberries. These are best shown as a short row of plants, or in a hanging basket. There's a big demand for strawberries in any kind of container, particularly planted in the pockets of a "strawberry barrel" and loaded with fruit.

Strawberries also look good in close-ups, showing one cone-shaped fruit sliced in half, with the green stem still attached. Photographed this way, you'll discover that the inside of a strawberry is really white with a pattern of red veins leading out from the center to the seeds, which are located on the outside of the berry.

Vegetable spaghetti is actually a type of Oriental squash. Unusual vegetable photos like this are sought by catalog houses. To create this still life, I cooked one squash and sliced it open, using one half to show the spaghetti-like interior. A second squash is shown uncooked. I made my arrangement on a plain cutting board, with a plain blue background to complement the creamy yellow tones of the squash. A red tomato was placed in the background just to add a little extra color.

This photo of Burpee hybrid cantaloupes is probably the most widely published melon picture ever taken. It appears regularly in the Burpee seed catalog, and has been used by publishers such as *Mother Earth News*. I found these beautiful specimens at peak ripeness in a trial garden where they had been picked for checking weight. A drought had turned the grass the same color as the melons so I used this as my background. Cantaloupes always photograph better sliced open with the seeds removed.

When sprouting seeds became popular, I made this arrangement of mung bean sprouts on a straw mat with a fresh green salad to provide additional color and help the composition.

The hot spots on these eggplants were caused by reflected glare. You can prevent them by shading the fruit with a light-colored umbrella.

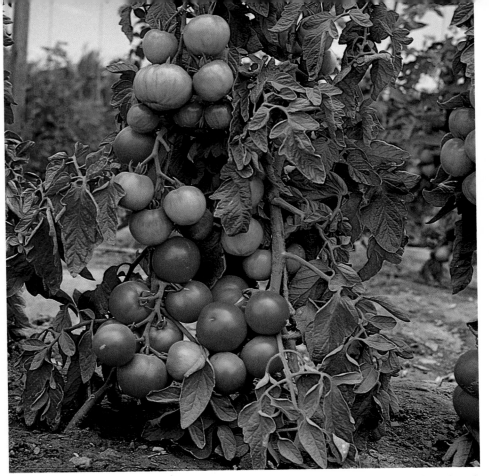

Tomato slices make beautiful pictures. This group close-up of Super Beefsteak shows slices from fruit grown in my own garden.

A popular type of tomato picture is the staked tomato. This variety is Better Boy, found growing in an experimental garden.

Tomatoes on the vine are very popular; the more fruit showing in the picture the better the chance of publication. This close-up of cherry-size tomatoes is especially attractive because of the green ones indicating a succession of fruit.

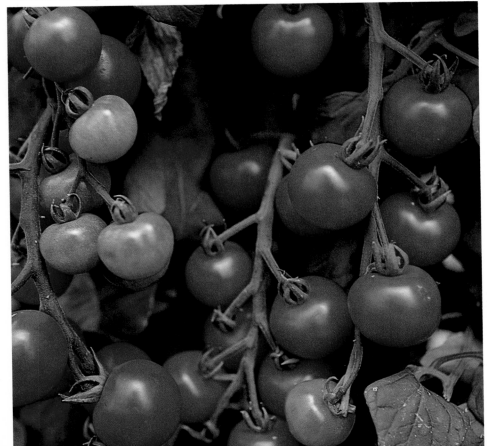

GIANT VEGETABLES

Show someone a giant vegetable and watch a smile come to his face. There's something whimsical about giant vegetables. You should consider several points if you want your pictures to look dynamic. The most important one is to provide scale so people can appreciate the giant size. The most common method of introducing scale is to show a person—preferably the proud grower of the vegetable—because this gives your picture added value. Be sure to get the person's name, the weight or dimensions of the vegetable and a written release if you plan to sell the picture.

Not all tomatoes are round and red—some are yellow, some are pear shaped and there's even a striped variety. This is a hollow variety called Burgess Stuffing. The picture was published by *Flower & Garden*.

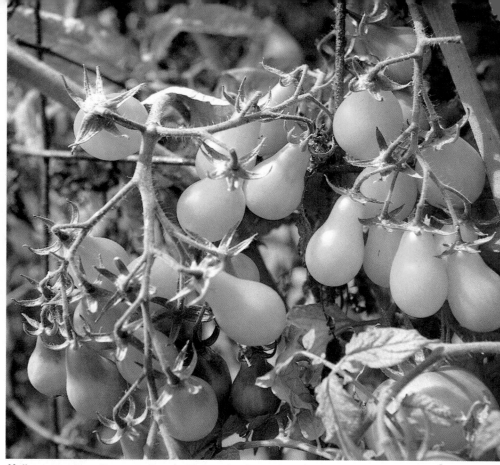

Yellow pear tomatoes are popular for cocktail snacks and salads. The wire mesh in the background is part of a tomato tower, a wire cylinder that supports tomato vines better than staking because the tomato plant sends its side branches through the mesh and becomes self-supporting.

These Super Beefsteak tomatoes were grown in my own garden. Using my daughter Tina as a model, I made an arrangement of them suitable for catalog illustration, placing the big tomatoes closest to the camera lens in order to emphasize size. This picture appeared in the *Chicago Tribune* to illustrate an article on vegetable gardening.

Children are especially good for showing size. Their charming faces will not only brighten the picture, the small size of a child seems to emphasize the vegetable's size.

Positioning the person properly is extremely important. *Always* have the vegetable closest to the camera, with the individual standing behind it. If you have the person standing to the side or slightly in front, the vegetable will not seem as large. To exaggerate size, have a child hold the vegetable toward the camera with outstretched arms.

Sometimes it is better to show a giant vegetable, such as a pepper or strawberry, as a close-up, with no room for a person to be included in the picture. In this case, a hand should be shown,

Here are strawberries galore, each one a perfect cone. Most berries photograph well this way, just picked from the vine and shot close-up, filling the frame.

These are Jerseybelle strawberries growing in the garden, with fruit at different stages of development. This picture appeared in *Mother Earth News* to illustrate an article on fruits and berries.

These fresh strawberries were arranged in a crystal bowl on a silver platter with a rustic background—a redwood picnic table with the branches of a beech tree draped around it. This type of arrangement, combining quality tableware in a natural setting, always appeals to food editors.

This gigantic pumpkin, weighing over 312 pounds, won the Newtown, Pennsylvania giant pumpkin growing contest one year. It was featured by Associated Press in a news story to daily newspapers. I later took the giant to New York for an appearance on the Today Show.

either holding the vegetable or touching it.

When photographing a tall plant such as a tomato vine reaching to the eaves of a house, a bean plant that has grown 30 feet up a telephone pole, or a sunflower the height of a two-story house, have the owner stand next to it at ground level. You'll produce a much more spectacular effect, however, if you have the person standing on a stepladder next to the towering plant. The stepladder adds a humorous touch and another dimension to your image—action.

FUN WITH NUTS

Autumn is a fine time to add some pictures of nuts to your library. Some are easy to photograph right on the tree. Chinese chestnuts, for example, usually have nut-bearing branches at waist level. In autumn it is possible to find photogenic nut clusters, with one or two of the spiny cases splitting open to reveal the shiny brown nuts inside.

Butternuts, hickories, walnuts and pecans, on the other hand, are usually too tall by the time they reach nut-bearing age. It is extremely difficult to photograph them growing naturally on the tree. In any case, photographing them that way would only show the outer nut casing. A black walnut, for example, has a round outer casing, or hull, which varies in color from avocado green to black, depending on its stage of maturity.

When I visited a vegetable garden in England, I was impressed with the size of their broad beans, or fava beans, as they are called in the United States. By having a youngster hold the beans toward the camera, a dramatic portrayal of size is given.

Inside the casing is the nut with a hard, black, deeply corrugated outer shell; and inside this shell is the rich brown deeply lobed and flavorful meat. With walnuts and similar nuts, a satisfactory picture is an arrangement of the round hulls at different stages of maturity in the background, and the nuts themselves in the foreground, together with a few half-shelled, showing the meaty interior.

Butternuts, hazelnuts, hickories, almonds and pecans make equally interesting arrangements when photographed the same way, each showing a complete pictorial composition of how the nut grows. Also interesting are pictures of nut trees showing the entire tree growing alone, in summer or fall coloring.

PHOTOGRAPHING HERBS

There is enormous interest in herbs. Two kinds of herb pictures are popular—specimen shots to show the different kinds, and examples of creative outdoor herb gardens, both large and small.

Although the overwhelming demand is for herbs used as flavorings in the kitchen, medicinal herbs, fragrance herbs and herbs used as natural dyes are also popular. By far the most called-for pictures in my herbal library are close-ups of parsley, chives, dill, rosemary, thyme, sage, mint, basil, catnip and lavender.

The problem with most herbs is that they resemble weeds. Indeed, most of them grow like weeds. In a home garden, it is often hard to confine them to small, neat plantings when their natural tendency is to grow like crazy and seed all over the place, invading every inch of bare soil.

With many herbs, you really have to work hard to create a photogenic picture because all you have to focus on is a mass of green leaves. No matter how plain or weedy an herb may seem, there's usually at least one good way to display it effectively.

Here is an effective way to show nuts. One shot illustrates a mature butternut tree and the other is a close-up of nuts collected from this tree, including the green oval nut cases, the nuts before shelling, and a nut cracked open to reveal the delicious meat.

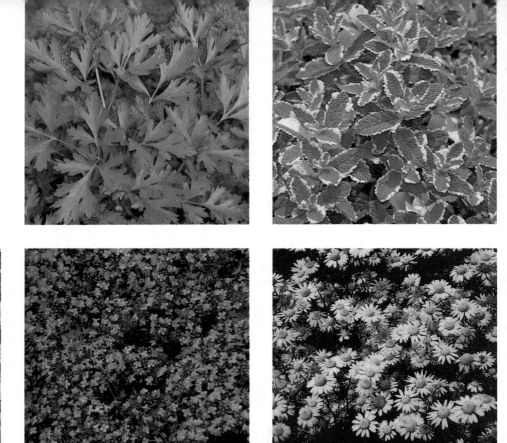

Golden mint is one of about 600 mint varieties used for herbal teas and flavor enhancers. The one above is the most ornamental, with its two-tone leaves creating an unusual pattern in close-ups.

Clockwise from top left: A bunch of plain green leaves doesn't allow for much creative photography, but I found this arrangement of plain-leaf parsley leaves splayed out in the same plane, offering an attractive design. The apple-scented variegated apple mint's attractive frosted leaf pattern helps make this picture appealing. Fake camomile, related to chrysanthemums, is used in herbal scents and teas. An unusual feature is its sparkling white flowers, very attractive in close-up. Hairy stem thyme grows as a spreading groundcover and has fragrant leaves used as a garnish for soups and stews. I obtained a colorful composition by closing in on these distinctive summer blooms and filling the frame with the dainty blossoms.

The entire flower-spike-covered plant of sweet basil makes a more attractive picture than a close-up.

Sweet woodruff is used in wines, but is also an effective groundcover in shady areas. This shot is interesting because of the dainty white flowers and the patterns formed by the star-shaped leaves.

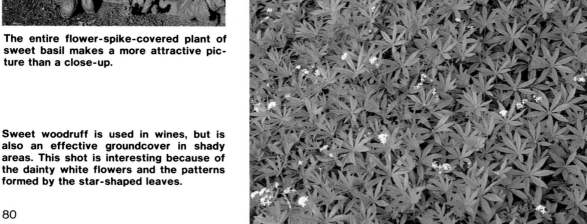

Neat, productive vegetable gardens are hard to find, and publishers want illustrations of them. Although this garden includes several vegetable varieties such as onions, carrots and lettuce, the cabbage heads are by far the most interesting feature. As a result, I made these the focus of my attention.

This is one day's harvest from a vegetable garden I planted. Note the strong color contrasts and the barn-siding as a background to give this picture a total rustic look. It has been published many times, twice as a book cover.

EXAMPLE GARDENS & HARVEST SCENES

Keep a sharp eye for model vegetable and fruit gardens. Food plots are popular, but you will find only one in a hundred good enough to make a satisfying picture. Vegetable gardens have a tendency to be dominated by green foliage, with all the plants merging into each other. Or, the garden will have too many weeds and insect damage. Other times you'll find the range of plant material uninspiring, the garden has an untidy layout, or is poorly located. The best vegetable gardens are neat, exhibiting straight rows of uniform height, decorative mulch such as pine needles or fir bark between the rows, and a contrast among the plantings. For example, a row of cabbage heads in front of a row of tomatoes, with a row of corn behind them is

attractive. Take pictures with and without people—and if you can find a vegetable garden where all the plants are growing in containers or raised beds, that's even better.

If you get a little discouraged at all those vegetable gardens showing severe insect damage, take heart. I have sold several color transparencies of badly eaten cabbages and other insect depredations to publishers for articles and books on pests and diseases!

Harvest scenes of vegetables are popular as covers, especially mixtures of vegetables with good color contrasts, such as red tomatoes, yellow squash, purple eggplant, green cucumbers, white onions, orange carrots and others.

Try creating several seasonal harvest pictures. For example, an arrangement of spring onions, spinach, radishes, asparagus, rhubarb, peas, watercress, lettuce

and strawberries could make an attractive spring harvest display, Ornamental corn, peppers, pumpkins, winter squash, sunflower heads, purple cauliflower, popcorn and tomatoes make an appealing autumn display.

Arrangements of fruits can be extremely colorful. Try a checkerboard design using pint baskets of berries, with each basket containing a different colored berry, such as green gooseberries, red and yellow raspberries, black currents, blueberries and blackberries.

Harvest scenes showing different colored grapes make excellent photos, as do colored apple groupings with green, gold, russet, red, striped and yellow varieties in the same picture. You can also make a colorful arrangement with different varieties of plums, including red, black, blue, purple, yellow and green.

5
Trees & Shrubs

A Chinese proverb states that for a man to lead a life of complete fulfillment, he must do three things before he dies—have a son, write a book and *plant a tree*. Certainly, a world without trees would be very sterile indeed. Not every man can be blessed with a son and few of us have the time or the talent to write a book—but every living person has the opportunity to plant a tree.

Although trees such as tulip poplars and magnolias have blossoms to compare with any beautiful garden flower, trees offer greater possibilities for photography in their leaf formations, branch configurations, bark textures, symmetry and grandeur.

What's more, trees can be as photogenic in the dead of winter as in the height of spring, providing you can see them as more than leaves and a trunk.

A popular picture sequence is a series of scenes depicting the four seasons—the whiteness of winter, light greens of spring, dark greens of summer and burnished colors of autumn. The sequence is most effective when you focus on a handsome tree or a picturesque landscape with trees. When shooting these seasonal changes for a series, shoot each one from the same spot.

Of course, each season brings about changes that affect trees in different ways:

Spring—Although early-flowering trees such as ornamental cherries, crabapples, forsythia, magnolias, dogwoods and azaleas command attention, I also go looking for woodland scenes with wildflowers and sparkling streams where I can capture a sense of springtime freshness. Spring is a season of pastel colors produced by delicate blossoms and mint-greens from unfolding leaves. Backlighting is often a good way to enhance these scenes.

Summer—The numbers of flowering trees diminish. In northern areas the sweet chestnut and franklinia tree are the last to flower. Although the franklinia is now extinct in the wild—the last

Pictures showing seasonal changes in the landscape are best if trees are conspicuous. This is the road General Washington took on Christmas Day during the Revolutionary War, when he crossed the Delaware River to fight the Hessian army in Trenton, New Jersey. It is now known as the Continental Highway, and is preserved as a state park. One illustration shows the highway in fall, and the other is the identical scene in winter, much as George Washington might have known it.

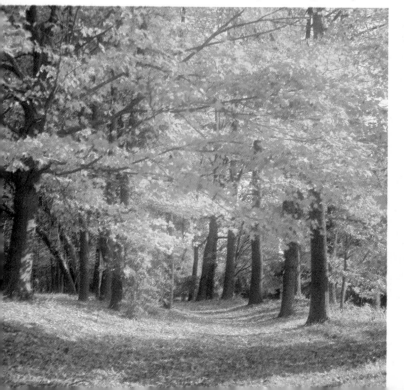
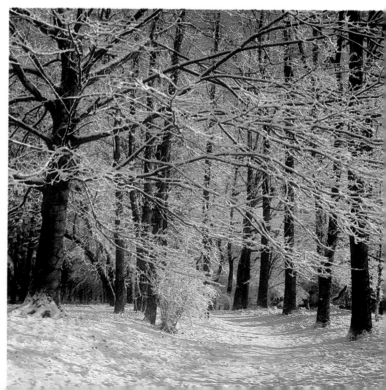

wild specimen was found in Georgia in 1789—cultivated kinds still survive in botanical gardens. This is a good time of year to seek out specimen pictures of billowing shade trees, when leaves are at their deepest shades of green.

Autumn—This is the season of striking leaf colorings, of pine cones, seed pods, fruit, berries and nuts. Maples, hickories, tulip trees, aspens, sumac and oak trees liven up landscapes with reds, browns and golds. It's a time for climbing mountains to photograph whole valleys clothed in fall colors, for seeking out lakesides and streams with the colors of fall reflected in their mirrored and rippling surfaces, and for wandering through wild woodland areas to capture the forest carpeted with fallen leaves.

Winter—The monotone moods of winter create stark contrasts, with dark branches against mellow skies. Look for interesting bark textures, branch formations, special effects caused by coatings of ice, snow and hoar frost. Shoot trees silhouetted against winter sunsets and snowscapes. Visit woodlands with streams and frozen waterfalls to obtain Christmas card scenes.

I classify tree and shrub pictures according to three main types requested by publishers:

Artistic compositions—Examples of artistic compositions include a grove of trees silhouetted against a glowing sunset, branches bending in the wind, a mass of gleaming peach blossoms, a silent forest shrouded in mist. The objective is to produce a visually exciting picture expressing a mood and relying heavily on subtleties of color, patterns and unusual camera angles for dramatic impact.

Patterns formed by branches are a source of many artistic pictures. While visiting a Japanese garden at Malvern, Pennsylvania, I admired a planting of several thread-leaf Japanese maples with arching branches and different colored leaves. I ducked inside the leaf

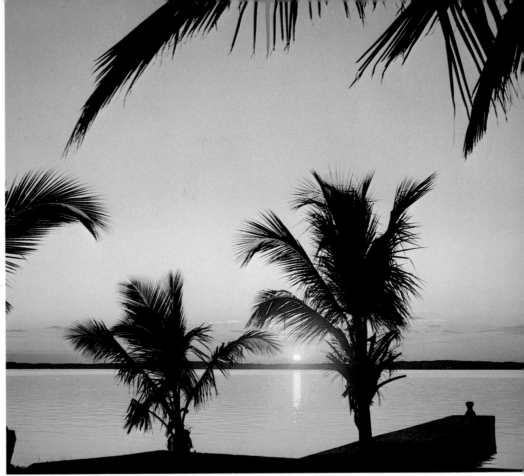

A Bahama sunset helps to silhouette an artistic composition of palm fronds at the dockside on Harbour Island.

Blossoms of this flowering peach tree, *Prunus* Hally Jolivette, look like a star-studded galaxy. The artistic effect was achieved by stepping inside the flowering canopy and shooting out at the backlighted blossoms.

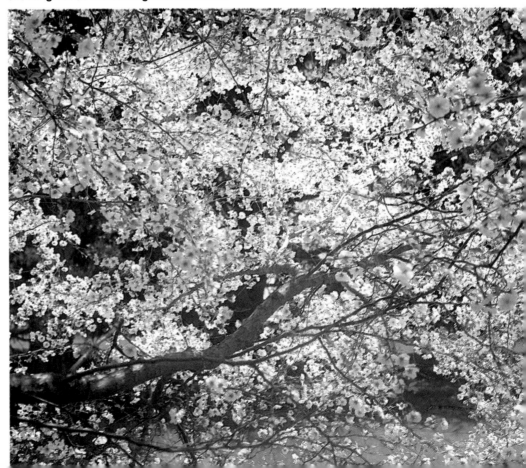

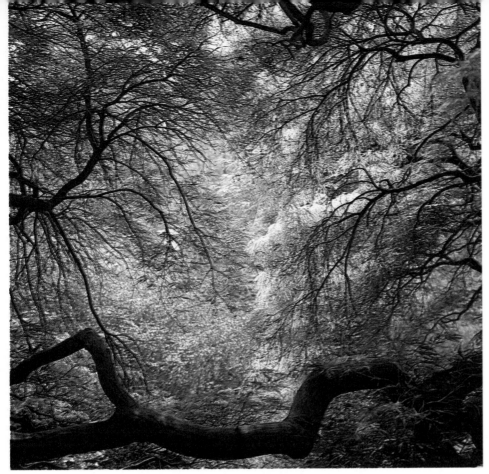

This is not a fall scene, but the fresh spring foliage of thread-leaf Japanese maples, the delicate multi-colored drapery of leaves contrasting beautifully with the twisting, spreading branches. The leaves are backlighted, and I exposed a stop lower than the meter reading to obtain better rendition of the branches.

canopy to discover a delightful composition of twisted branches and backlighted leaves.

Age is also an important quality to look for. Bristlecone pines in the White Mountains of California are the world's oldest living objects, some of them more than 8,000 years old. They are twisted into beautiful shapes by the arid climate of the region. You don't have to journey to remote areas to record the artistic beauty of old trees. During a walk through an arboretum in Lima, Pennsylvania, I found an old osage orange tree toppled by a hurricane in 1955. The once noble giant still presented a majestic sight, lying on its side in a glade, with its gnarled and textured trunk creating a startling contrast against the fresh living greenery of younger trees and spring wildflowers.

You will find these pictures wherever there are trees, whether they are dead or alive, and during all seasons of the year. Their beauty changes from minute to minute with the light and the moods of nature. You can never take a picture of a tree and be done with it—its capacity to charm the eye is endless. You will find these pictures everywhere—from mountain tops to city streets, in far away places and in your backyard. You are limited only by your own abilities to perceive and photograph it.

Specimen shots—These should be clinical in appearance, preferably showing a single tree, lit from the front, against a clear blue sky on a green lawn, or in front of a typical suburban house with no distracting elements such as children's playthings or telephone wires in the background.

Your picture should show a definite shape—all trees have an outline as distinguishing as a fingerprint—and if the tree has other special qualities that aid identification from a distance, these should also be included. For example, in the case of the burning bush, *Euonymus alata*, the plant should be shown in fall color. A horsechestnut tree, which produces large flower clusters called candles, should be shown in full bloom.

You will find the best specimens around suburban homes, arboretums, farms, parks and golf courses. But before scouting for trees and wasting film on imperfect specimens, buy a pocket-size tree identification book, such as the *Golden Series* (Western Publishing), so you can learn the distinguishing features of each tree.

Close-ups—Many trees have qualities that can be admired only in close-ups, such as the peeling bark of a eucalyptus, the delicate blossoms of a flowering cherry, the spiny nut cases of a sweet chestnut, the colorful fruit of a crabapple, the shiny smooth seed pods of a catalpa tree, the intricate leaf shape of a threadleaf maple, or some other distinctive plant part.

Publishers often use specimen shots and close-ups in combination, the specimen shot as a dominating illustration and the close-up as a circular inset.

FLOWERING TREES

The beauty of flowering trees is usually fleeting. Although flowers may appear on a tree for up to ten days, there is a peak period of bloom generally lasting only a day or two. The secret of really spectacular flowering tree pictures is to make the photo at the precise moment of peak bloom. Many times I have discovered a magnificent flowering tree just past its best. I make a note of its location and blooming time, and return another year to capture it at the right moment.

Some flowering trees also produce ornamental berries in fall, so two sets of pictures are often needed to show a tree's dual per-

sonality with specimen shots to show the overall appearance and close-ups with specific detail.

Following is a list of what I consider the ten most photogenic flowering trees:

Crabapples—There are pink and white flowering kinds, also single- and double-flowered, and weeping forms. The most popular pictures are of the hopa flowering crabapple, *Malus* Hopa, bearing bright pink flowers in spring and small red fruits in fall; the radiant flowering crabapple, *Malus* radiant, bearing rosy red flowers in spring and bright red fruits in fall; and the *Malus* Snowcloud, bearing double white flowers. Photograph them as a lawn highlight, preferably with a suburban home in the background.

Dogwood, *Cornus florida*—There are pink, red and white flowering dogwoods, all producing their flowers in spring. The best photos are of the tree in full flower on a green lawn with an attractive suburban home in the background. Dogwoods also produce pretty fall colors, with bright red berries attractive to birds.

Cherries—Both the Kwanzan cherry, *Prunus serrulata* kwanzan, a double-flowered pink, and the Weeping Japanese cherry, *Prunus subhirtella pendula*, with dainty semi-double pink flowers, are best photographed in early spring on green lawns, with blue sky to emphasize the delicate pink flower coloring. The Kwanzan cherry grows to a spectacular size. I have found the best specimens in open parks.

Golden Chain Tree, *Laburnum vossi*—Produces beautiful golden yellow pendant flowers in May. It is often seen as a lawn highlight, but sometimes is trained over an arbor to form a tunnel of golden yellow blossoms.

Magnolias—Magnolia soulangiana is the most popular and grows into a towering tree. Also, there is a smaller-flowered version, called the Star Magnolia. The Southern Magnolia has very large

Even in death, old trees make beautiful subjects. This ancient osage orange tree came down in a hurricane, and I was struck by the contrast between the gnarled, decaying trunk and the living greenery surrounding it. The *Philadelphia Bulletin* published this in their Sunday supplement to illustrate an article about Pennsylvania trees.

flowers, glossy evergreen foliage and highly ornamental seed pods, and is normally planted against the wall of a house. In addition to a specimen growing this way, you should shoot close-ups of its enormous flowers and seed pods in the act of opening.

Red Bud Tree, *Cercis canadensis*—Good specimens are hard to find because the branches are brittle and they need careful pruning, but they are a popular flowering tree, covering themselves with rosy pea-shaped flowers in spring. They are used mostly as a lawn centerpiece showing a typical tree shape, with straight trunk and spreading branches; but most often you will encounter them as an untidy mass of branches sprouting near the ground, so be highly selective before wasting film on such poor specimens.

Wisteria, *Wisteria sinensis*—Grown mostly as a flowering vine to cover walls and trellis. There are basically two colors—the blue and white. However, the most popular photos feature them as tree forms, showing the plant in full flower on a straight trunk. They bloom in spring when you should also take close-ups of the flower panicles.

Dove Tree, *Davidia involucata*—Sometimes called the Pocket Handkerchief Tree because the flowers resemble white handkerchiefs, this tree is not common, but it has a romantic history involving plant exploration in China. It is constantly appearing on "want" lists from publishers. The best place to locate a good specimen is in an arboretum. Try to obtain a shot of an entire tree in full bloom, but you also will need close-ups of the flowers which appear in spring.

Fringe Tree, *Chionanthus virginicus*—Flowers in May and June with masses of white, frothy

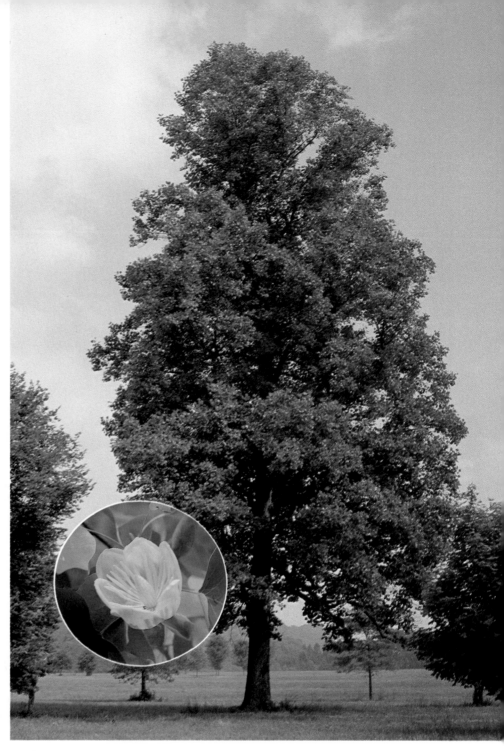

Top: Here's a cut-leaf weeping birch tree pictured as a specimen, on a green lawn, with blue sky as the background. The photograph was taken on the fairway at Hershey Golf Club in Pennsylvania.

Above: This is a franklinia blossom in close-up. The flowers appear in mid-summer and resemble camellias which bloom in spring. The tree is now extinct in the wild, and can only be found in arboretums.

Right: This composite picture illustrates the use of an *inset*. The large picture shows a tulip tree, while the inset shows a clear close-up of its beautiful flower, which cannot be appreciated from a distance.

flowers. Perfect specimens are usually found as young trees, with the tree itself presenting an oval shape. Because the flowers are so bright, the best background is a tall hedge or planting of green trees.

Scarlet Hawthorn, *Crataegus oxycantha*—Resembles a flowering crabapple, with fragrant, rosy-red flowers. Best photographed as a lawn highlight, with a straight trunk and a dense canopy of

flowers which appear in spring, followed by dark red fruits in fall.

SHADE TREES

Although flowering trees are more colorful when photographed at the height of their blooming period, don't overlook the value of trees grown to provide shade during summer. These are normally tall with a distinctive shape and a lush canopy of leaves. Some have decorative flowers or colorful

fall foliage; these special features often dictate the best time of year to capture them on film.

While artistic compositions and close-ups are interesting, don't overlook specimen pictures showing a single tree against a plain, contrasting background.

Following is a list of America's ten most popular shade trees:

Black Walnut, *Juglans nigra*—Grown extensively as a shade tree because of its valuable hard wood. It is one of the last trees to leaf out in spring, and the first to drop its leaves in fall. Shoot specimen shots of a lone tree in midsummer because it has no fall coloring. Also, take close-ups of its catkins in spring and its green nut clusters in late summer.

Clump Birch, *Betula verrucosa*—Graceful trees with slender trunks and silver bark, with several trunks growing together in a clump. These are used most often beside a lake or stream and as a lawn centerpiece, so shoot your pictures showing water or with an attractive suburban house in the background, in late spring and mid-summer when the green leaf coloring is at its best.

Ginkgo, *Ginkgo biloba*—I find educational publishers request this tree a lot because it dates back to prehistoric times and is famous as a "fossil tree." Leaves are golden yellow in fall, so shoot it two ways as a specimen—in spring or summer colors and fall. Also take close-ups of its distinctive fan-shaped leaves in fall coloring.

Lombardy Poplar, *Populus nigra*—Often used to line property or along both sides of a driveway. Your pictures should show a line of these trees, all the same height, photographed in mid-summer when the foliage is fully mature.

Mountain Ash, *Sorbus aucuparia*—Produces beautiful orange-red berry clusters in late summer and early fall. Pictures should show a perfectly shaped tree with both berries and green leaves. Mountain ash trees are highly susceptible to premature leaf drop,

This pink dogwood features sweeping branches and triangular shape, and is located in front of a suburban home.

Here's a superb specimen of mountain ash shade tree displaying its distinctive pyramid shape and beautiful berry clusters. It also combines several other factors desired by nursery catalog houses—a suburban house in the background, a clear blue sky and no distracting power lines.

Top: This forsythia bush is shown as a lawn centerpiece with a typical suburban house in the background. Perfectly symmetrical shape and even lighting with lots of modeling in the flowers make this an exceptional specimen picture.

Above: Bordering my garden, this rose hedge, Robin Hood, is part of an 80-foot-long planting. Hedges are best photographed at an angle; the longer the length you can show, the more impressive your picture will be.

leaving a bare tree with only berries, and this is not a desirable picture. Also take close-ups of both red and yellow berry clusters.

Pin Oak, *Quercus palustris*—Has a distinctive pyramid shape. Leaves turn a rich brown in fall, staying on the tree all through winter. Shoot two pictures—one in spring

with green leaves, and another of the same tree in fall with brown leaves. Also take close-ups of its acorns.

Royal Paulownia, *Paulownia imperialis*—Fastest-growing shade tree for most areas of the United States, although not reliably hardy north of New York City. Covers itself in magnificent blue flowers in spring before its leaves appear, so your pictures should show a mature lone tree in full flower. In winter the sweeping branches and dried fruit clusters can look beautiful when photographed in silhouette against snow or winter sunsets. These flowers are subject to the ageratum effect.

Sugar Maple, *Acer saccharum*—One of the most beautiful trees for fall color, so shoot the tree two ways—in spring with green leaves and in fall with its golden coloring. Other kinds of maples are Norway, Japanese, Silver and Crimson. Maples produce attractive flower clusters in spring, followed by conspicuous winged seeds which look good in close-ups.

Tulip Poplar, *Liriodendron tulipifera*—One of America's tallest deciduous trees, producing a remarkably straight trunk, beautiful golden yellow flowers the size of teacups, and magnificent butter-yellow leaf coloring in fall. Shoot it two ways—in spring with the flowers in full bloom, and again in fall when the leaves change color. Also take close-ups of the flowers in spring and fruit clusters in fall.

Weeping Willow, *Salix babylonica*—Prefers moist places; thus, your pictures should show it growing beside a pond or stream in mid-summer when the foliage is at its best. There is also a corkscrew form of willow with twisted branches that stand erect. Make specimen pictures of this variety and close-ups of its unusual twisting effect.

ORNAMENTAL SHRUBS

I am often asked the distinction between a shrub and a tree, and

was surprised to discover that in horticultural circles there is a fairly clear-cut definition. A shrub becomes a tree when it grows 20 feet high. Any woody plant that tends to stay under 20 feet is normally classified as a shrub. If it is capable of growing more than 20 feet tall, it is considered a tree.

When referring to trees, we tend to talk about flowering trees and shade trees, to make a distinction between those grown for their foliage cover or ornamental flowers. Horticulturists generally make no such distinction with shrubs, and refer to all of them as ornamental, whether we grow them for their leaves or their flowers.

In my experience of supplying nurserymen and book publishers with thousands of shrub pictures, the following ten shrubs are in greatest demand:

Beauty Bush, *Kolkwitzia amabilis*—Well-grown specimens almost smother themselves in masses of pink, bell-shaped flowers. It is usually planted against a wall or in a shrub border with other plants, but the best pictures are of single specimens as a lawn highlight.

Burning Bush, *Euonymus alata*—The leaves of this compact shrub turn brilliant red in fall, especially after a frost. In addition to being a lawn highlight, the plant is often used as a continuous hedge. Both types of picture are popular.

Deutzia—There are several forms of this compact, spring-flowering shrub, mostly in pink and white. In biggest demand are the pink form, *Deutzia gracilis* Rosea, and the white form, *Deutzia magnifica*. Both are best shown as specimens in foundation plantings or as lawn highlights.

Firethorn, *Pyracantha coccinea*—Grown for its brilliantly colored berries in fall. There are three basic colors—orange, red and yellow. They are grown as a hedge or trained up the side of a house. Because the flowers which appear in spring are highly ornamental,

pictures of the plant in flower are also desirable.

Forsythia, *Forsythia intermedia*—Although there are different forms of forsythia—upright and weeping, for example—they are all shades of golden yellow. The best pictures show every branch crowded with flowers, before any leaf coloring appears to compete with the floral display, with a house or garden feature in the background.

Hydrangea, *Hydrangea macrophylla*—Massive, ball-shaped blooms are pink, white or blue, although alkaline soil turns blue hygrangeas pink. Hydrangeas are usually incorporated into shrubbery plantings and are often seen as a hedge. Two kinds of hydrangea are *Hydrangea macrophylla*, blooming in midsummer, and *Hydrangea paniculata*, growing large white flowers in late summer and turning bronze by fall. The former are excellent for patio decoration, and in tubs and other large containers; these uses make the best photographs. The latter grows into tall shrubs, and is best photographed as a tree specimen, showing a straight trunk and a canopy of flowers on top.

Japanese Andromeda, *Pieris japonica*—Produces beautiful white blossoms in spring, resembling lily-of-the-valley flowers. It is usually planted as an ornamental foundation shrub right up against the house, and this is how people like to see them in pictures.

Lilacs, *Syringa vulgaris*—Flower colors include pink, white, red and blue, with single and double flowers. All are delightfully fragrant, and several kinds of pictures are popular, including specimen shots of the shrubs alone, covered in flowers; close-ups of flower clusters; and a mixture of different colors, showing the complete color range.

Pink Flowering Almond, *Prunus glandulosa Rosea*—One of the first shrubs to bloom in spring, this produces dainty pink flowers on a cluster of branches growing close

Paper birch, *Betula papyrifera,* has decorative white bark that peels off in wide strips. American Indians used to stretch the bark over frames to make canoes.

to the ground. It is usually planted as a lawn centerpiece or as part of a shrub border, and is best photographed close to the house, at the entrance to a doorway.

Smoke Tree, *Cotinus coggygria*—There are white, pink and purple flowering forms of this highly decorative plant. However, the branches are brittle, and it's extremely difficult to find a specimen with a perfect oval shape, billowing with flowers. Usually, you will find a plant damaged by the wind, with distracting gaps among the flowering stems, so be highly selective before wasting film on imperfect specimens.

HEDGES

This is how I prefer to photograph hedges:

Arborvitae hedge—showing tall height pruned or unpruned.

Blueberry hedge—unpruned, showing branches loaded with fruit.

Bridal wreath—in full flower unpruned.

Hemlock hedge—showing thick evergreen branches either pruned or unpruned.

Holly—pruned to a box shape and showing red berries.

Multiflora rose hedge—covered in flowers, unpruned.

Skimmia japonica, a low-growing ornamental shrub, displays beautiful berries in fall. The arrangement of leaves and berries here forms an attractive pattern.

Brilliant berries of *Viburnum dilatatum* grow in large clusters. The shrub is known as linden viburnum because its leaves resemble those of a linden tree.

Nanking cherry hedge—in flower and in fruit, pruned to compact size.

Red leaf barberry—pruned to a box shape.

Robin Hood rose hedge—in full flower, unpruned.

Russian olive—pruned to a compact shape.

TREES WITH UNUSUAL BARK & BRANCHES

Ornamental trees with unusual bark and branches are grown principally to add color to winter landscapes—and they are scarce. If you can build up even a small collection of these, you will be justly proud of it. *Acer griseum,* for example, is an Oriental maple with orange-red bark that peels and flakes, and makes beautiful close-ups. Buttonwood trees have bold patches of white, pale green and gray; the bigger the tree the more dramatic the color scheme. Paper birch has contrasting rings of charcoal gray and white bark. *Cornus alba atrosanguinea,* a dogwood, has bright red branches which look

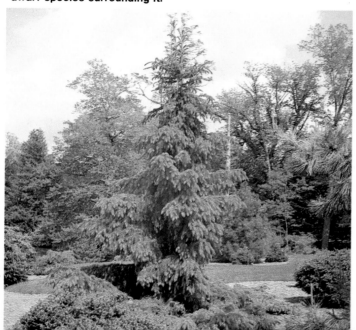

A Serbian spruce dominates the landscape in this garden of coniferous evergreens, its tall spire contrasting effectively with the dwarf species surrounding it.

Mediterranean cypress trees, towering above the landscape at Hearst Castle in San Simeon, California, are an important feature of this Italian-style garden. It took some searching to find a vantage point where other important elements of the garden—the marble balconies and bronze sculptures—could be included in the view.

The appearance of age is extremely important when seeking good bonsai subjects to photograph. This juniper is over 400 years old. Because bonsai is an ancient Oriental art form, the bamboo matting makes an appropriate background.

Cones, the seed bearing parts of evergreen coniferous trees, appear in fall and should not be overlooked by the plant photographer. These belong to the Norway spruce, the familiar Christmas tree.

their finest when photographed against snow. *Salix vitellina britzensis*, a willow, also has bright scarlet shoots to form a striking contrast in the winter garden. *Corylus avellana contorta*, a hazelnut, has strangely twisted branches which look like coiled snakes when photographed in close-up, and is an interesting oddity in the winter garden when the twisted form can be best appreciated.

BERRY TREES

Trees and shrubs with beautiful berries are another delightful subject for a photographic collection.

The berry clusters of mountain ash are so brilliant, they can be seen from a great distance and will show up well, even in specimen shots. Other berry trees have to be photographed in close-up to be really appreciated, including the hollies, cotoneaster, bittersweet, crabapples, firethorn, beautyberry and American cranberry. Blue sky complements most close-ups.

Certain kinds of seed pods are also good to include in your berry collection. Take group close-ups of locust beans and Southern magnolia seed clusters which have bright red seeds.

Occasionally, I receive requests for pictures of berry-bearing and seed-bearing shrubs attractive to birds. Barberry, dogwood and hawthorn are the best of these.

EVERGREENS

Although deciduous trees drop their leaves in the fall, evergreens stay green all winter. There are two groups—the broadleaf evergreens, such as rhododendrons, and the needle evergreens, such as pine trees. The needle evergreens in particular offer some exciting possibilities for odd and interesting pictures. Pines, for example, have exotic yellow catkin-like flowers that are captivating in their intricate design. The cones of many evergreens are equally decorative, making beautiful close-up pictures when photographed on the tree. Once you start paying attention to pine cones, you'll find them fascinating in their different shapes and colors—some short and fat, others long and slender, in colors ranging from silver to blue.

A thick carpet of beech leaves covers the forest floor around an upturned tree stump, visually telling the story of fall, a season of beauty and decay.

Oak leaves backlighted by the afternoon sun glow like lanterns in Independence Hall Historic Park, Philadelphia.

There is also tremendous variation in the shape and size of evergreens, adding infinite interest to a collection. Incense cedars are tall and columnar, magnificent to show as a grove. Horizontal junipers are low-growing and creep to form an attractive ground cover. Hemlocks have fine feathery foliage, making the most beautiful of all dense hedges. Golden arborvitae gleams yellow and looks terrific in a rockery. Blue spruce shows up well as a lawn centerpiece.

Cedar of Lebanon and white pines are a delight to discover, especially when they are mature specimens with long, low-growing branches sweeping out 20 feet or more. Step inside the perimeter of spreading branches and see what lovely garden scenes you can frame with the branches and pine needles silhouetted in the foreground.

Even though evergreens are not very colorful, you will often find that their size, shape or form are the most important feature of a landscape or garden. For example, while touring the Monterey Peninsula in California, I found many picturesque coastal scenes where the headlands were covered with beautiful Monterey pines spreading their branches over the clifftops, with some of the older trees stripped of their leaves by wind and salt spray, and sculptured into bizarre shapes. Although the Monterey pine has become a very popular tree for gardens, it is native only to the storm-swept clifftops of Point Lobos on the Monterey Peninsula.

South of Monterey, at San Simeon, I visited the Hearst Castle, where newspaper baron Randolph Hearst built a palatial home and garden on a mountain top. Here, towering specimens of Mediterranean cypress are a prominent feature. I was also impressed with the fine bronze sculptures and marble balconies. After careful searching for the right camera angle, I finally worked them all into a composition which to me portrayed perfectly the grandeur and Italian influence of this fine garden.

BONSAI

A good bonsai specimen is one of the finest subjects a plant photographer could wish for. Pose bonsais in a garden against a beautiful lawn, rockery, waterfall or statuary, and photograph them under various light conditions. Morning mist and a setting sun can create an exquisite atmosphere. Indoors you can experiment to your heart's content. Stage them against wild paintings of pounding seas, mountain wilderness and Japanese prints.

A woodland garden, brilliant with fall color from deciduous trees, contrasts with evergreen shrubs and groundcovers. The rustic bird house provides an appealing focal point and sense of scale.

This coconut sprouting on a deserted beach illustrates the dispersal system of the coconut palm. The nut had rooted in a clump of seaweed which I removed to show the root system.

Create your own morning mist with an incense burner or cigar smoke, and compose snowscapes with white detergent flakes. Of course, many specimens of bonsai are so lovely they look terrific simply posed against a plain background or bamboo screen. This way the whole focus of attention is directed at the exquisite features of bark texture, branch shape and leaf patterns.

FALL FOLIAGE

To build an impressive collection of fall scenes, consider some of these compositions.

To make a collection of leaf colors and leaf shapes, go into a wooded area such as a state park and gather as many different leaves as possible—red maple, bronze oak, yellow tulip poplar, golden hickory and whatever else you find. Arrange them on a suitable background. I have sold this type of picture several times to encyclopedias and children's book publishers.

Look for a grove or an avenue of trees all the same kind, and photograph them backlighted by the sun. The symmetry of their trunks, their branch patterns and the similarity in leaf coloring can present a pleasingly uniform picture. My personal favorites include a hillside covered with aspens, their silver trunks and golden leaf coloring gleaming in the sun; a grove of tulip poplar trees, with trunks so straight they look like a forest of ship's masts; a long avenue of osage orange trees, their heavily textured trunks and tangle of overhead branches creating a sinister effect.

Large, unblemished leaves backlighted by the sun can be effective in both spring and fall. A personal favorite is a branch of pin oak leaves in Philadelphia at Independence Historic Park. I later sold it to the *Philadelphia Bulletin* for an article on Pennsylvania trees.

Be alert for patterns formed by fallen leaves, especially those floating on a lake or pond, or simply covering the forest floor. One of my favorite compositions shows a thick carpet of oak and linden leaves surrounding a gnarled tree root, graphically displaying the story of fall—a season of beauty, age and decay.

Fall landscapes and garden pictures should include an interesting focal point—a gate, bridge or frog pond, for example. My most widely published fall picture shows a peaceful glade in a wooded setting, with a rustic bird house to add interest and a sense of scale.

Brilliant fall colors depend on two factors—deciduous trees which lose their leaves in the winter, and areas with frost. In the

Banyan trees can reach amazing dimensions. A type of rubber tree, they form brace roots along the branches to support their incredible weight. National Geographic Society used this picture for one of their books on natural wonders of the world, *Far-Out Facts*.

a temple ruin with philodendron vines growing from its crevices, a beach fringed with coconut palms or an immense rubber tree overlooking a harbor. By seeking out these scenic views, you'll often discover that you not only have a fine botanical illustration, but a top-notch travel picture also.

During a visit to the Bahama Out-Islands, I stumbled across a coconut sprouted in a clump of seaweed after being washed ashore on a deserted beach. I carefully removed the seaweed to expose the roots of the coconut, and took a picture of it exactly where I found it, with the beautiful curving beach in the background. The picture not only conveys the seclusion of that beach as I fondly remember it, but it has been used several times by educational publishers because it shows how the nut sprouts on sandy beaches after floating on the ocean.

I also look for pictures of tropical crops of economic importance to man, such as a banana plantation, tea plants growing on a mountain slope, breadfruit, sugarcane, pineapples, orange groves, sisal and quinine trees. These are in constant demand by publishers of encyclopedias and educational books.

Some tropical trees reach incredible sizes. Banyan, a type of rubber tree, can reach incredible proportions and, in order to support the enormous weight of their spreading branches, they grow brace roots. I found a particularly fine specimen in the Marie Selby Botanical Garden in Sarasota, Florida.

Pictures of the coco de mer, a type of coconut which grows the world's largest seed, and the rafflesia, the world's largest flower, are sought after. The coco de mer grows only in the remote Seychelles Islands, while rafflesia hides out in the jungles of Malaya and Borneo! Ah, well, you can't expect to have everything in your plant collection—but it's something to aspire to.

northeast sections of the United States, maples provide the best fall coloring; in the West it is mainly aspens. Generally speaking, the further north you travel, the more intense the fall colors will be. But if you go too far north, you reach the evergreen belt, with few deciduous trees to provide fall colors. Vermont and New Hampshire are famous for their fall scenes, not only because of the intensity of fall coloring, but also

the charming villages, churches and farms tucked away in picturesque valleys.

TROPICAL TREES & PLANTS

When visiting tropical areas of the world, be alert for exotic tree specimens such as swaying palm trees, gigantic rubber trees and rambling vines that are part of a lush landscape. For example, you might find a grove of bamboo with a volcano cone in the background,

6
Wildflowers & Wayside Plants

Dandelions are among the most prolific weeds in lawns and gardens, but in spring the fluffy white seed heads, called clocks, are beautiful in open meadows.

Wildflower photography requires more patience and ingenuity than any other form of plant photography. It took me several years to develop the necessary understanding and techniques for satisfactory results. For me, this is the most exciting and aesthetically rewarding part of plant photography.

Many kinds of wildflowers are not showy or spectacular as single specimens except in extreme close-ups. Their beauty is appreciated best as part of an overall setting in which definite patterns, textures and natural configurations are important.

The objective in wildflower photography is to *keep it natural*

because your best pictures will be those not only showing the color, shape and form of the flowers, but also the environment in which they grow.

For example, if you were to find an interesting group of Jack-in-the-pulpit growing in a moist wooded area near a stream, you might photograph it so the stream

sparkles in the background, or shoot in the early morning when the diffused light and background greenery suggest a cool, shaded environment. It would not be appropriate to photograph it against a clear blue sky because Jack-in-the-pulpit is a shade-loving plant, preferring the cool forest floor of early spring.

Queen Anne's lace, on the other hand, is a tall meadow plant that blooms in the height of summer. It looks majestic photographed from below, its umbels of dainty white flowers contrasting with the clear blue sky. This shows it as a lover of sun and open space.

Spring is usually the busiest time for wildflower photography because many of the most photogenic wildflowers will grow, flower, store food and produce seeds even before the trees are in full leaf.

As spring rolls into summer, all kinds of beautiful wayside and meadow flowers compete for attention, such as the delicate blue flowers of wild chicory, the bold yellow of black-eyed Susan, pink bee-balm and fiery orange butterfly weed.

In late fall, a multitude of wild berries, fruit and leaf formations with bold colors takes over as the center of attention—winterberries, bittersweet, poke berries and milkweed pods thrusting their fluffy white seeds into the wind.

It's a good idea to classify your wildflower pictures according to different ecological areas. For example, I am often asked for pictures of Desert Wildflowers, Prairie Wildflowers, Alpine Wildflowers, Woodland Wildflowers and Wildflowers of the Arctic Tundra.

Fungus, wild mushrooms, toadstools, ferns, mosses and lichens are still another world of beauty for the wildflower photographer to explore. Nothing could be more symbolic of spring than baby fiddlehead ferns unfurling their tightly folded fronds as the sun penetrates the leafless trees to warm the forest floor.

You must not forget the weird and wonderful world of weeds. I don't believe anyone has properly defined a weed. It has been described as a plant that man has not yet found a use for, but that's not accurate. Dandelions are considered noxious weeds, yet their flowers can provide man with wine, their young leaves can make an early spring salad and the root is used for medicinal purposes. For the wildflower photographer, dandelions are a delight. In spring the bright yellow flowers make beautiful pictures, especially in wide masses and vigorous clumps. They are lovely in well-composed close-ups.

For most wildflowers, a good close-up lens is essential, and even that is sometimes inadequate for the most effective close-ups of the smaller ones. When you need to get really close, as you will with the smaller-flowering varieties such as arbutus and wild ginger, you step into the realm of photomacrography. Then extension tubes and bellows take over as the best close-up accessories.

Because many of the most interesting wildflowers grow in deep shade, you will find that a

When photographing masses of wildflowers, you should show part of the environment in which they grow. Here are two examples. Black-eyed Susans, left, are a common wayside flower preferring open meadows. I spotted this field of them growing between a busy highway and a railroad track. Careful framing makes it appear as though they are a long way from civilization. At right, wild mountain pinks growing on a cliff face suggest an alpine environment. To gain this angle, I had to balance precariously at the edge of a 350-foot sheer drop, with only one foot on a secure spot.

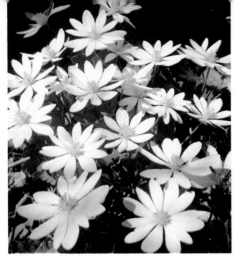

This shot of bloodroot flowers, their sparkling white faces contrasting perfectly with the dark brown leaf cover of a forest floor, was used by *Plants Alive* magazine for an article on wildflowers.

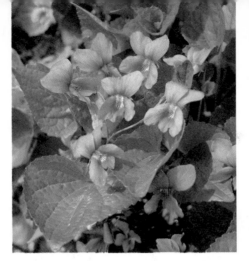

This picture of a beautiful cluster of common violet flowers, all on the same plane, was used by *Flower & Garden* magazine.

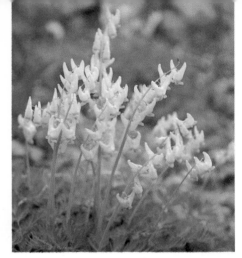

Dutchman's breeches normally grow two flower spikes. This highly unusual cluster features more than ten. It was published by *Woman's Day* magazine.

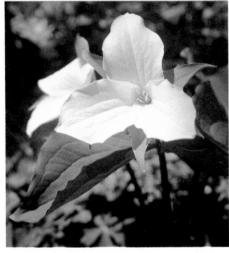

This shot of giant trillium, its three-petaled white flowers contrasting effectively with the dark brown leaf cover of the forest floor, is probably my most widely published wildflower picture.

Jack-in-the-pulpit fruit is one of the most intense natural reds you can find. This cluster of berries had a shaft of light falling on it which brightened the fruit. The dark forest floor formed a perfect background.

Wild orchids are a thrill to discover, and a pure pleasure to photograph. This is yellow ladyslipper.

cable release and sturdy tripod are essential. You should also make sure that your tripod can be used to position the camera at ground level—many can't.

Finding wildflowers is another problem. Vast areas of woodland and meadowland are disappearing. Many public and private gardens have wildflower areas with good selections. There are many parks with nature trails, and even a few wildflower preserves such as the Bowman's Hill Wildflower Preserve near New Hope, Pennsylvania.

It's a mistake to believe that for spectacular wildflower scenes you have to travel to remote mountain meadows of the Rockies or deep into the forests of Appalachia. I once photographed a beautiful meadow of black-eyed Susans, *Rudbeckia hirta*, on the way home from the supermarket. They were sandwiched between a busy railroad track and a line of trees that screened out a housing development.

You may also want to consider making part of your own garden a wild garden, complete with pools, waterfalls and rustic bridge, planted with ostrich fern, trout lilies, giant trillium and other eye-catching wild plants. Check the classified sections of garden magazines for sources of seeds and plants.

SPRING FLOWERING WILDFLOWERS

Although there are wildflowers blooming at all times of the year—except the dead of winter—by far the most prolific time is spring. During the first week of May, I normally spend every day in a wildflower area capturing the fleeting beauty of the hundreds of different wildflowers that rush into bloom all at once.

Here is a "Top 10" selection of those I feel are most photogenic:

Some wildflowers are hard to find, such as these May apples, *Podophyllum peltatum*, which normally have a large umbrella-shaped leaf hiding them. A close-up lens brings out the exquisite beauty of these two flowers, both in sharp focus from being in the same plane, even though they are at different angles.

ground in April. Each plant has feathery foliage with an arching flower stem crowded with white pendant flowers resembling old fashioned Dutch breeches. A pink form, *Dicentra formosa*, grows in the West. You must get close to soil level to photograph them effectively.

Giant Trillium, *Trillium grandiflorum*—Three-petaled and white as snow, it is a curious sight on wooded slopes and ideal for your own garden. There is a rare double form which makes a magnificent close-up. The pink and red forms are fun to find and photograph.

Jack-in-the-Pulpit, *Arisaema triphyllum*—Shady stream banks and the edges of ponds are the places to search for Jack-in-the-pulpit. Backlighting highlights its extraordinary pulpit and distinctive pistil. Jack is one of the most miraculous flowers of the forest: All the young plants start off life as males, and after three years they literally change sex and become females. Fertilized females then produce clusters of bright red berries containing seed to multiply the species. In fall, the bright red berry clusters are a beautiful sight and make good color pictures.

Ladyslipper, *Cypripedium species*—The pink and yellow kinds grow in acid woods, puffing out beautiful orchid-like blooms in mid-May. They are now quite scarce in the wild. One of the most dramatic wildflower pictures shows a thick stand of ladyslipper orchids against pine needles or brown leaves.

Several Virginia bluebells flower clusters grouped together here form a colorful close-up.

These two wild columbine flowers presented themselves in the same plane.

Bloodroot, *Sanguinaria canadensis*—The anemone-like flowers are clear white with golden yellow stamens and burst into the world from an underground root which bleeds blood-red when cut. The rare double form is not as photogenic as the single-flowered type which often covers large areas of forest floor in late April. They photograph well in tight clusters, looking down on several to a dozen blooms contrasting with dark soil or brown leaves. Look for them in acid woods and hedgerows.

Common Violet, *Viola cucullata*—There are dozens of different wild violets in many colors, but the common blue violet is the most widely distributed, growing prolifically in open meadows and woodland, especially in moist places. I've photographed it effectively in close-ups.

Dutchman's Breeches, *Dicentra cucullaria*—These are an enchanting sight on sloping wooded

This moss lawn with wild Quaker-ladies naturalized in it is one of a group of pictures used by *Architectural Digest* to illustrate a wildflower garden located just a few miles from my house. After my feature appeared in the magazine, the owner was inundated with requests from greeting card companies wanting to use the garden for posing models.

I found this beautiful toadstool, *Collybia radicata*, deep in the forest, with its transluscent cap backlighted on top of a long slender stem, and a young oak sapling also brightly backlighted against the dark forest floor. Glare resulted from not using a lens hood, but adds a dramatic quality. This picture was used in the *Philadelphia Bulletin* Sunday supplement for an article on the Bowman's Hill Wildflower Preserve.

FUN WITH FUNGUS

Wild mushrooms, toadstools, mosses and lichens are yet another world of beauty for the plant photographer to explore. Someday someone may publish an authoritative book on fungus. So many books are full of errors from authors copying each other's mistakes that it has become difficult to identify them correctly. This is compounded by inadequate line drawings or photographs of old, disfigured plants which bear little resemblance to what you are most likely to find in the wild. Books on fungus even seem to disagree on whether a variety is poisonous or edible!

One interesting fungus photograph is the straightforward specimen shot, showing the fungus growing in its natural habitat. If it's a cluster, you may want to take close-ups of the whole cluster, and then take a closer shot showing a portion of it in greater detail. If the fungus is growing on a tree stump, try to show a portion of the stump.

For specimen shots of parasol-type mushrooms and toadstools, position one on its side with the underside of the parasol pointed toward the camera. The underside often has distinctive features such as gills or tubes which help to identify the variety.

You can have fun making special arrangements. Search for specimens of different kinds—red and green russulas, yellow cantharellus, puffballs and collybias—and at the same time gather lichens and various mosses, dried leaves, twisted branches and other natural props. Assemble them into an interesting composition, in a scene reminiscent of Walt Disney's film *Fantasia*. Toothpicks are invaluable in making these arrangements. By pressing a toothpick into the stem of the mushroom, you'll find you can place it in the ground exactly as you want it.

May Apple, *Podophyllum peltatum*—Early in the spring this prolific woodland wildflower bursts through the forest floor with a pair of leaves resembling green parasols. As soon as the leaves are unfurled, a beautiful large waxy flower appears, usually hidden by the leaves, followed by a bright yellow fruit. The plant is photogenic throughout its life, although my most satisfying pictures are close-ups of the flowers.

Quaker Ladies, *Houstonia caerulea*—These have dainty, pale blue flowers, and grow in large colonies in open meadows. Photograph them as close-ups and in landscape scenes showing a mass planting as the focal point.

Virginia Bluebells, *Mertensia virginica*—This plant covers the forest floor with clusters of blue bell-shaped flowers. Although landscape scenes of mass plantings in woodland settings can be incredibly beautiful, it also looks good in close-ups.

Wild Columbine, *Aquilegia canadensis*—The bright red flowers are tipped with yellow and seem to glow with an inner light when backlighted by the sun. They grow in thick clusters on moist, rocky slopes and are a familiar sight in wild gardens in early May.

This collection of toadstools is actually an arrangement I created by picking several kinds from woodlands adjoining my garden. I inserted toothpicks in the base of each and positioned them on the ground. Varieties include the red *Russula emetica,* yellow *Cantharellus aurantiacus,* puffball *Schlederma vulgara* and brown *Actarius deliciosus.*

I found this poisonous Jack-o-lantern toadstool, *Clitocybe illudens,* with its bright orange coloring, growing in my backyard on a decaying oak stump.

Saddle fungus, *Polyporus squamosus,* shows its beautiful freckled coloring against a contrasting black background. The surface of the fungus is perfectly exposed, but the deep shadows of the tree are out of the film's effective exposure range, helping to highlight the fungus.

This picture of shelf fungus growing on an old elm tree was purchased by a publisher of educational materials for schools, and was used on a poster.

Backlighting of mushrooms and toadstools can create beautiful pictures so unusual that it seems hard to believe they are not scenes from a distant planet. Mushrooms with long slender stems and gills, such as collybias, are especially good when backlighted. You can also experiment with diffused, misty morning light and the warm, red light of the setting sun.

Because most varieties of fungus are found in dense woods and inaccessible places, you may find it necessary to move them from those locations to a place where there is adequate light.

Be careful when moving mushrooms. Move them to an environment similar to their natural location. It would be wrong, for example, to photograph shade-loving cantharellus as though they were growing in an open lawn. Also, handle all mushrooms gently because they bruise very easily. Wash your hands thoroughly afterward to remove any poisonous juices.

A sturdy tripod and cable release are essential accessories for shooting fungus, just as they are for doing other forms of wildflower photography.

EDIBLE WAYSIDE PLANTS

It is extremely important to show the entire plant and a little background so the viewer can clearly identify the plant. A good close-up of the edible part is also essential.

POISONOUS PLANTS

Every year at least one publisher features a story about poisonous plants, particularly wayside plants attractive to children. To photograph poisonous plants effectively, show the entire plant and some of its surroundings so your picture can be used for identification purposes by people unfamiliar with the plant. Then take close-ups of the plant's most distinguishing features.

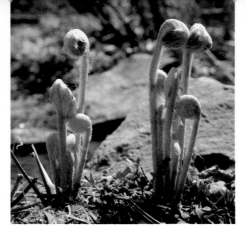

Here are two common edible wayside plants, photographed to provide easy identification.

Left: Wineberries, *Rubus phoenicolasius*, ripen in midsummer on brambles that grow along hedgerows. Originally from Japan, the plant is now widespread throughout the United States.

Right: Fiddlehead ferns, *Osmunda cinnamomea*, appear in early spring. They are young shoots of cinnamon ferns and grow in moist areas.

Here are two common poisonous wayside plants, photographed to provide easy identification.

Left: Jimson weed, *Datura stramonium*, has distinguishing features such as a spiny seed case and trumpet-shaped flower.

Right: Oleander, *Nerium oleander*, is a flowering shrub, found in frost-free areas of the United States. All parts are potentially dangerous—a single leaf can cause death.

Most Common Edible Wayside Plants		Most Common Poisonous Wayside Plants	
Amaranthus	leaves	Baneberry	berries
Burdock	leaves	Bittersweet	berries
Cat-tails	roots	Black locust	seeds
Curly dock	leaves	Bleeding heart	leaves, tubers
Dandelion	leaves	Bloodroot	roots
Fiddlehead ferns	young shoots	Boxwood	leaves
Lamb's quarters	leaves	Cherry, wild black	fruit
Milkweed	flowers and young pods	Daffodils	bulbs
Pokeweed	young shoots	Deadly nightshade	berries, leaves
Purslane	leaves	Death cap toadstools	all parts
Sorrel	leaves	Euonymus	leaves, fruit
Watercress	leaves	English ivy	leaves, fruit
Queen Anne's lace	flowers	Foxglove	leaves
Daylily	flowers	Glory lily	leaves
Ginseng	root	Hemlock	all parts
Wild lettuce	leaves	Holly	berries
Wild onion	bulbs	Hyacinth	bulbs
Wild strawberries	fruit	Jimson weed	all parts
Blackberries	fruit	Lily of the valley	leaves, flowers
Black raspberries	fruit	Lupine	leaves, pods, seeds
Wineberries	fruit	May apple	leaves, roots, stems
Beach plums	fruit	Mistletoe	berries
Wild cherry	fruit	Monkshood	leaves, roots, seeds
Wild cranberry	fruit	Mountain laurel	leaves
Wild blueberry	fruit	Oleander	all parts
Black walnut	nut	Pokeweed	berries
Butternut	nut	Poison ivy	all parts
Mulberry	fruit	Privet	leaves
Rose hips	fruit	Ricinus	seeds
		Yew	berries

7
Landscapes & Scenic Views

There is a big difference between photographing gardens and doing landscapes or scenic views. In my experience, most gardens are intimate, enclosed places, bordered by hedges, walls or tall trees. The point of focus is usually a garden feature such as a bridge, gazebo, brilliant clump of flowers or a prominent tree. Only in the most spacious gardens do I find myself focusing the camera lens at infinity. Normally, focus is on a prominent foreground feature or a middle-ground highlight, with the background in soft focus.

When I became interested in plant photography, I became very close-up conscious. Everything I shot was in close-up, and for a time I became almost blind to the "big picture"—the landscape or scenic view. As you widen your horizons in search of beautiful plants to photograph, you will find some outstanding scenic views and landscapes that can be a source of potential income if you are interested in selling your work. At the very least, they will provide you with endless pleasure simply as reminders of beauty you have seen and admired.

To me, landscapes and scenics are vistas. They can be wild and desolate like a desert landscape, or busy and colorful like a forested mountain range. More often than not, you focus the lens at infinity so everything in the distance is clear and sharp.

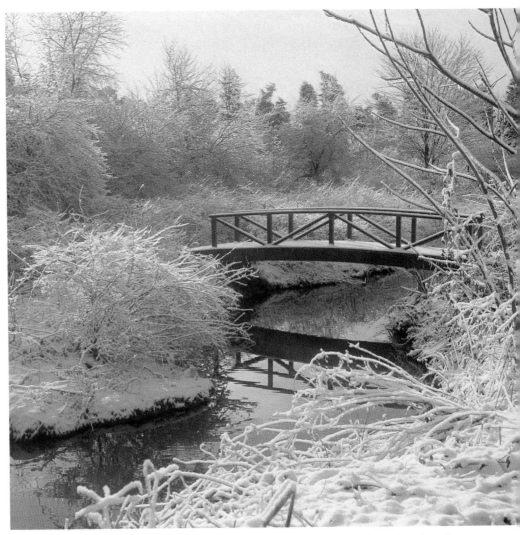

This bridge on my property is framed by the sparkling monotone colors of an ice storm, mellowed by early morning sunlight. I waited almost an hour for the ice to sparkle in the advancing sunlight. I sold this picture as a Christmas card to a greeting card company.

The best landscapes express a mood and project some atmosphere of the location. For example, a lake photographed in the early morning with mist rising from its water; a seascape of cliffs and rocks silhouetted against a glowing sunset; ground fog swirling around the base of a monument; a meadow of wildflowers basking in brilliant sunlight.

The biggest problem with photographing landscapes is capturing them on film as you see them. A view of a magnificent mountain can literally take your breath away, but on film the scene may look disappointingly flat, with too much earth and sky and very little mountain. Generally, there has to be more than just a beautiful view. Some factors influencing a landscape scene are often beyond your control, such as billowing cloud formations, a glowing sunset, a mirror-smooth lake surface creating a certain type of reflection, a snow sky, a full moon. Often you must make a mental note of the scene and return to the spot when a change occurs in the weather. You must be able to sense the development of an atmospheric condition before it actually occurs.

One winter morning I woke before dawn to discover there had been an ice storm. I went outside into the garden with my camera and stalked the property, sensing a good picture. Even before the sun came up, I found that picture in an arched bridge crossing a stream to a wild area where lots of brambles and shrubby branches were laden with ice. I waited. As the sun climbed higher, the ice sparkled, and the picture improved with every passing minute, until finally I considered the lighting perfect. Thirty minutes later the beauty was gone. As the sun rose higher, the lighting became too harsh and the ice melted away.

Quite often a good scenic view can be improved with a simple foreground feature to help frame your subject, even though that object, such as the sweeping branches of a tree or a prominent rock formation, is out of focus. Lacking this, some elevation may improve the shot.

Whenever I visit a scenic area, such as a famous seashore, a national park or a resort, I scan the postcard racks and guide books to see how others have photographed a particular view. I challenge myself to try and improve on those scenes. Then I have a point of reference; if I can't compose a better shot, I already know how a similar angle looks.

If visiting a seashore, include some ocean in your composition. Scenes of clifftops, sand dunes, rock formations, beaches and headlands look better when a corner of blue ocean projects into the picture—no matter how small that patch of blue seawater may be.

Two photo features I enjoyed shooting had lots of landscapes and scenic views. Both were coastal locations, but at opposite ends of the earth—the North

I was the first photographer to publish a pictorial feature about the North Cornwall Coastal Footpath. I was impressed with the incredible profusion of wildflowers growing in such close proximity to the sea, and tried to capture this characteristic in general scenic views. This one shows clumps of wildflowers against a background of rugged headlands, conveying a feeling of rugged splendor for which this area is noted.

Cushions of sea pinks grow precariously along the clifftops. Nothing was more dramatic than the delicate wildflowers contrasting with the rugged cliffs. I photographed every kind of wildflower colony I could find in order to portray the floral beauty of the coastal footpath.

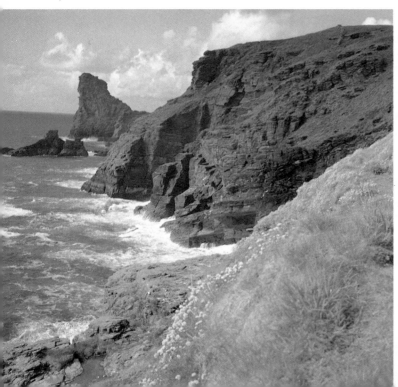

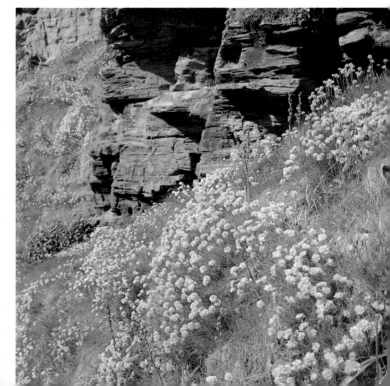

This stand of purple foxgloves had established itself on an exposed headland, and presented me with another opportunity to portray wildflowers against a background of surf and cliffs.

Cornwall Coastal Footpath in England, and the Hanakapiai Trail, a coastal footpath on the precipitous Hawaiian island of Kauai—The Garden Island.

Yellow gorse, its flowers pervading the air with a fragrance similiar to coconut, grows at the very edge of the precipitous cliffs. In order to capture this composition of the unusual rock face and the clear blue water, I had to climb down to the clump of gorse. I felt more like a mountain climber than a plant photographer.

The fruit of the pandanus tree resembles a pineapple, and is one of the many unusual tropical plants growing along the Hawaiian footpath. To obtain this scenic view of the fruit in the foreground and the rugged coastline behind, I scrambled down a steep cliff face for the right elevation.

THE NORTH CORNWALL COASTAL FOOTPATH

In the southwest corner of England, the counties of Devon and Cornwall form a peninsula of rare scenic beauty dominated by high rugged cliffs, wide beaches and vast moorland. It is the least populated area of the country, with breathtaking sights of rocky headlands, vast seascapes, fern-covered glens and clifftop meadows where wildflowers thrive in such abundance it is claimed to be the richest wildflower region in the world. Wild primroses, fragrant bluebells, heath orchids, sea pinks, foxgloves, sedum, heather, gorse and countless other native British wildflower species flourish there from early spring to late autumn.

One of the most appealing features is a little-known 500-mile-long footpath that runs along the magnificent clifftops and shoreline for the majority of its length. It hugs a coast that is more spectacular than California's Big Sur or Arcadia National Park in Maine.

The most rugged and beautiful portion is a 150-mile stretch called the North Cornwall Coastal Footpath. It's possible to drive to portions of it for exploring a few miles of coastline at a stretch. Nowhere is it marred by any large city or town.

It was opened officially as a national park in 1973, and I was fortunate to be one of the first professional photographers to hike it, recording some of the magnificent scenery.

I have traveled to many wilderness sections of the United States and in Europe and Asia, but the sight of the wildflowers along the North Cornwall Coastal Footpath will remain one of my most exhilarating experiences. Thus, my photo feature concentrated on capturing their impressive beauty.

My North Cornwall Coastal Footpath feature was published in the April 1979 issue of *Horticulture* magazine, which used the photography in a rather unique manner. They supplied my color transparencies as "record shots" to a brilliant watercolor artist, George Ulrich, who transformed them into landscape paintings as though he himself were sitting on the clifftops painting the scenery. The watercolor renderings were truly spectacular, faithfully recording my photographic compositions. I could not have wished for a better use of the pictures. The best of these was a field of bright red corn poppies with a Tudor cottage in the background. I was delighted when the artist sent me the original.

At left is a field of red poppies with a Tudor cottage in the background. Although the footpath passes through small fishing villages and shore resorts, nowhere along its length is it marred by a large industrial city. Above is George Ulrich's watercolor rendering of that scene.

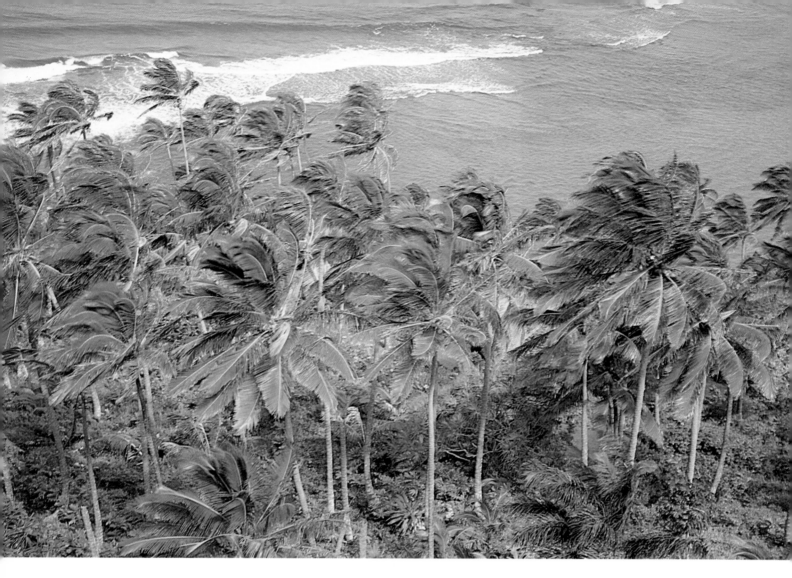

Looking down from the start of the coastal footpath on the island of Kauai, I spotted this grove of swaying coconut palms with the bright blue Pacific in the background. This combination of lush tropical plant growth and pounding surf symbolized Hawaii more than anything else I saw.

This grove of pandanus screw pines, or walking trees, is an eerie sight. The profusion of tropical plant growth is one of the wonders of Kauai, and nowhere is it more impressive than along the coastal footpath where only a young heart and a sure foot can travel in safety.

HANAKAPIAI TRAIL, HAWAII

Paradise is a greatly overused superlative among travel writers, but nowhere is it more aptly applied than in describing the island of Kauai. Formed by volcanic action, Kauai—The Garden Isle—is not only the oldest of the Hawaiian Islands, but also the most beautiful. The entire island is a garden, decorated with rainbows from the brief showers that keep most of the island moist and green.

Kauai offers incredible contrasts and scenic wonders. Within a few miles of a mountain peak claiming the distinction of 460 inches of rainfall a year—the wettest place on earth where ferns and vines grow in profusion—there is a dry coastal plain where cacti and succulents thrive in desert gardens.

In spite of its small size—64 miles across and almost circular—Kauai displays a grandeur unmatched by any of the other islands. It has the lushest tropical growth, the most secluded beaches, the highest cliffs and the deepest canyon, an awesome chasm slicing through Kauai's wilderness region for 14 miles.

Close to the southern shore are several impressive landscaped gardens, the best of which is the Allerton Garden, adjacent to the Pacific Botanical Garden at Poipu. Owned by an architect and once the royal residence of a former Queen of Hawaii, it is a beautiful tropical garden with swaying coconut palms, bamboo groves and water courses leading to a white sand beach.

The footpath is a photographer's dream because the scenery along its entire length is breathtaking, with high volcanic peaks to the left and steep sea cliffs to the right. Here the footpath can be seen at the lower left, winding its way high above the Pacific Ocean.

An isolated beach, viewed from the coastal footpath. In order to emphasize the coastal location, it was essential to include portions of surf and ocean in as many of the scenic views as possible.

Oala Pua Gardens, a former plantation manager's house, is memorable for its jade vines and small theme gardens laid out around the house, including a miniature rain forest, a food garden and a Japanese garden. Close by are Plantation Gardens near the town of Poipu, landscaped entirely with cacti and succulents, where trails twist and turn through outcroppings of rock.

The most thrilling spectacle of all Kauai's charms is an ancient hiking trail called Hanakapiai, which hugs the rugged coastline for 12 miles. It leads across mountain meadows, passing waterfalls by the dozens cascading from the steep conical volcanic peaks. At every turn some new species of tropical plant life presents itself, such as a grove of coconut palms, a bank of ferns or a field of wild dendrobium orchids.

Strangest of all the Hawaiian plants are the walking trees, or pandanus. They form stiff straight roots above ground to brace their trunks. Several of these together look as though they are walking on stilts.

Unmistakably tropical in appearance, the Hanakapiai Trail presented a different challenge. While one moment the wildflower-bordered footpath was high in the sky, skirting almost vertical lava cliffs, the next moment it plunged into the darkness of a humid jungle. The overwhelming beauty of the trail is the lush, green tropical vegetation and the towering cliff formations cloaked in ferns and vines to the very pinnacles.

Therefore, my camera recorded the scenery with an emphasis on the lush tropical growth. Many of the images show a portion of the footpath with a corner of clear blue ocean to give the pictures a sense of "place."

Scenes from the Hanakapiai Trail were used in *Popular Gardening* magazine, and also in my slide lecture, "Great Gardens of the World."

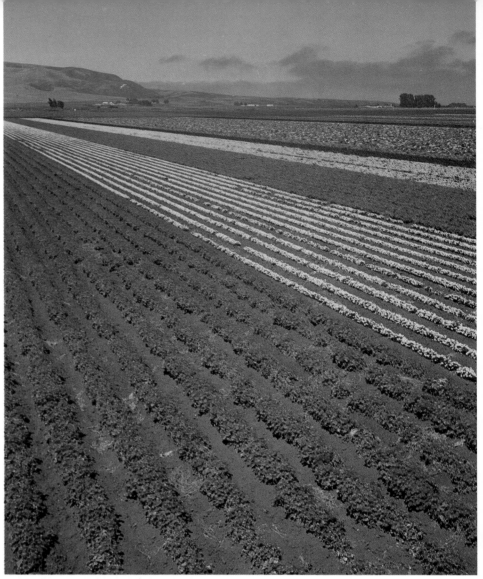

One of my most dramatic scenic views is this field of garden flowers growing for seed production at the Waller Flowerseed Company Farm near Guadalupe, California. A similar picture appeared in the January 1980 issue of *Horticulture* magazine. It shows 84 acres of nasturtiums, marigolds and petunias, the seeds from which will be harvested and eventually end up in seed packets.

CALIFORNIA'S FABULOUS FLOWER FIELDS

One of my most enjoyable trips was a bus tour of California's seed farms. As a member and past director of the Garden Writers Association of America, I was invited to join a group of 30 professional writers and photographers to see how the garden-seed industry produces new flower and vegetable seed varieties.

Our hosts were major seed companies. The group spent a week visiting one seed farm after another, from Los Angeles to San Francisco. It was an unusual adventure, and provided an opportunity to shoot some outstanding landscape scenes in addition to close-ups and specimen shots of new plant varieties.

American plant breeders have received more international awards for flower breeding than any others. Their big advantage is California. There every type of growing condition is available, from a hot, dry climate for raising hot weather crops, to moist, cool valleys, such as Lompoc, where mist rolls in from the ocean at 5

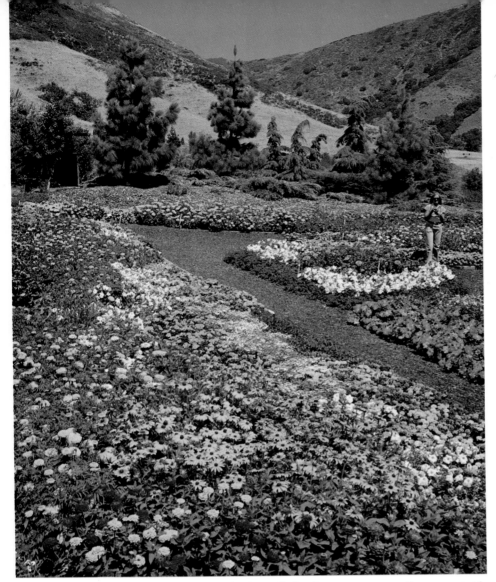
Importance of elevation is evident in this dramatic landscape scene on the campus of California State Polytechnic University at San Luis Obispo. A friend posed in the garden to provide scale and add an element of human interest. When using female models in pictures, it's best to have them wear slacks because dresses can date a picture.

mass of golden yellow, caused a companion to exclaim: "Just look at all those marigolds—they seem to grab all the sunshine and hand it right back to you!"

A third exciting landscape scene presented itself when the group took a side trip to California State Polytechnic University at San Luis Obispo to see a formal display garden set high above the Pacific Ocean in the Santa Lucia Mountains. The garden was a feast of color, with plants beautifully displayed in 14 beds laid out like a sundial. At ground level I had a good view of the mountains, but not of the extensive plantings. Again, the answer was to gain elevation. I climbed on top of a fence rail. Although I shot lots of pictures of the landscape without people, my favorite picture shows a friend posing with her camera in the middle of the garden, providing a sense of scale.

REDUCING ATMOSPHERIC HAZE

One of the biggest problems when shooting landscapes is atmospheric haze and glare. Haze normally appears as a blue fog obscuring the distant view. We usually are not aware of the problem in person, but in pictures, its effects are plainly evident. Distant details are blocked out or the picture is disappointingly dark.

To overcome the problem of blue haze, you must use a filter. The most common one for black-and-white film is a yellow filter which cuts haze without significantly affecting other colors. A red filter cuts the effects of haze still further, but darkens foliage colors in the process, producing too many dark tones. When using black-and-white film, it is also essential to use some kind of filter to make clouds stand out against blue sky. Otherwise the sky may look washed out. Yellow is the most common filter for enhancing the sky.

Haze is most often encountered in tropical climates and along

p.m. and rolls out again by 10 a.m. day after day. Here, cool weather crops grow to perfection.

Several exceptional landscape pictures made this trip visually outstanding.

There were the production fields where hundreds of acres of flowers were being grown for seed. In some places the effect of all this color turned an entire valley floor into a gigantic work of art. One field alone consisted of 84 acres of flowers in full bloom. The scene was breathtaking, with a range of mountains in the background. But shooting from ground level didn't

adequately convey the scene I wanted. The blaze of color was there, but as a thin band across the middle of the frame. I needed more flowers and less sky. Because I didn't have a stepladder, I asked our driver if I could use the top of the bus. When I climbed on top, I discovered I had the elevation I needed to capture the scene dramatically. I'm often asked if I shot that scene from a low-flying helicopter!

Another effective landscape picture showed a field containing more than 300 varieties of marigolds. The entire view, a solid

These illustrations of The Long Bridge at Magnolia Gardens, South Carolina, taken with a 35mm camera, demonstrate the value of using a telephoto lens. The left illustration was made using a 55mm lens, usually standard for this format. It covers approximately the same field of view as the human eye. On the right is this same scene, photographed from the same position using a 135mm lens. In addition to bringing the bridge closer, the telescoping effect of the lens has shortened the apparent distance between the azalea flowers in the background and those in the foreground, helping to create a more dramatic composition.

coastal areas. Also, at higher altitudes, there is more haze. With color film, use special haze or ultraviolet filters which are clear and require no exposure compensation. They do not adversely affect color film. Many photographers use one permanently like a lens cap. Aside from their photographic value, they also protect the

Notice how the trees at the edge of this picture are leaning toward the middle of the frame, while the central trees are perpendicular. In this instance the distortion caused by perspective is not objectionable, and even highlights the tall stature of the tulip poplar trees. To straighten the trees, I would need to either elevate my camera or use a perspective control lens.

lens surface from dust and fingerprints.

Another type of haze is white, caused by industrial pollution or coastal fog. At one time I couldn't understand how anyone could take a clear picture of Mt. Fuji in Japan because whenever I have been there the industrial pollution from Tokyo has always obscured the view. The only way to cut through this "white" haze is with an infrared filter and infrared film. For more information about filters read *Understanding Photography* and *SLR Photographers Handbook*, both by Carl Shipman.

WIDE-ANGLE & TELEPHOTO LENSES

The standard lens of a 35mm camera is normally 50mm, with a 46 degree field of view, about the same as the human eye. Lenses shorter than 50mm focal length are called *wide-angle* lenses, and those longer are *telephoto*.

The wide-angle lens is excellent for confined spaces such as a compact garden hemmed in with high hedges and retaining walls. It allows you to photograph more of the garden than would otherwise be possible. This lens is also good for photographing wide vistas such

as a mountain range, or tall features like a grove of towering trees, without moving back.

A telephoto lens brings the subject closer, acting like a telescope. A 135mm lens, probably the most popular among landscape photographers, has a field of view of only 18 degrees, but enlarges images more than 2-1/2 times as much as a standard 50mm lens. In addition to bringing the subject closer, it visually compresses space so distant objects appear to be closer together.

Using wide-angle or telephoto lenses can be fun—but be careful to avoid perspective distortion. For example, a very low angle with a tall tree or rock formation in the background will cause the tall feature to appear as though it were leaning backward. Sometimes this is desirable because the effect can be quite dramatic, but other times the picture will not look natural.

This distortion can be corrected by moving the camera until the sides of the tall subject are parallel with the sides of your viewfinder, but sometimes you cannot gain the necessary elevation to achieve this correction. Another solution to the problem is a perspective control, or shift lens.

8
Close-Ups

One leading botanical garden organized a plant photography contest, judged by a picture editor from a national magazine. The top prizes went to close-up pictures. Among ten other awards, nine were for close-ups, with only one for a general landscape scene.

If I had been judging, the ratio might have been different because I feel that a stunning landscape scene is far more difficult to capture than a beautiful close-up. Although close-ups can be quite dramatic, they are easy to take, especially with a 35mm SLR camera and close-up lenses, extension tubes or bellows.

Among subjects suited to close-up photography, flowers, fruit and leaves offer almost unlimited scope. There seems to be no end to the bizarre shapes, exciting textures and brilliant colors that can be captured photographically in clear close-ups.

CLOSE-UP LENSES

The simplest, most inexpensive way of getting closer to the subject than the standard lens allows is to add screw-on close-up lenses. These lightweight accessories resemble filters and magnify the image. Most come in sets of three—numbered 1, 2 and 3— with the larger numbers taking you progressively closer to the subject for greater image magnification. No exposure increase is required when you use them.

Close-up lenses screw onto the front of the camera lens just like a filter, and can be stacked to achieve a desired magnification. For example, stacking a #2 and a #3 will take you closer than using a #3 alone. Stacking a #1, #2 and

#3 together will take you in even closer. When stacking them, you must place the strongest lens—the highest number—closest to your camera.

I have found that 99 percent of all my flower close-ups were photographed with the #3 close-up lens. These close-up lenses allow you to take beautiful close-ups of most garden flowers.

The next easiest way to take close-ups is with a macro lens. This makes an image up to one-half as large as the subject, with no additional accessories! Macro lenses usually come with a special extension tube that provides magnification up to life-size. Most SLR manufacturers offer at least one in their interchangeable lens systems. Typically, the macro lens

This lotus blossom was photographed at the Aquatic Gardens in Washington, D.C. An important feature of the lotus flower is its unusual cone-shaped ovary which later develops into a hard brown seed case, highly prized for dried flower arrangements.

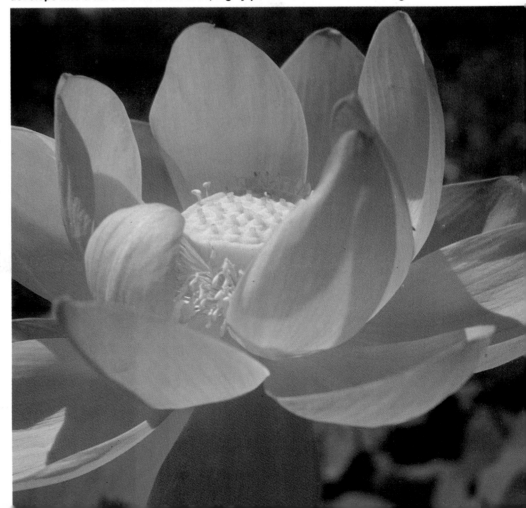

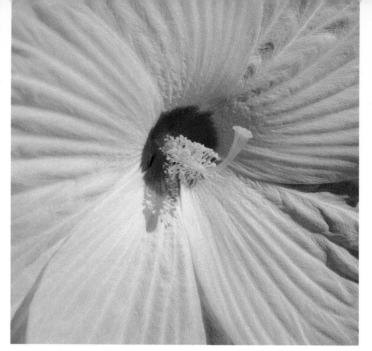

The close-ups on this page and on page 113 were taken with a simple #3 close-up attachment that fits over your standard camera lens. Much of my close-up work with plants is done with this accessory. At left, red jade vine, *Mucuna bennettii*, photographed in Hawaii, is perhaps the world's most beautiful flowering vine. The flowers hang like garlands—often three feet in length—but only with a close-up lens can you appreciate the unusual form of these flowers, like lobster claws or parrot's beaks. At right, this bloom of hibiscus Southern Belle is ten inches across, allowing a simple close-up lens to capture the heart of the flower in clear detail. The centers of the flowers make attractive close-ups because they are brightly colored to attract insects as pollinators.

The leaves of *Anthurium warocqueanum* often grow to the height of a man, with prominently displayed leaf veins which show up well in close-ups. To achieve this effect with most other leaves you would need a bellows or extension tube.

focal length is about 50mm, although 100mm is also common.

If close-up photography is your primary interest, consider using a macro lens as your main lens instead of the standard lens offered with the camera. You can buy the macro instead of the standard one when purchasing your camera.

I have focused on insects as small as ants, tiny plants such as moss and lichen, and even small seeds using a macro lens.

The lens allows you to shoot from infinity—vital for landscapes and scenic views—to half life-size in one continuous motion, with no stopping to change lenses or add an extension ring. However, as magnification increases, the light level at the film plane decreases. If you use the camera's built-in meter, it automatically compensates for this light loss.

EXTENSION TUBES & BELLOWS

For greater magnifications, consider additional equipment such as extension tubes and bellows. Extension tubes allow you to photograph objects up to life size, although they can also be stacked, letting you move in closer for more magnification. Bellows allow even greater magnifications.

It's a big step, however, to move from the simple screw-on close-up or macro lens to extension tubes and bellows. While close-up and macro lenses can often be used without a tripod, it's extremely difficult to hold a camera steady when fitted with an extension tube or bellows for high magnification. And, at high magnifications, the light level at the

film plane may be out of the range of your camera's built-in meter.

The extension tube has no lens. Basically, it is a fixed-length hollow cylinder that fits between the camera body and lens to give greater magnification than the lens gives by itself. It is great for getting dramatic close-ups of insects such as butterflies and bumble-bees pollinating flowers.

A bellows is similar to an extension tube except that it offers greater flexibility because it offers adjustable extension. Like the extension tube, it fits between the camera body and the lens. With a bellows you can photograph tiny plant parts, such as pollen grains, in clear detail.

GENERAL CONSIDERATIONS

Generally, when working in the close-up and macro range, it is essential to use slow-speed, fine-grain film in combination with as small an aperture as possible. The wider the aperture, the less depth-of-field and the more difficult it is to produce a sharp image. I prefer to shoot close-ups at f-11 or f-16 and f-22 when possible. This requires plenty of light. On a

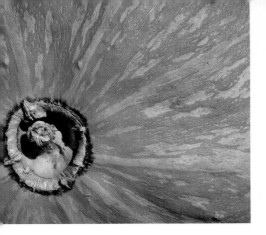

Top: No, this is not the surface of some distant planet. It's the skin of an ornamental gourd. The "crater" is simply the blossom ring, where the flower was originally attached to the fruit.

Center: The dramatic contrast between green leaf veins and white leaf coloration here is produced by the popular caladium plant. This variety, Candidum, is perhaps the most striking for color effect.

Bottom: The intimate parts of a squash blossom, an inviting place for any pollinating insect. The blossom is short-lived, opening at dawn and closing by mid-morning—long enough for nearby insects to be drawn to it by the large velvety yellow petals.

With the aid of a macro lens, you can explore a fantastic world of beauty, full of dramatic colors and bizarre forms. The pictures on this page were taken with the *f*-3.5 55mm Nikon "micro" lens. The top close-up shows slices of okra resembling intricate cog wheels. It is a southern vegetable with tender white seeds gleaming like pearls in the seed cavities. Immediately above, the crested cockscomb resembles a magnificent specimen of brain coral. This common flowering annual never looked lovelier than in clear close-up. The world is full of delightful surprises when you view it through a close-up lens.

cloudy day, take a sturdy tripod so you can shoot at slow shutter speeds.

Of course, there is nothing wrong with using medium or fast films if you need only moderate enlargements. Where natural light is inadequate, you can use flash, floodlights or ring lights, as discussed in Chapter 9.

When working at extreme close-up ranges, as with bellows and extension tubes, be sure you get the correct exposure setting. With ordinary close-up lenses, no compensation is needed for light readings, but when you use extension tubes or bellows, you must compensate for reduction in light at the film plane.

Three degrees of close-up are illustrated here with these photographs of a coleus, made using a Nikon "micro" lens. At top left is a mass planting with the colorful leaves filling the frame to create a pattern. The lens was approximately 30 inches from the subject. By positioning the lens to about 14 inches from the subject, I was able to close in on an especially attractive arrangement of leaves, and could show more clearly the leaf shapes, texture and color gradations. The extreme close-up limit of the lens is illustrated at left. Here, the color impact is more dramatic and even the leaf veins are clearly visible.

ARTIFICIAL LIGHTING FOR CLOSE-UPS

There are three choices of artificial lighting—flash, floodlights and a ringlight.

The most difficult artificial lighting to control is flash because you cannot see its effect on your subject. Flash may cause harsh shadows, and may produce bright reflections or hot spots on shiny surfaces. If your flash unit has a diffusing attachment, you will find it essential. When you consider my emphasis on simplicity, flash is a poor choice for close-up work unless you use an automatic flash unit that measures light at the film plane. See "Artificial Lighting" in Chapter 9.

Floodlights are easier to control because they can be moved around and you can accurately evaluate the lighting effect before making any exposures. Professional photographers do more close-up work with floodlights than any other form of artificial lighting.

If your camera has built-in through-the-lens metering, correction for lens extension is automatic. If you plan to do a lot of close-up work this is the system you should use. For more technical information, read Kodak's publication N12-N, *Photomacrography*, and Carl Shipman's *SLR Photographers Handbook*.

Effect of Background—Even with the simplest close-up lenses, correct exposure is not always easy to determine. Any light meter can be fooled under certain conditions. The best example is shooting a brightly-colored flower, such as a yellow primrose, against a dark background. Your exposure meter might read more of the dark background than the light flower, so the resulting picture will be over-exposed. To compensate for the gradations in color and light reflections presented by close-ups, it's a good policy to take the light reading from a special gray card. Place the card directly in front of the subject while you take the light reading. This *Neutral Test Card* is available at camera stores.

Lighting close-up subjects with direct sunlight creates harsh shadow areas that can spoil a delicate composition. For better results, use a white umbrella or diffuser screen held high above the subject. This throws a light shade over the subject, eliminating harsh contrasts between light areas and dark shadows. It still allows you to use a small lens opening for acceptable depth-of-field.

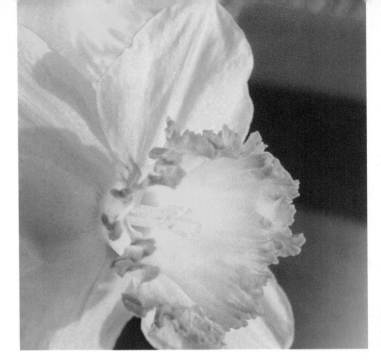

These close-ups were taken with extension tubes to show tiny plant parts approximately life-size, using natural light. The African violet leaf hairs allow the plant to trap moisture to meets its requirement for high humidity. A daffodil displays its frilly orange lip in clear detail. You can also see the arrangement of pollen-bearing golden-yellow male anthers that are located below the female stigma in order to avoid self-pollination.

Caution: Floodlights can get quite hot so you must be careful when working with them to avoid being burned. They can also cause the plant you are photographing to wilt.

Ringlights are circular flashtubes that mount on the front of the camera lens, surrounding it with light. An example is the *f*-5.6 200mm Medical-Nikkor lens from Nikon which has a built-in flash in the form of a ringlight surrounding the front of the lens. A ringlight illuminates a small, close subject with even, shadowless light and is excellent for close-ups of flowers and other plant parts with non-reflective surfaces. However, when you have a subject with a shiny surface, such as a tomato, you may encounter some reflection problems which can be eliminated only by using a diffused light source. Olympus makes an automatic ringlight, called a T 10, which features a polarizing filter. When used to shoot subjects with shiny surfaces, it cuts reflected glare. With this unit the camera's built-in light sensor measures the amount of light reaching the film and cuts off the flash when a correct exposure has been made.

Two factors are important for close-up black-and-white photography—simplicity and high contrast between the subject and its background. Left: The bright petals of this rudbeckia stand out superbly against a medium-tone background, with a second flower peeking into the frame to soften the composition. In the picture of germinating tomato seeds at right, a shadow has been cast behind the seedlings to make them stand out. Without the shadow for contrast, the seedlings would merge with the light soil tones and produce an unsuitable close-up.

9
Indoor Plants

It's fun to concentrate on families of plants, starting small and setting your sights on recording a vast range of varieties and compositions. African violets offer this opportunity, as do geraniums, cacti, orchids, begonias, ferns, palms and gloxinias.

It's also worthwhile to create special arrangements. Collect a group of different-colored African violets or different-shaped cacti, and arrange them on a table to make an attractive grouping.

Window arrangements of flowering or foliage plants can be enhanced by unusual containers, or photographed tier upon tier on shelves to the top of the window. Some types, such as miniature roses, photograph well in hanging baskets, in bubble bowls and as table arrangements. Shoot miniatures in a miniature garden or bottle garden.

TEN PHOTOGENIC INDOOR FLOWERING PLANTS

Pictures of flowering house plants are more popular than foliage house plants. Generally, close-ups are the best, with the flower photographed against a contrasting plain background or natural foliage. If you plan to sell your photos, you will also need pictures showing a perfect plant specimen covered in blooms, growing in a pot.

Following are ten of my favorite subjects:

Calamondin, *Citrofortunella*—Although this dwarf citrus tree covers itself with fragrant white flowers, its most colorful stage is when the small orange-colored fruits ripen. In fruit, the plant is good to photograph as a specimen in a decorative pot. Close-up shots of the orange fruit also make striking pictures.

Flamingo Flower, *Anthurium andraeanum*—These heart-shaped flowers are usually red with a contrasting protrusion, called a spathe. The spathe comes out of the center and forms seeds when fertilized. Although a single plant often produces a dozen or more flowers, they are usually too widely spaced to make good specimen pictures. A single flower makes a dramatic close-up, especially if you focus at the base of the spathe so the shiny red background is also in clear focus.

Fuchsia, *Fuchsia hybrida*—Bell-shaped flowers hang down from this plant in tremendous numbers on well-grown specimens. In frost-free areas they are planted outdoors as ornamental shrubs and hedges, but they are best photographed either as colorful hanging baskets smothered in flowers, or as close-ups showing a group of flowers from the side.

Gloxinia, *Sinningia speciosa*—These develop large upward-facing

Fuchsia **"Whitemost," showing its use as a tree form in a conservatory display at Long-wood Gardens.**

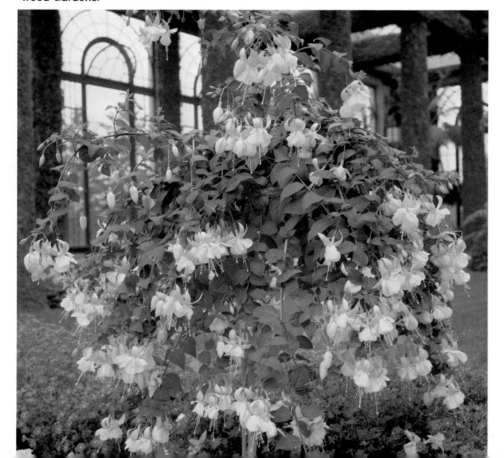

bell-shaped flowers with petals that feel like velvet, mostly in shades of blue and red, often speckled toward the throat, or with white edges on the petals. Photographs showing a plant covered with flowers, group close-ups of several plants in different colors and single close-ups of one stunningly beautiful flower, are all dramatic pictures.

Golden Candles, *Pachystachys lutea*—I showed a picture of this plant with its beautiful, long upright yellow flowers during a lecture at a meeting of mail-order nurserymen in Chicago in 1975, and suggested it might make an excellent item for them to offer in their catalogs. Until that time it was generally confined to botanical gardens. As a result of my recommendation and the beautiful picture, the nurserymen listed it as a mail-order item. It is now widely available as a flowering pot plant. Although compact specimens make excellent pictures, the shot that sold them was a close-up of several flowers.

Hibiscus, *Hibiscus rosa-sinensis*—The best varieties of tropical hibiscus are found in botanical gardens. They are capable of blooming all year round and, although the plants can look good from a distance if flowers are plentiful, they are best photographed in pairs or singly for dramatic close-ups. The color range is incredibly beautiful, especially the red, yellow and orange hybrids. It's best to have plenty of light on your subject and use a small aperture because *hibiscus* have a pistil and colorful stamens that project forward a long way, so you need maximum depth-of-field to have them in focus along with the petals.

Hydrangea, *Hydrangea macrophylla*—These have immense globular blooms in red, pink, white and blue, although the blue forms will turn pink in alkaline soil. In addition to superb single and group close-ups, you can obtain some magnificent pictures of container plants.

This flamingo flower was in a greenhouse where light was softened by shading material. This picture was composed for a magazine cover, leaving space at top, bottom and left side for titles that were to show up white on the dark background formed by leaves in soft focus.

In addition to attractive flowers, look for decorative fruit among house plants. This close-up of fruit on a dwarf orange is a popular picture from my rental files.

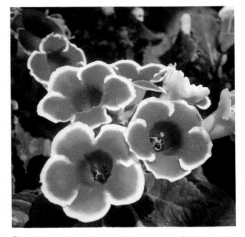

Gloxinias have large flowers and dramatic colors. Three prominent symmetrical, fully-open flowers make a perfect arrangement. This picture has been published in *Woman's Day*.

King Protea, *Protea cynaroides*—This tender ornamental shrub from South Africa is found rarely in homes, but in botanical gardens you will encounter good specimens producing flowers measuring up to 12 inches across. The outer ring of pink petals forms a crown, surrounding a snow-white powdery dome of stamens. A single flower will make one of the most dramatic close-ups you could ever wish for.

Poinsettia, *Euphorbia pulcherrima*—I can always count on selling poinsettia pictures for

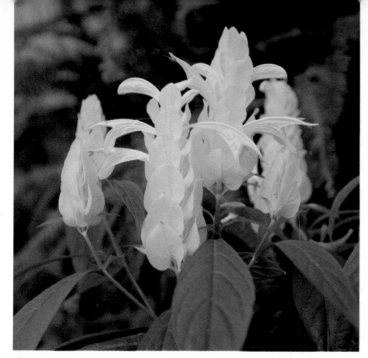

Golden candles, *Pachystachys lutea*, is the name of this popular indoor flowering plant. Any specimen picture showing a handsome cluster of flowers has sales appeal. I have sold this one many times to catalog houses.

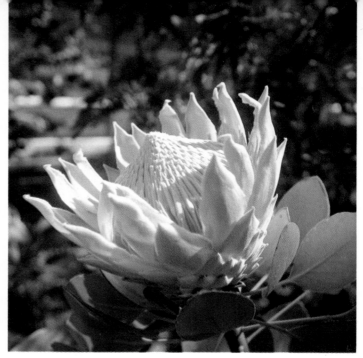

This picture of king protea, a South African plant, was used by *House Plants & Porch Gardens* magazine for a feature, "Weird but Lovable," about plant oddities.

Christmas issues of magazines and greeting cards, especially the big red varieties, although the white and pink forms are popular, too. In addition to close-ups and specimen shots, look for pictures showing it used imaginatively as a Christmas display, as a hanging basket and massed together over a wire pyramid to form a Christmas tree shape, for example.

Salpiglossis, *Salpiglossis sinuata*— Although not commonly found in the home, this plant is used by botanical gardens for indoor display around Easter. The trumpet-shaped flowers have a velvety texture and are mostly red, yellow, white or blue, with intricate petal veins. Group close-ups of several flowers, either the same or different colors, are spectacular.

TEN PHOTOGENIC INDOOR FOLIAGE PLANTS

When photographing indoor plants, it's easy to overlook the fact that many varieties are not grown for flowering qualities, but for their decorative leaves. The leaves themselves may be colorful, they may have an unusual texture that shows up well on film, or the leaf shape may be appealing.

There are several ways to photograph these: Shoot the plant as a complete specimen in a clean pot against a contrasting plain background, preferably black. Or show the plant in a room setting, either as a table centerpiece, a floor unit or a hanging basket, depending on its size and shape. The container must be decorative, also.

Foliage plants can also be photographed in their natural environment. I always experience a thrill at finding a magnificent wild specimen—the same pleasure an animal lover experiences at finding a zebra or a lion in the wild.

Here is a list of ten indoor plants grown mainly for their beautiful leaves, some of them common enough to be found in a home; others more scarce.

Elephant's-Ear Plant, *Alocassia watsoniana*—Native to the steaming jungle swamps of Sumatra, the large blue-green leaves of this plant are shaped like a shield, and appear to be made of patent leather. A distinguishing feature is its prominent silvery-white leaf veins. Close-ups of a single leaf make impressive pictures, especially when side-lighting enhances the shining leaf surface. It is most often found in botanical

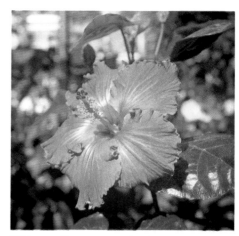

Hibiscus flowers present a photographic problem because the pistil and the exotic yellow stamens extend so far from the petals it is difficult to have them and the petals in sharp focus.

garden conservatories where its requirement for high humidity can be satisfied.

Caladium, *Caladium hortalanum*— This plant originated in Brazil. Its heart-shaped leaves have colorful patterns in shades of green, red, yellow and white, with contrasting leaf veins. A single leaf makes a dramatic close-up. Also, pictures showing a range of different leaf colorings are stunning. Popular varieties are sold through garden centers around Easter time as potted plants.

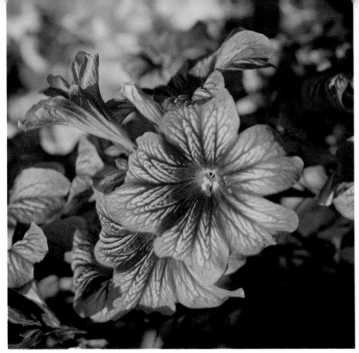

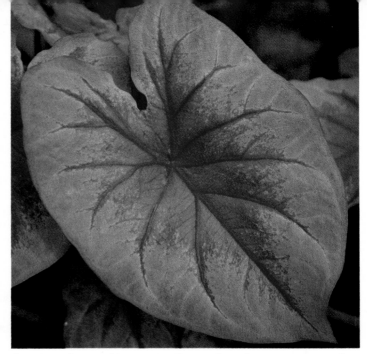

Although grown as an outdoor display plant in cool areas, salpiglossis is a popular flowering pot plant for cool greenhouses, where its delicate-veined petals can be photographed free from blemishes.

Caladium Scarlet Pimpernel, offers colors that can compete for ornamental effect with the most beautiful flowers.

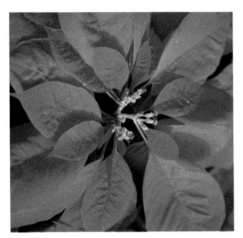

Poinsettias make dramatic close-ups. The flowers, the yellow parts at the center of this picture, are actually quite small; the red petals are really bracts, or colorful leaves.

Croton, *Codiaeum variegartum*—This beautiful tropical shrub with freckled and zebra-striped leaves originated in India. Colors include shades of red, yellow and green, with contrasting leaf veins. A crown of leaves, radiating out like the spokes of a wheel, makes an appealing picture.

Dieffenbachia, *Dieffenbachia picta*—Grown in homes and offices as floor specimens because they tolerate low light conditions, there are several popular varieties with large green oblong handsomely marked leaves, with either stripes, spots, freckles or broad color bands. The most photogenic is a variety called Rudolph Roehrs, with green-bordered cream colored leaves. Although individual leaves make dramatic close-ups, these plants are best photographed as free-standing specimens in a home, office or greenhouse setting.

Dracaena, *Dracaena species*—This is a large family of plants, mostly from Africa, but the kinds most often grown as house plants are so completely different in appearance it's difficult to believe they are related. The most popular is *Dracaena fragrans*, the corn plant, with striped, arching, strap-like leaves; *Dracaena godseffiana* with oval green leaves with yellow leopard spots; and *Dracaena marginata* with narrow striped leaves growing as a tuft on a slender trunk. Build up a collection of specimen pictures showing the different appearance of each plant. You should also take close-ups of distinguishing features such as the leopard spots of *Dracaena godseffiana*.

Fittonia, *Fittonia vershaffeltii*—This creeping plant grows in hanging baskets and terrariums. It is an excellent subject because of its intricate leaf pattern resembling netting, formed by the leaf veins. Sometimes called the nerve plant, it comes from Peru, and is best pictured in close-ups, hanging basket specimens or as part of a companion planting in a terrarium with other plants.

Jade Plant, *Crassula argentea*—A tree-like succulent from South Africa, this plant has thick, fleshy, rounded leaves, and is a beautiful potted plant for tables and floor display. The best pictures show it as a specimen plant in a decorative Oriental pot. Close-ups of the white, star-shaped flower clusters are also popular.

Philodendron, *Philodendron species*—The large family of philodendrons from South America includes some of the most interesting leaf shapes to be found in house plants. *Philodendron selloum*, with enormous deeply cut leaves, and *Philodendron oxycardium*, the heart-leaf philodendron, are popular. In addition to building a collection of specimen pictures showing the many kinds, take close-ups of the leaf shapes.

Spider Plant, *Chlorophytum comosum*—The spider is claimed to be America's most popular house

plant. It grows decorative baby spiders at the end of flowering stems. They hang below the "mother" when it is planted as a hanging basket. Finding a perfect specimen without blemishes is a problem because its long, slender, arching leaves turn brown at the tips at the slightest sign of discomfort. Shoot pictures of hanging basket specimens with baby spiders hanging all around the plant, and also take close-ups of the flowering tips showing the baby spiders forming.

Wandering Jew, *Tradescantia species*—This is another large family of plants from continental America that is extremely popular in the home because it is easy to grow and is tolerant of low light conditions. The striped varieties are best photographed as hanging baskets, although close-ups of the leaves and their zebra stripes are also attractive.

PHOTOGRAPHING FERNS & PALMS

Although ferns and palms resemble each other, they are from different plant families requiring totally different light conditions when grown as indoor plants. Ferns, for example, require shade and high humidity, while most palms prefer bright light and tolerate dry conditions.

Because ferns are common as house plants, you'll see them featured often in magazines. Most popular are the Boston fern, maidenhair fern, bird's nest fern, rabbit's foot fern, holly fern, stag's horn fern and mother fern.

Photographs should show the distinct differences among fern fronds. Some are feather shaped, others have strap-shaped leaves; some have creeping roots resembling animal feet. There are also ferns with different physical characteristics: The Japanese climbing fern is popular and so is the walking fern, which exhibits tiny plantlets at the end of each leaf.

I shoot lots of hanging baskets, and show ferns as decorator pieces in attractive house settings.

Palms are certainly beautiful in their natural state, especially the coconut palm photographed along a crescent-shaped beach. But palms should also be shown as indoor plants in decorative containers, adding interest to a hallway or a sun room.

In addition to real ferns and palms, there are many imposters—plants that look like these famous plant families, generally found where the real thing proves difficult to grow. Among the most interesting and the most "misunderstood" of these look-alikes are cycads, one of the world's oldest forms of vegetation, dating back 120 million years. Cycads once covered the earth and are closely related to evergreens. They provided food for dinosaurs, and their remains helped to create today's vast coal deposits. Ecological changes have

Dieffenbachia "Exotica" is noted for its freckled leaves, but in this specimen I chose to focus on its unusual and uncommon flower spike.

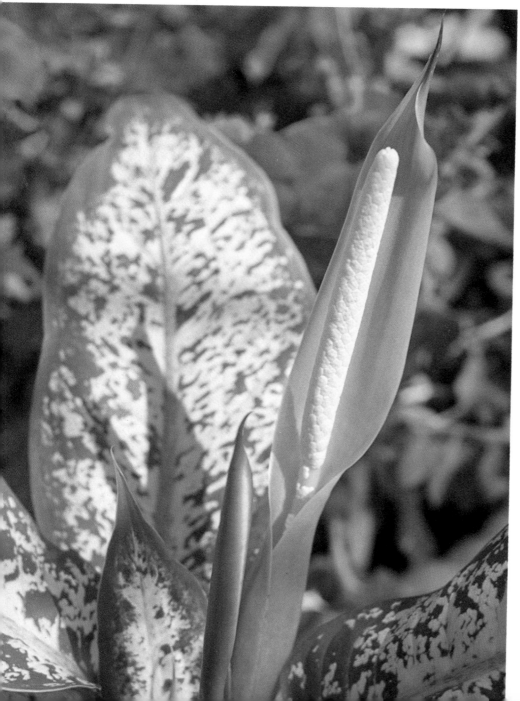

shrunk their natural habitat, but pockets of cycads still survive in the wild, notably in parts of Japan and Mexico. In addition to beautiful arching fronds forming a crown on top of a slender trunk, cycads produce magnificent cones at the center of the crown.

An effective way to photograph these is looking down at the center, with the arching fronds radiating out to all sides of your picture frame, creating a pinwheel effect. A grove of cycads is also a beautiful sight, but they are not hardy outside coastal California or north of Florida.

FLOWER ARRANGEMENTS

Although flower arranging is truly an art form, you don't have to be an expert to take some magnificent pictures of your own flower arrangements. Vincent Van Gogh's famous paintings of *Blue Iris* and *Sunflowers* are astonishingly simple arrangements that even a child could have put together. In fact, many informal flower arrangements can make spectacular pictures. Of course, there are

This is a fine specimen of *Dracaena godseffiana* growing in a conservatory.

Fittonia verschaffeltii shows off its intricate leaf pattern in this picture of the plant growing in a hanging basket.

infinite varieties of styles, settings and influences from the informal Van Gogh type to the powerful Williamsburg, and sophisticated Japanese schools of flower arrangement.

The best flower arrangement pictures are taken in a room setting. I dislike flower arrangements "posed" against plain backgrounds or displayed like so many

flower show entries in recessed cubby holes and picture frames. That may be fine for exhibition and judging purposes, but for good photography they are sterile.

Many fine historic houses are sources of exquisite flower arrangements. In the homes and buildings of Colonial Williamsburg in Virginia, for instance, you'll find some of the very best.

This close-up of split leaf philodendron, *Monstera deliciosa*, shows its deeply-cut leaves which give it decorative appeal.

Young leaves of croton Gloriosa start off yellow, changing to red with age. To show the full effect of the color change, I tilted the pot slightly so all the leaves came into sharp focus to fill my frame.

This well-grown spider plant specimen in a hanging basket, with lots of decorative baby spiders, was photographed in a plant room.

Here's a beautiful specimen of staghorn fern, *Platycerium grande*, growing in a greenhouse, with backlighting enhancing the richly veined fern fronds. I consider this to be a good specimen picture because of the maturity of the fern and its clear outline against an interesting but uncluttered background. I used available light for this photo, which was used as a cover picture for a book on ferns.

INDOOR LIGHTING ALTERNATIVES

When shooting indoors you will encounter three basic lighting situations: Adequate natural lighting, as in greenhouses and conservatories; uneven natural lighting, such as directional light streaming through a window, and inadequate natural lighting, as in a dark room or a windowless studio.

I prefer to shoot most indoor plants in natural light. The plants can be in a home, growing in a greenhouse, or I may create special setups in a sun room.

NATURAL LIGHTING

Many professional plant photographers never use anything but natural light to photograph indoor plants. Although I spent many a wintry evening experimenting with my own artificial lighting techniques, it's surprising how versatile and creative you can be using only natural light, with a reflector to bounce the daylight into shadow areas.

Greenhouses are great places to photograph indoor plants. Except on the brightest of days, the glass tends to diffuse the sun and illuminates plants with just the right

This striped variety of wandering Jew presented an interesting arrangement of leaves for an appealing close-up.

On the left is a wavy bird's nest fern, *Asplenium nidus crispum*, and a regular bird's nest fern, *Asplenium nidus* is on the right. Photographing these varieties from the same angle shows vividly the distinctly different qualities of each plant. The wavy bird's nest fern appeared in *House Plants and Porch Gardens* magazine. Both pictures were taken with available light.

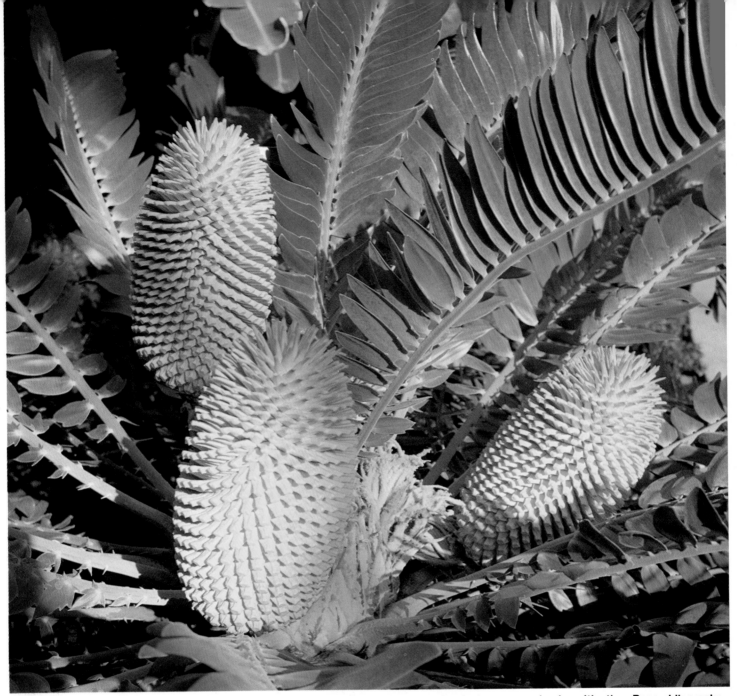

Wood's kaffir bread, *Encephalartos woodi*, is extinct in the wild, and only the male plants now survive in cultivation. Resembling palm trees, but more closely related to pine trees, they were the most plentiful plants on earth in prehistoric times, providing food for the dinosaurs and eventually forming much of the earth's present-day coal deposits and other fossil fuels. This magnificent specimen, showing three male flowers, was taken in the main conservatory at Longwood Gardens using available light.

kind of light. Take special care, however, to exclude any ugly background distractions such as watering cans, faucets and irrigation pipes. If these show, cover them with foliage from other plants such as ferns, or use a suitable artificial background.

In winter, moisture may condense on your lens when you walk into a warm greenhouse on a cold day. The lens steams up, creating a foggy picture. Carrying the camera in a bag from your car to the greenhouse or conservatory will help prevent condensation from forming. Be careful when wiping your lens clean. Even the smallest piece of grit, rubbed carelessly across the surface of your lens, can scratch it. I carry a pack of special lens paper which is available from camera stores. Use these once and discard them. Blower brushes will remove dust particles, but they don't remove condensation or fingerprints.

When photographing plants indoors using natural light, you may have to use a tripod for your camera and a sturdy table to hold the plants steady.

ARTIFICIAL LIGHTING

When shooting indoors, you often encounter an uneven light-

Here are four examples of indoor scenes using only available light. Inside the Tropical House at Longwood Gardens, the curtain of vines at right is the season vine, *Cissus sicyoides*. The gradations of color produced by light and dark areas from the natural daylight help to make this a striking indoor picture.

This garden room is a real live lived-in room for entertaining in the home of J. Liddon Pennock, a retired Philadelphia florist. The plant material is changed with the seasons.

ing situation where part of the scene is in bright light, and the other part is in dark shadow. This produces a brightness range difficult for the film to reproduce. Use some form of artifical lighting, such as flash or floodlights, or go in closer, shooting only one part of that scene.

Flash—You can use flash where existing light is inadequate or to modify existing light for a technically better picture. Flash can involve the old system of flashbulbs, discarded after one use, or the reusable electronic units prevalent today. Read the camera manual for specific information about the best type of flash to use.

Flash Metering—The best way to obtain accurate exposure with flash is to use a flash meter placed in front of your subject. Fire a test flash, following the instructions for the meter.

Guide Numbers—If you don't have a flash meter, use the guide numbers for your flash. Select the guide number for the film speed you are using and divide the guide

number by the *f*-stop you wish to use. This gives you the distance the flash should be placed from the subject. For example, if the guide number is 45 feet and the *f*-stop you want to use is *f*-11, the distance you should hold your flash from the subject is 45 ÷ 11, or approximately four feet.

Greenhouse display at Meadowbrook Farm near Philadelphia: The red hanging basket plant at left is columnea, and the centerpiece is a flowering verbena. *Plants Alive* published this picture as part of a photo feature about the owner, J. Liddon Pennock.

Excellent flower portraits can be obtained with diffused electronic flash. Charles Marden Fitch, plant explorer and plant photographer, is one of the world's best close-up photographers, and he prefers diffused electronic flash to any other kind of lighting. A specialist in orchids and tropical plants, he

Decorator ideas showing house plants used in creative ways are popular, especially among magazines appealing to homeowners. This picture shows an indoor swimming pool decorated with tropical plants adjoining the bedroom of a couple living in St. Louis, Missouri.

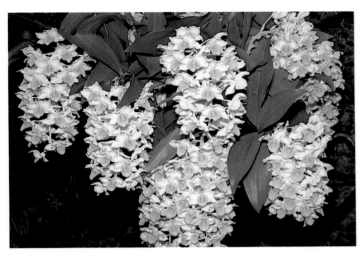

The magnificent cluster of dendrobium orchid flowers above would not have photographed well at all with a mixture of incandescent and weak natural lighting. This flash-illuminated photo is lit just right. Realizing that the flowers on the left would be perfect for a close-up, I moved in and made the exposure at right without any further adjustments. Both photos were taken with an Olympus OM2N 35mm SLR, with a T 32 automatic flash mounted on the camera hot shoe.

started off using daylight, but found that suitable daylight wasn't always available. He then tried photo floodlights, but the heat from these sometimes caused the flowers to wilt. He found diffused electronic flash to be the most convenient method, even for close-ups. However, he emphasizes that a flash meter is essential in order to have precise exposure control.

There are several types of electronic flash units.

Manual Flash—These are simple inexpensive flash units with no automatic features. You set film speed on a calculator dial on the flash and that dial then indicates what aperture to use for the shooting distance to the subject. You can also calculate f-stop for any subject distance using the flash guide number. The flash instruction booklet explains how.

Conventional Automatic Flash—Some flash units have a light-measuring sensor in the housing, positioned so it "looks" at the subject being photographed. This sensor measures reflected light from the subject and turns off the flash when enough light has been measured for correct exposure. You set film speed on a calculator dial on the flash and the dial then tells you what aperture size to use for a *range of subject distances*. As long as you work within that distance range, the flash controls the amount of light automatically and you should get good exposures of average subjects. This kind of flash is called conventional because there is a newer type with some additional advantages.

Camera-Regulated Automatic Flash—With conventional automatic flash, the flash unit measures the amount of light for the camera and shuts off when it "thinks" the film has received enough exposure. With camera-regulated automatic flash, the camera itself measures the amount of light reaching the film and shuts off the flash when the measured light at the surface of the film is sufficient for correct exposure. You normally dial in film speed on a control on the flash, but even this is sometimes not necessary. With this system, you can use a much wider range of aperture settings than with conventional flash. Also, if you shoot through bellows or extension tubes, the resulting light loss is automatically compensated for because the system is measuring light actually reaching the film. Several camera brands now offer this type of flash capability. It requires a special

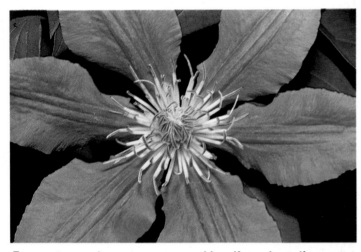

Even extreme close-ups are no problem if you have the proper equipment and know how to use it. The flash window of the T 32 can be tilted forward so the flash is aimed directly at the subject—Clematis Prince Hendrick.

This attractive dining area decorated with plants had too many dark areas with only the natural lighting from picture windows along two walls. Using flash as fill, I produced a pleasing photo with balanced lighting.

flash unit designed for the camera brand and model.

Dedicated Flash—When a flash unit does something special on a particular brand or model camera, such as setting shutter speed automatically or responding to control by a light sensor in the camera body, the flash is said to be "dedicated" to that brand or model. Both conventional automatic and camera-regulated flash units can be dedicated. When purchasing a flash, be sure you understand its automatic features and confirm that they work with your camera.

Hot Shoe—Most cameras have a "hot shoe," usually positioned directly above the lens, for mounting a flash unit. In this position the flash light can flood the subject head-on with bright light, creating harsh shadows behind petals and leaves. If you fit a diffuser over the flash—a white handkerchief can be

used if you don't have a proper diffuser—you will find it helps to soften the shadows and produce a superior picture. To prevent ugly background shadows, position the subject sufficiently forward from the background so no shadow can show on it.

Two or more flash units are sometimes better than one because you can position one for your main light and aim the others to soften background shadows. To ensure that the units fire simultaneously, you can use a sync cord or slave units. Check your camera manual for specific information; not all camera models allow use of multiple flash units.

Floodlights—To take pictures of plants indoors, you can use floodlights. The simplest setup is a single floodlight, best used when photographing a single flower or a compact plant growing against a

dark background. By shining the floodlight on the subject at an angle, you can illuminate the plant or flower well while keeping the background in total darkness for good contrast.

Floodlights allow you to evaluate the lighting effect continuously. The best way to meter an indoor scene lit with artificial light is to use a hand-held meter and a gray card. Place the gray card in front of the subject, angled so your meter does not measure glare from the gray card. Meter the card if you do not have an accessory light meter. To meter, bring the camera up to the card. Set the proper *f*-stop and shutter speed before returning the camera to the tripod.

Two lights are better than one. The first provides main light on the subject and the other creates fill light to eliminate harsh background shadows.

This indoor light garden was made from a television set. The charming display was in an office illuminated by tungsten light, but the grow lights inside the unit were balanced for daylight. Using daylight film, I obtained an accurate color picture that has been used several times to illustrate articles on indoor light gardening.

There are circumstances where even more lights may be needed to adequately illuminate an indoor scene. This can happen when shooting large groups of plants or large room interiors with plants placed in different areas. For example, you may wish to shoot a room filled with hanging baskets, floor specimens and table plants, each plant capable of throwing undesirable shadows unless lights from various angles are trained to cancel out those shadows. In a situation such as this, you could bring in a main light, a fill light, a spot light, a background light, an edge light and even an overhead boom light.

Bounce Lighting—A major problem with artificial illumination is that it might throw harsh light on your subject. Flash tends to make deep shadow areas and floodlights can sometimes be overpowering. The best light for color photography, whether done indoors or outdoors, is diffused light. An effective way to diffuse light from a floodlight or single flash unit is to bounce the light off a light-colored wall or ceiling.

To calculate exposure without a flash meter, measure the distance from the flash to the reflective surface, then to the subject. Use your flash guide-number system for calibration, increasing exposure by at least one full stop or more, to compensate for light loss due to reflection or absorption. Some of the newer cameras and electronic flash units compensate automatically for many such lighting setups. Read the owner's manual for complete details.

You can find more information about artificial illumination in David Brooks' *How To Control & Use Photographic Lighting.*

FILMS FOR INDOOR LIGHTING

Daylight or tungsten film can be used for indoor lighting situations. Use daylight films when relying on natural light to illuminate the subject and when using electronic flash. Tungsten film is for incandescent lighting, such as floodlights, unless the floods are fitted with special blue lamps that are color corrected for daylight film.

An interesting lighting problem presents itself when shooting unusual indoor gardens. In a friend's office, I found that he had converted a television set into a garden, with plants growing where the tube and screen had been. The office was lit with tungsten bulbs, and the television set was fitted with special grow-lights simulating daylight. These two light sources produce colors that are visibly different on film.

Illustrations of such gardens are unusual, and are therefore in demand. Spotting this unit was like finding money, if only I could capture it on film. I didn't have an electronic flash with me, but I obtained a satisfactory picture just the same by moving in close to the screen area where the plants and grow-lights were located, and using daylight film.

10

Plant People

Whenever I see people in plant pictures, I think of them as intruders. If I am photographing landscapes and gardens, I seek scenes without people. I am so particular about this, I will often wait hours for a group of tourists to wander out of my view.

However, there are occasions when a person does contribute something special to a scene—such as when someone is needed to provide scale, when a child or young couple will add human interest for a greeting card picture or news photo, or when an individual just helps make the image more attractive.

PERSONALITY FEATURES

I enjoy photographing a "plant person" involved in his craft. One of my most satisfying personality features told about the men and women responsible for famous flower seed introductions, with photographs of each breeder in a planting of the new flowers.

I find the best pictures of people with plants are those compositions where the plants are conspicuous in the foreground and the person is to the rear, or to one side. Sometimes you can frame the individual with the plant material to create a satisfactory composition. If not, arrange a lot of plants together in front and shoot the person with his face close to the plants. This seems to work when nothing else will.

Another tip: Try to persuade your subject to be natural, in clothes normally worn while working with plants. When shooting pictures at an iris farm for the *Philadelphia Bulletin*, I spotted the owner, Mr. Paul Lewis, with his shirt off and a spade over his shoulder, digging plants. I asked him to pose for a picture, and he immediately reached for his shirt. I begged him to leave it off because it would have spoiled the natural, carefree quality I wanted to portray. The resulting picture of him proudly posing bare-chested among his prize iris is one of my favorite people pictures.

Paul Lewis is an iris grower in his spare time and manager of a bowling alley during his working hours. His burly build and bronzed features are a dramatic contrast to the delicate iris flowers, but his totally natural, carefree appearance is also an appealing feature.

John Waller, president of Waller Flower-seed Company, posed in a production field of Whirlibird nasturtiums, a new flower variety developed by his company. His presence not only gives this picture news value, but also conveys dramatically the true scale of the planting.

IMPROVING PEOPLE PICTURES

Top: One spring I was horrified to discover that my front lawn had been killed off by a fungus disease during the winter, and only weeds—plantain, chickweed and dandelions—were sprouting. My young daughter, who had just learned to walk, was fascinated with the dandelion clocks, or seed heads, and I snapped a charming picture of her gathering the stalks, absorbed in discovering one of nature's miracles.

Bottom: On another occasion, I discovered a beautiful weeping cherry tree in a park, its branches creating a curtain of color. By moving in close I was able to screen out superfluous background and concentrate on a delightful portrait of my daughter fascinated with the delicate blossoms.

Opposite Top: To make good people pictures even more appealing, try these techniques: The first picture shows Sue in a field of daffodils, photographed with a 55mm standard lens on a 35mm camera. While this is certainly a beautiful picture in its own right, the composition is dramatically improved by using a 135mm lens which telescopes the flowers into a tighter group, at the same time bringing the subject closer.

Opposite Bottom: In this pair I photographed Sue against a background of golden yellow forsythia, again using a 35mm camera and 135mm lens, without any special effects. This is a good "people portrait," but the composition is improved significantly by creating a soft focus effect at the edges of the frame. I simply breathed on the lens and quickly dabbed a small clear spot in the middle with a lens tissue so the subject appeared in clear focus. This dream-like quality can also be achieved with a special soft-focus attachment which screws onto your lens like a filter, or by using petroleum jelly on a clear glass filter mounted in front of your lens.

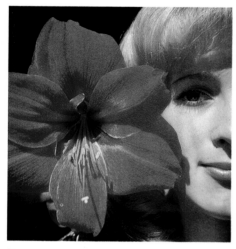

This African amaryllis, Christmas Red, was photographed with a model to show relative size. It was taken indoors using natural light from a south facing window.

Glenn Goldsmith, a prominent California plant breeder, was photographed in his test plots to illustrate an article I wrote about America's foremost plant breeders. The row of marigolds is a special new jumbo-flowered variety still in the development stage. By posing him off center, the line of perspective created by the test rows and the trees in the background draws the eye to the subject like a target, making this an effective personality picture.

It's a good idea to photograph the person's home as well; people love to see how others live. When *Flower & Garden* magazine invited me to produce a piece about David Burpee to commemorate the Burpee Seed Company's 100-year anniversary, I concentrated on telling readers about his beautiful home, a 500-acre estate called Fordhook Farm.

My best picture was a distant shot of the farmhouse on a hill framed by the backlighted blossoms of a magnolia tree. This was featured on the magazine's cover.

"HOW-TO-DO-IT" PHOTOGRAPHY

An important aspect of plant photography involving people is the How-To-Do-It sequence. Garden magazines regularly need picture sequences showing things like "Pruning a Grape Vine," "Planting a Hedge," "Building a Greenhouse," "Starting Seeds Indoors," "Planting an Asparagus Bed," "Seeding a Lawn" and other similar gardening jobs that are difficult to explain without the use of pictures.

One photographer in England makes a comfortable living specializing in how-to-do-it pictures. These are mostly in black-and-white, but more and more they are being requested in color.

One of my most widely published how-to-do-it sequences showed assembly of a greenhouse. Edward Owen Engineering, a greenhouse manufacturer, asked me to produce a manual illustrating clearly every step of the assembly of their greenhouse. I photographed more than 50 separate stages in the construction, showing every nut and bolt going into

place. From this set I selected four pictures showing the principal steps. This series has been published in magazines and dozens of newspapers.

In how-to-do-it sequences, it is important that the models wear clothes that will not quickly date the pictures. Women should always wear slacks that don't go out of fashion, and sweaters or blouses with neutral colors so the reader's attention is not distracted from the main action of pruning, hammering, digging or whatever.

Another series of how-to-do-it pictures was taken for Rotocrop (USA) Inc., a compost bin manufacturer. They needed some product shots of a new design. One appealing feature of the bin is its sliding panels which provide access to the finished compost at the bottom of the heap while the upper layers are maturing. The

HOW TO ASSEMBLE AN ALUMINUM FRAME GREENHOUSE
Unit shown is an Edward Owen Safety Greenhouse

1-Preparing the site. Here an aluminum base wall is placed in position after the ground has been cleared of turf and leveled. Gravel in center will form floor of greenhouse after base wall is in place.

2-Assembling the frame. Aluminum glazing bars, gutters and roof ridge are assembled using nuts and bolts. After frame is up check for straight sides and corners using a carpenter's square.

3-Installing the glass. Safety glass panes rest between the glazing bars on adhesive strips. A plastic cap clips over the seams and locks the glass in place. Never glaze a greenhouse on a windy day.

4-Assembled Greenhouse. The greenhouse is now ready to use. Aluminum is maintenance free, and safety glass is 5-7 times stronger than double strength window glass. Total assembly time is two days.

How-To-Do-It pictures about gardening are extremely valuable. They are among the most difficult to shoot because they require much planning and acceptable models to demonstrate the different stages. This series shows how to assemble an aluminum frame greenhouse.

This picture of a new type of squash called melon-squash was published in newspapers and magazines throughout the country. The attractive model provides human interest and gives an idea of size. Note how the model has been posed so the vegetable is the main feature.

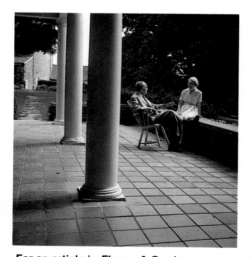

For an article in *Flower & Garden* magazine about the eminent seedsman, David Burpee, I photographed Mr. and Mrs. Burpee relaxing on the terrace of their home. I also took a scenic view of their farmhouse, shot through the backlighted blossoms of a magnolia tree.

action could only be shown by having an attractive model kneeling at the base of the bin with the sliding panels raised, removing finished compost with a trowel. The sales manager's wife was the model and we staged the product shots in his garden. The picture was used widely in advertisements and sales catalogs.

NEWS PHOTOGRAPHY

When you need a picture for news purposes, it's difficult to get by without a person in the picture because news editors want an element of human interest whenever possible. Newspapers especially like to show attractive women and children.

Several years ago I made a series of news pictures at a seed company, Thompson & Morgan, for their introduction of a new vegetable called a Melon-Squash. They wanted to distribute a picture and press release to 1,600 daily newspapers in the United States. The vegetable has the appearance and extraordinary keeping qualities of a winter squash, but the flavor and aroma are more like a cantaloupe melon. It can be eaten raw like a melon, or cooked like a squash.

Very rarely does a seedsman have an opportunity to present to home gardeners a totally new vegetable with benefits so unique and so excitingly different that anyone can understand and appreciate the value of growing it.

Fortunately, the squash is large-fruited and distinctive in shape, having a long curved "swan's" neck. I made a pile of these on a picnic table in front of a maple tree and posed a model with one in her hands. The best picture showed her holding a sliced-open fruit close to her face, her eyes looking directly at the squash with a look of appreciation. The picture was widely published in newspapers and in magazines, including *Mother Earth News*. Later the model told me people constantly stopped her, saying "Aren't you the girl in *Mother Earth News*?"

11
Selling Your Work

Many plant photographers try to sell their work and would like to see their images in print. The lessons learned from seeing your work published, and the immense satisfaction you feel at having your work accepted are worth far more than the modest fees. Don't expect to become wealthy from selling plant pictures. Although there is a fairly steady, consistent demand for quality plant pictures, payments are not very high, and the better-paying publications usually accept pictures only on special assignment.

CORRECT IDENTIFICATION

Apart from taking quality plant pictures, the most important step you can take toward selling your work is *correct identification.* Nothing will irritate an editor more than receiving batches of color transparencies with no information about what they show. Therefore, when you take a plant picture, identify it accurately.

There's usually no problem getting the proper information in parks, public gardens and arboretums because specimen plants are identified. If they are not labeled clearly, *ask* a superintendent or a gardener. If that fails, go to a good reference library and search. If you still draw a blank, a local horticultural society or arboretum may be able to refer you to someone knowledgeable enough to help. Some universities, societies and arboretums provide a plant identification ser-

These are magazine covers using my photos. Notice that most of these are close-ups with either natural or dark backgrounds. Garden magazines are always looking for good cover pictures and, of course, these illustrations fetch higher-than-usual rates. Be sure to examine the magazine's covers carefully before sending selections. Study where the type would go in your illustration: Will your cover selections accommodate the title of the magazine and other type headings? Do the publications prefer close-ups or garden scenes? As you can see, the dramatic close-up seems to be the most popular cover choice among garden editors.

Importance of accurate identification can be seen in this display of marigold pictures, each one a distinctly different variety:

French marigold Queen Sophia
Tagetes patula

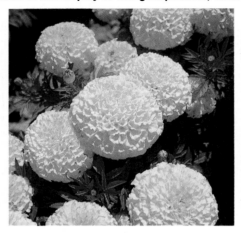

American marigold First Lady
Tagetes erecta

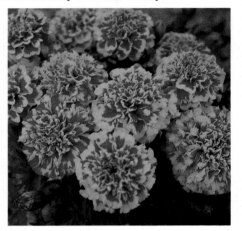

French marigold Queen Bee
Tagetes patula

vice for a modest fee. At Harvard University's Orchid Herbarium, for example, a staff botanist identifies flowers using a collection of 100,000 preserved specimens and 5,000 library volumes for reference.

The books I most often use for plant identification are *Exotica* and *Tropica* by A. B. Graff, two photographic encyclopedias of exotic plants, covering mostly house plant varieties; *The Color Dictionary of Flowers & Plants* by Roy Hay and Patrick Synge, full of color photographs identifying annuals, perennials, alpines, trees, shrubs, flowering bulbs and greenhouse plants; and *The Readers Digest Encyclopedia of Garden Plants & Flowers* by Roy Hay and Kenneth Beckett.

Hortus Third, by the staff of L.H. Bailey Horatium, Cornell University, is a widely recommended horticultural reference book, but it has no photographs for identification of plant varieties. It contains only a few inadequate line drawings so it is very poor as a source book for identification purposes. Where *Hortus Third* is helpful is in *nomenclature.* When in doubt about the correct spelling of a botanical name, *Hortus Third* is the best reference.

The ultimate reference book for plant photographers hasn't been published yet. It would have the

listings and descriptive content of *Hortus Third* and color photographs similar to *The Color Dictionary of Flowers & Plants.* Until that book arrives, I regret that you will have to use several sources for identification.

This question of accurate identification may sound like a time-consuming chore, but it is absolutely essential to clearly and correctly identify your work if you wish to sell it.

When I first started, I found it difficult to correctly identify some fungus and wild mushroom pictures I took in my garden. Books from the library were of little help because they were incomplete, or in most cases, were extremely confusing because they differed on botanical names, illustrations and even as to whether a variety was edible or poisonous!

I was advised to take my problem to a local wildflower preserve, but the resident botanist could only positively identify a small number of the varieties. He in turn referred me to a retired doctor whose hobby was collecting fungus. Although I had to take a two-hour car trip to see him, I spent a fascinating afternoon as he rattled off the botanical names and showed me his own slide collection, paintings and reference books on fungus. It was also interesting to note that all his

reference books were covered with pencil notations and *deletions* where he had methodically corrected inaccuracies. I left elated, not only at having spent such an absorbing afternoon, but also because I had succeeded in positively identifying my pictures, making them salable.

Certain plant societies have published books on the correct classification of plants, and these are a great help. The large flower classes such as lilies, tulips, daffodils, rhododendrons, roses and orchids are especially complicated without a good reference book. Always try to be as complete as possible in your identification. It's absolutely useless to any editor or publisher if your color transparencies are simply labeled "red apples," "white tulip," "yellow daffodil" or "purple rhododendron."

A good tulip identification would be *Tulipa fosteriana* Red Emperor. For a daffodil, a good identification would be *Narcissus poeticus recurvus*. The first name gives the species, the second is the sub-species and the third name is the variety, or cultivar, meaning a cultivated variety. The minimum identification for these two flowers would be Tulip Red Emperor or Daffodil *recurvus*. Encyclopedia publishers are even more fussy about identification, preferring

also the genus, and sometimes the family to be given. Roses—genus *Rosa*—and blackberries—genus *Rubus*—belong to the family Rosaceae, for example. The more particular you are in naming plants, the more professional you will be regarded by the people you try to sell to—and the better respect you will gain for your work.

PRESENTATION

Having built up a collection of quality pictures and identified them correctly, your next most important consideration is *presentation.* How you present your work to prospective buyers makes a great deal of difference when it is being considered with that of other photographers.

Unprotected color transparencies collect dust easily and pick up ugly fingermarks and scratches which can render them useless for publication. In either 35mm or 2-1/4 x 2-1/4-inch formats, transparencies are not the easiest things to handle even in slide mounts. To send them out to editors and publishers without protection is asking for trouble. Before a decision to buy is made, your pictures may be viewed on light tables, through projectors and handled by several people. A transparent protective sleeve is vital.

For 35mm slides, there are plenty of transparent sheets available from any photo dealer. Some have a dozen or more pockets. These are excellent because they keep the slides in full view, and slides are easily removed. At a glance you can see an assortment of slides without any fumbling.

For 2-1/4 x 2-1/4-inch transparencies, however, it is better if each color transparency has its own *individual* transparent sleeve. A mounted slide is easier to handle, frames the subject neatly, and allows you to print variety names and other important data on the mount. However, I feel that mounted slides are no better for

HOME-MADE TRANSPARENCY SLEEVES

COMMON NAME —————— Beach Plum
BOTANICAL NAME —————— Prunus maritima
OWNERSHIP —————— Copyright: Derek Fell

SAME SIZE SLEEVE ALSO HOLDS 35mm SLIDES

Although it's possible to buy "glassine" paper envelopes to hold individual color transparencies I dislike this type of enclosure. While the envelopes allow you to see through them to identify the subject matter, editors must remove the picture in order to see clear details such as sharpness and color quality. With my home-made sleeves, however, removal of the picture is unnecessary.

To make my own sleeves I purchase a roll of polyethylene "Lay Flat" Tubing in continuous rolls, and cut it into pieces 3-3/4 in. long to accommodate a white self-adhesive label at top, above the picture area and I staple the bottom closed so the picture cannot slide through. Rolls to make these sleeves are available by mail from The Nega-File Company Inc., Edison-Furlong Road, Box 78, Furlong, PA 18925.

presentation purposes than unmounted slides because the mount has to be removed before the publication can use the transparency.

I keep all my 2-1/4 x 2-1/4-inch slides unmounted, in individual sleeves with a label at the top of the sleeve identifying the plant and showing my name as the owner of the copyright.

I have been so disappointed with available 2-1/4 x 2-1/4-inch sleeves that I make my own. I buy a roll of clear plastic sleeve from Nega-File Inc. (Edison-Furlong Road, Box 78, Furlong, Pennsylvania 18925) and cut individual sleeves 1/2-inch longer than the color transparency itself. Then I punch a staple in one end so the slide cannot drop through when

inserted through the top of the sleeve. It fits snugly inside with enough room at the top to place a self-adhesive label containing my name and the plant identification. Your name and address on every sleeve reduces the chance of editors losing or misplacing your slides—and believe me, that is the biggest problem in dealing with editors. The clean protective sleeve allows full view, and the area for identification immediately above gives the editor all the information he needs at a glance.

FILING

File your pictures alphabetically by plant category. My files are arranged in the following groupings because this is how most publishers request them:

Annuals & Perennials
Flowering Bulbs
Fruits & Vegetables
Gardens
Herbs
House Plants
Landscapes & Scenic Views
Personalities
Trees & Shrubs
Wildflowers & Fungus
Miscellaneous—which includes greenhouse scenes, unusual landscape features like garden seats, and special container plantings.

MARKETS FOR PLANT PICTURES

Once you have your work correctly identified, filed and protected, and ready for presenting to prospective users, you must decide where the best markets are. **Monthly Garden Magazines**—By far the biggest users of plant pictures in America are the monthly garden magazines. In addition, there are several annual and semi-monthly publications with varying payment rates. A cover subject might command $50 to $250 for a stock picture.

Before you send material to any publication, study copies of that publication first and analyze the type of pictures they use. Some magazines, for example, prefer pictures with human interest. In

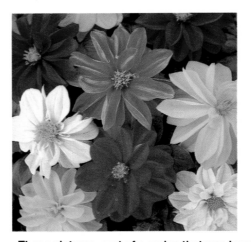

These pictures, part of a series that was bought by Horta-Craft corporation, were used on a new line of plant ID labels. This was one of the biggest single stock-picture orders I ever filled, totalling fees of more than $9,000. They show a range of colors in simple arrangements and were photographed outdoors in natural light. At left, for Dahlia, Rigoletto Mixed Colors, I selected representative colors, cut the stems short and arranged the flowers on a nearby leafy groundcover. At right, for Pansy, Majestic Giants Mixed Colors, I found the large, perfectly-shaped, blemish-free flowers in a British seedsman's test garden and searched for a suitable place to arrange them. The ideal location was a compost pile with a covering of clean straw; it proved ideal for holding the short flower stems in place.

color pictures they may like to show people enjoying their gardens—a husband and wife working together on a special project or a young couple enjoying their home garden. In black-and-white pictures, they may prefer to show projects being completed, step by step.

To introduce your work to a garden editor, write a brief letter accompanying a small selection of your best work, carefully identified. Include postage and a self-addressed envelope for the return of your work. Be sure the return envelope is large enough to hold the materials. In your letter, tell the editor what other types of pictures you have to offer. If you specialize in wildflowers, be sure to include several of your best in the selection, listing some of the other varieties you have. In deciding what other work to send, look three to six months ahead at what the editor would be planning. You might be fortunate to send something he needs at that very moment, and your chances of a sale first time around are greatly improved.

Don't be disappointed at some of the reactions you may receive. Some editors will return your

work with a very impersonal rejection slip. Others may take the trouble to explain why they are rejecting your work, and some may even suggest ways you can improve it to gain a better chance of acceptance.

If your work shows promise, but the selection you sent the editor does not meet his immediate needs, he may place your name in his file of plant photographers and contact you later with a list of his requirements, inviting you to submit work for approval.

Don't try to sell your work too soon. If an editor keeps sending you lists of pictures and you have nothing to offer him, he will soon regard you as a poor source of supply. I strongly urge every plant photographer to work at least three to five years before attempting to sell your photos to busy garden editors. In three years, if you are active and take advantage of every weekend to photograph plants, you may be able to build up a large enough collection. It took me *five years* of constant picture-taking before I felt I had accumulated a sufficiently varied selection of material.

Don't be discouraged by rejections. Keep submitting work with

return postage and self-addressed envelopes. If you start to get discouraged, politely ask how to improve your chance of acceptance. Reasons may include "Not sufficiently high standard," "Poorly identified," "We don't use 35mm material" or simply "Keep trying."

Whether you insure your pictures is a matter of choice. I never do because I have never had any pictures lost in the mail. I don't mind taking the risk when dealing with 35mm or 2-1/4 x 2-1/4-inch transparencies, because the cost of materials is low. However, it is advisable to request a return receipt, to show proof of delivery. I have had several cases where *customers* lost pictures and tried to avoid compensation payment by claiming they never received them!

Black-and-white pictures are not normally returned by garden magazines because the photographer has the negative to make more prints. However, color transparencies are usually purchased on a "rental" basis because the photographer does not have a negative to make extra copies for future sale, and duplicate color transparencies will not be accepted by most publications. When pictures are purchased on a "rental" basis, the magazine keeps the color transparency until printing plates have been made, after which it is returned to its owner, allowing him to rent it elsewhere.

General Magazines—There are a number of general magazines with gardening sections. However, the color work in these magazines is usually purchased on assignment—they will plan a feature down to the finest detail, contact a professional photographer, brief him on their requirements, and hire him to do the job on a special "day rate" or an "assignment" rate.

These publications rarely use stock pictures, although they will sometimes buy an exclusive

Zucchini squash, Gold Rush, an award-winning new vegetable. This won cover space over dozens of other submissions because mine was the *only* one showing the fruit on the vine.

feature—one submitted to only one magazine—consisting of pictures and an article as a complete package. However, you must be very familiar with the magazine's style and general editorial approach before you can hope to be successful in selling an editorial package.

Generally speaking, minimum color rate for a magazine is $50 for spot color, where your picture is used as a small reproduction or one of several on a page, and $100 for a full page, double-page spread or cover. Some of the better-paying magazines, however, pay $150 for spot color, and up to $1,500 for a full page, double-page spread or cover subject.

Once you have sold a feature package to a magazine and they have confidence in your ability, it is only necessary to give them an outline of future feature ideas, and

they will indicate whether they are interested in making it a definite assignment for you.

Book Publishers—Book publishers, especially those handling garden and educational books, use many plant pictures. Encyclopedia publishers are particularly interested in high quality plant pictures. When an encyclopedia starts a new volume, the editor assigned the job of finding pictures usually issues a *want list*. These want lists sometimes run to dozens of pages, together with specification sheets clearly explaining the types of pictures required, usually clinical pictures or specimen shots showing the plant in its natural state in impeccable detail. The photos must be well composed but devoid of any extraneous objects, and should not be backlighted.

With flowering plants, a good portion of stem and leaf should be

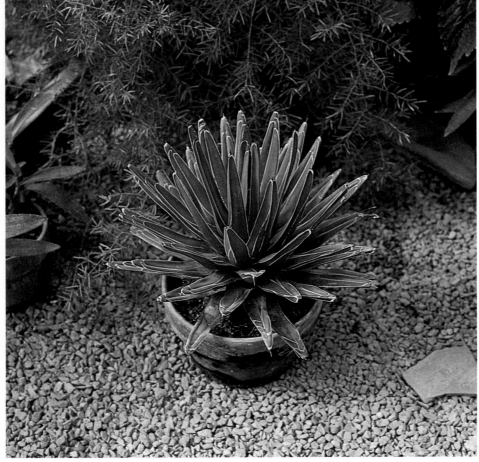

Agave victoriae reginae, a popular house plant from desert regions, was used as a cover not only because it is a pleasing picture but also because adequate dark space around the plant enabled the magazine to place titles above and below.

included in the composition; in larger plants such as shrubs and trees, the editors prefer either a specimen shot of a lone tree showing its distinctive shape or a close-up of stem, leaves and fruit or stem, leaves and flowers if these are distinctive features. Do not include people or any sign of artificial or man-made surroundings such as labels, irrigation pipes and thermostats.

With encyclopedia and other book publishers, it is usually sufficient to write a letter stating what kinds of pictures you have available. They rely heavily on non-commercial photographers, and they may contact you when collecting material for a book.

Fees vary considerably from publisher to publisher. Some will ask what *your* terms are, and you will have to decide what you feel your work is worth to that particular publication. Pictures used as a

jacket cover command the highest prices, but payment is usually negotiable, with each publisher seeking the lowest price and choosing his work accordingly.

Publishers are often slow in making selections, and can tie up color transparencies for many months before making final decisions. It helps to be patient.

Catalog Houses—I estimate there are more than 100 companies publishing full-color seed and nursery catalogs in the United States alone, each using a great number of flower pictures. Many of these companies also use pictures to illustrate seed packets and plant labels. Although most have their own sources for photographs, they also rely on outside contributors. The best way to make them aware of your interest in supplying illustrations is to write a letter to the catalog manager. Submit a small selection of pictures and give

a list of other subjects you have available. Be sure you send them pictures *better* than those they already use in their catalogs.

To sell to this market, a special understanding of catalog needs is helpful:

In general, catalog houses prefer their pictures to be specimen shots. For flowers, the emphasis should be on a single bloom, with a bud in close-up against a plain background such as blue sky or foliage. If the plant has a distinctive "habit," such as large flowers on dwarf stems, the complete plant should be shown. Simple application pictures are also in demand. If you have a good hanging basket arrangement or a container planting without too much extraneous matter, these are good prospects as well.

Other than to show size relationship, humans should not appear in catalog pictures, although dwarf tree pictures, for example, generally benefit from having someone in them to show comparative size and positon.

CATALOG PICTURES

Shoot your pictures in the vertical format rather than horizontal because the overwhelming demand is for a vertical or square format. Also, you must realize that the biggest-selling flower varieties are *mixtures*. For example, Crackerjack Marigolds Mixed Colors and Thumbelina Zinnias Mixed Colors are two of the biggest selling flower seed varieties. For catalog or seed packet illustration, it is imperative to show a broad range of colors; the best way to achieve this is to arrange the flower heads close together on plain backgrounds in the same plane so all the flowers are in sharp focus. Each flower should be perfectly symmetrical, uniform in size and blemish-free.

The type of background you use depends on the flower shape. With flat, upward-facing flowers, such as pansies, impatiens and zinnias, simply place the flowers on a con-

trasting flat background and shoot from above.

Sometimes it is difficult to balance a number of flowers, such as the trumpet-shaped blooms of petunias and globular blooms of geraniums, on a perfectly flat background. In such cases, I have found it easier to arrange the flowers on a raised frame of chicken wire. Find a box and cover the open top with the fine wire mesh. Cover the wire with foliage from the plant and poke the flower stems through the wire. Then shoot down on the arrangement.

Other flowers, such as the long-stemmed delphiniums and fox-gloves, can only be arranged upright and photographed against a vertical background. Here, bottles are good accessories. Insert the stems into the bottles and stop the stems from swaying by poking pieces of crumpled newspaper around the necks. Then arrange the bottles to position the flowers properly in your viewfinder, ensuring that the necks of the bottles are out of the frame.

Mixtures are also good shot as mass plantings, outdoors in flower beds, although these are not as popular among catalog managers as clear close-ups showing one each of the colors.

Flowers with one color, such as the popular green Envy zinnia, are best photographed showing a close-up of one flower and a par-tially-open bud against a contrasting background.

Flowers of all one color are also photographed effectively as a straight border with a rustic fence behind and a strip of grass edging in front. The row of flowers should run diagonally across the photo. When you visit a seedman's trial garden you will often find hundreds of flower varieties planted in straight rows, usually in 15-foot lengths with three-foot spacing between rows. To create an instant border scene, take along a portable fence section to place behind the row you wish to photo-graph and a strip of artificial turf

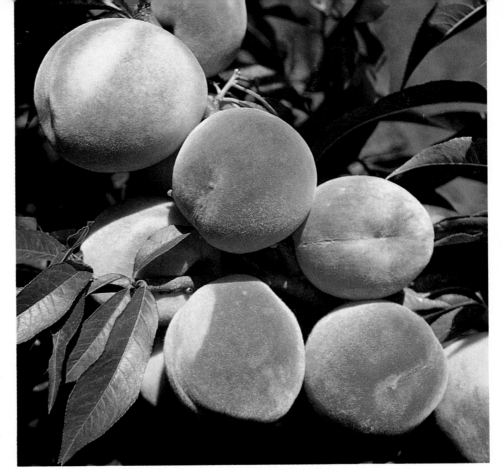

These are Elberta peaches, exactly as nature grew them. I used a stepladder for sufficient height to shoot the peaches at eye level, and focused on one blemish-free fruit at the center of the fruit cluster. I trimmed away a number of leaves to give full view of the fruit.

from a florist shop to place in front to suggest the edge of a lawn. Tidy up the row by removing blemished flowers, replacing them with unblemished specimens, if neces-sary. You will find this kind of pic-ture welcomed by catalog managers.

Calendar and Greeting Card Manufacturers—These outlets are also good markets for plant pictures. Your best approach is to send them a representative selec-tion of pictures you consider suita-ble for calendars and greeting cards.

Following are descriptions of 11 photographs I have sold for greet-ing card usage. Some of them appear in other sections of this book. These pictures were purchased by one company from a portfolio consisting of about 20 photos submitted speculatively:

A wooden bridge crossing a stream, photographed in the early morning after an ice storm. The ice sparkles and the scene is pre-dominantly white, suggesting a peaceful Christmas scene.

A large expanse of golden daffodils on a hillside, for use as an Easter card.

A woodland with luxuriant ferns and moss suggesting springtime freshness, for an Easter card.

A close-up of a white Easter lily, for an Easter card.

A close-up of a red-spotted garden lily, as a Mother's Day card.

A close-up of a pink rose, as a Mother's Day card.

A quiet woodland path in the early morning after a recent snowfall, as a Christmas card.

The same scene in fall, as a Thanksgiving card.

A pumpkin display at a garden center, as a Thanksgiving Card.

A giant pumpkin growing in the garden, as a Thanksgiving card.

AUTHORIZATION FOR PUBLICATION

Permission is granted to _____
Name of Photographer

to publish photographs and text of the _____ garden/residence
Name of Owner

Address City State Zip

The garden/residence to be published was photographed by _____
Name of Photographer

Views of architecture, garden scenes and decorative features may appear in the pictures.

If the owner wishes to remain anonymous please indicate by checking this box. ☐

Signature of Owner Address City State Zip

Date

A woodland garden in fall, with the golden glow of autumn colors in the overhead canopy of leaves creating a beautiful Thanksgiving scene.

None of these pictures was shot with special filters. They were all natural scenes photographed in natural light. However, to broaden your appeal to greeting card publishers, you may want to shoot scenes like these through different color filters and lens accessories such as a soft-focus attachment.

Two good reference publica-tions for names and addresses of publishers and other prospective buyers are *Writer's Market* and the *Photographer's Market*, available from your local bookstore or li-brary. Names and addresses of publishers, card manufacturers and other markets are listed.

Permission—When photograph-ing private gardens for publica-tion, it is important to obtain the owner's permission. Some magazines will insist on seeing a release form before they will con-sider garden scenes that can be identified as someone's private property. Lawsuits based on inva-sion of privacy are extremely rare because most gardeners enjoy having other people admire their gardens, but it is common cour-tesy to ask permission. You may use the sample release form repro-duced here as a basis for any form you draw up. Be sure the form you use is suitable for your purposes.

Stock Photo Agencies—A num-ber of companies such as Armstrong Roberts, Black Star Publishing and Harold M. Lam-

bert Studios maintain extensive stock photo libraries and supply a range of pictures to publishers, advertising agencies and catalog houses.

When a stock photo agency agrees to represent you, they normally pay you 50 percent of the selling price for color sales and 35 percent on black-and-white sales. Some photographers deal on an exclusive basis with individual stock photo agencies for a larger commission. Others send them only their surplus material for adding to their files. Lists of the most active agencies are in *Photographers Market*, published by *Writer's Digest Books*. Because each agency works differently, write to each individually, asking how they would like you to submit material for consideration. I have never dealt with an agency because I maintain my own library and sell direct to publishers.

Lecture Slides—There is a big demand among schools and other educational institutions for 30- to 60-minute slide lectures containing from 50 to 100 duplicate 35mm slides numbered to match a script. The person renting or buying the slide lecture simply inserts the slides into a projector and reads the script in synchronization with the slides.

For example, popular slide lectures cover "How to Plant a Vegetable Garden," "How to Grow Ferns," "Planting Flower Gardens" and many other aspects of horticulture. Typically, these are rented for a set fee, depending on length. A way to market them is through the classified sections of gardening or educational magazines, or through a slide agency.

I have never rented slide lectures with scripts, but I have made up slide lectures for organizations. I have several slide lectures which I deliver myself. The most popular are "Great Gardens of the World" and "How to Photograph Plants & Gardens."

This scene would appeal to a greeting card company. Woodlands, wildflower meadows and beaches with an attractive model, or a pair of young lovers, are all in great demand.

Clivia miniata, an indoor flowering bulb, was one of the first flowering plants I ever photographed. The picture is over 20 years old and was taken at Kew Gardens, in England. The dark background allowed bright titles to be used around the flower head.

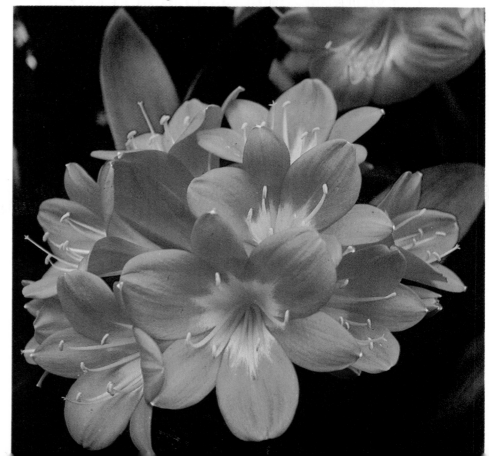

12
Working With Publishers

Some of my best garden photography has appeared in *Woman's Day*, a leading woman's magazine with 19 million readers; *Architectural Digest*, a high-class "shelter" magazine for affluent homeowners and individuals involved in decorating homes of wealthy people; and *Plants Alive*, a leading garden magazine. Each of these publications is completely different in its needs, working methods and rates of payment.

SHELTER MAGAZINES

Publications such as *Better Homes & Gardens*, *House & Garden*, *Architectural Digest* and *House Beautiful* are often referred to as "shelter" magazines because they deal mostly with homes and home furnishings. They have large circulations, work in a highly competitive atmosphere, and use a moderate amount of garden photography because gardens are an extension of the home.

Every issue of *Architectural Digest* includes a garden feature. These are not just beautiful gardens—they are *fantasy* gardens, almost always private or unknown public gardens.

Managing editor Kelley Younger told me why the garden feature fits into their publication: "We think of the garden feature as a visual break for the reader in that it is outdoors, romantic, pretty, poetic. The photography should include a certain number of overall views as well as specific views. We are, of course, looking for lots of colorful blossoms, plus noteworthy arrangements and landscaping. When the story is accepted on the basis of the photos, we assign the text."

Kelley also expressed a preference for pictures showing paths leading through the garden because they help to draw people into the picture and create a more inviting quality.

Architectural Digest normally does not accept freelance material sent on speculation. They like to see slides of what a garden looks like—called record shots—but usually will assign the photography to an individual they have worked with in the past, paying the freelance a finder's fee. Most of my work for *Architectural Digest* has been speculative, generally including both the text and picture material. I keep careful track of what they publish, and then go looking for gardens completely different from anything they have featured in the past. Sometimes I just dream up a garden, then ask among gardening friends if they know of one to fit my fantasy.

This is Tollgate Farmhouse, the bare hillside contrasting with masses of golden yellow blossoms below. When shooting gardens always try to include a picture of the house as well as general scenes showing an overall view, medium range shots and close-ups of specific plants or plantings.

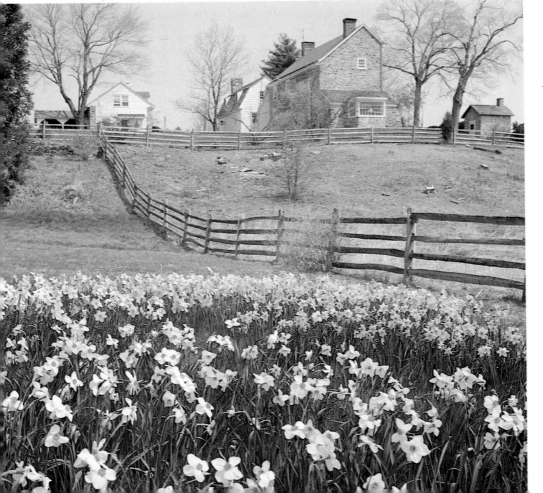

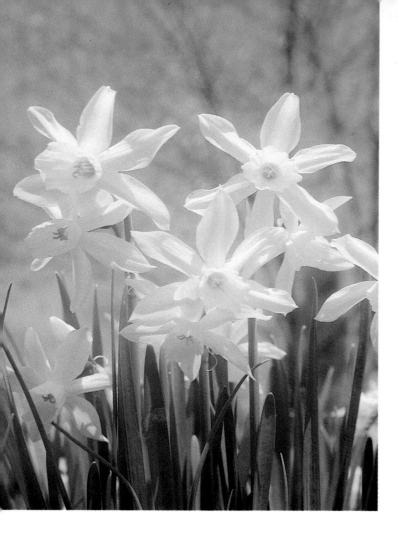

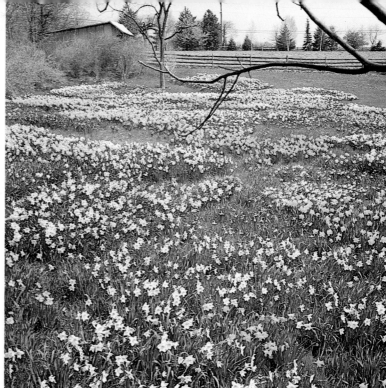

I climbed a tree to achieve this unusual angle showing the true extent of the plantings. Always look for elevation when shooting mass plantings. In fact, I usually bring a lightweight aluminum stepladder in my car when I go out to photograph plantings like these.

These pure white triandrus daffodils have petals backlighted by the morning sun. Such photographs are difficult to make because light readings indicate too high an *f*-stop when flowers have a clear sky background.

That's how I found a beautiful rock garden called Innisfree in New York. In my mind I conjured up a garden surrounding a cobalt blue lake with stone retaining walls and terraces overlooking the lake. Plants grew among rock formations with zig-zag bridges, stepping stones, waterfalls and cliffs. I told a friend about this garden and he directed me straight to it, just a few hours drive from my home. It is the most romantic garden I ever visited.

Architectural Digest is graphics oriented. Pictures must dazzle the senses and must be usable at enlargements up to double-page spreads. I usually submit a selection of at least 50 color transparencies, each clearly identified, accompanied by an outline stating where the garden is located, whether it is privately owned and listing some unusual features setting this garden apart from others.

Also important are some biographical details about the owner and, if the garden is old, some historical details.

After the story has been bought on the basis of the pictures, the editor will often invite me to write the text. I enjoy garden writing as much as I enjoy garden photography. It doesn't always happen that way—sometimes the editor prefers that a staff writer do the text.

For these gardens, the editors normally devote six to eight pages of color. Gardens appealing to this market are usually theme gardens. It is often one special feature that makes the garden noteworthy. For example, the first garden I photographed for *Architectural Digest* was a beautiful farm near Philadelphia, the country retreat of Robert L. Green. It has a perennial garden, Japanese pagoda, beds of daylilies, peonies and bearded

iris. The most spectacular time of year is early April, when tens of thousands of naturalized daffodils are in full bloom.

The daffodils sweep across a meadow area, around a pond, down a grassy slope and along both sides of a sparkling stream gushing from a picturesque spring house, with a stone farmhouse and brick-red barn commanding a view of the entire scene from a hillside.

I took single and group close-ups and panoramas showing the extent of the naturalized plantings. For the most impressive shot of all, I climbed a tree and photographed a swirling mass of flowers carpeting the ground. *Architectural Digest* devoted almost their entire picture treatment to the daffodils, and it was this special emphasis that made it a spectacular feature.

I had visited Mr. Green's garden twice in the spring to photograph

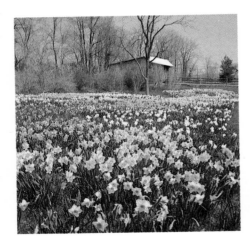
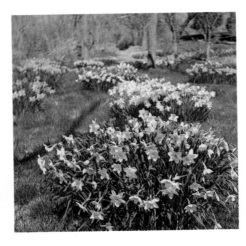
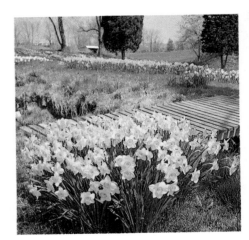

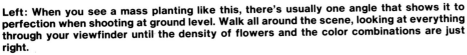

Left: When you see a mass planting like this, there's usually one angle that shows it to perfection when shooting at ground level. Walk all around the scene, looking at everything through your viewfinder until the density of flowers and the color combinations are just right.

Center: Clumps of daffodils border a path running through a wooded area, a different planting theme from the broad sweeps of flowers in the open meadow areas.

Top right: These daffodils, variety Sempre Avanti, were growing profusely beside a slatted bridge. The sheer number of blooms and the size of the clump make this an outstanding specimen shot, and the slatted bridge adds a rustic background to highlight the scene.

Right: Like a flock of butterflies, the swept-back blooms of this miniature daffodil, Beryl, give the appearance of motion. The cluster is a magnificent specimen rarely seen in such profusion.

his magnificent daffodil plantings, taking more than 50 pictures, and he was pleased with the results. A year later he told me that *Architectural Digest* was interested in featuring his garden. I submitted those pictures for consideration and they were accepted for the November 1977 issue. One of the pictures—a composition of daffodils against a split rail fence and log pile, was blown up to a double-page spread, and when I later visited the magazine's headquarters in Los Angeles, I was delighted to see my picture framed and hanging in the general editorial office.

Another successful garden feature was Inverewe, a sub-tropical garden on the remote northwest coast of Scotland, where palm trees thrive in the open air as a result of a microclimate created by the Gulf Stream. It was a lucky day when I visited Inverewe—a

beautiful clear sky and very few tourists. The garden is situated in a spectacular setting, on a sparkling blue horseshoe bay surrounded by the awesome Torridon Mountains.

To capture the atmosphere of the garden, I first took a number of general scenic views showing the bay and mountains in the background; this gave it a sense of *place.* I then concentrated on special features in the garden, such as group plantings where several kinds of plants presented a mass of color.

Particularly unusual was the blue poppy, a striking perennial from the high Himalayas, which is extremely difficult to grow. The blue sky, the blue bay and the blue poppies, contrasting with the darker hues of gray retaining walls, brown mountains and green foliage, were a particularly impressive combination that helped to convey the fact that this

is a special garden. Sometimes it takes just one special scene to make a salable photo feature.

Although I will travel anywhere in the world to photograph exceptional gardens, it's a mistake to believe that you have to travel great distances to find marketable garden pictures, or that a garden must be on a grand scale to offer sufficient scope for a feature with publication qualities. One of my favorite garden features is a wild garden located near my home, covering only two acres. I visited it one morning in May after calling the owner, David Benner.

It was a perfect day, the peak of the wildflower season, and after an hour of shooting I had all the makings of a top-notch photo feature. The garden was located on a wooded hillside and ascended the slope in a series of terraces, each one a separate garden area, all connected by stone steps and winding

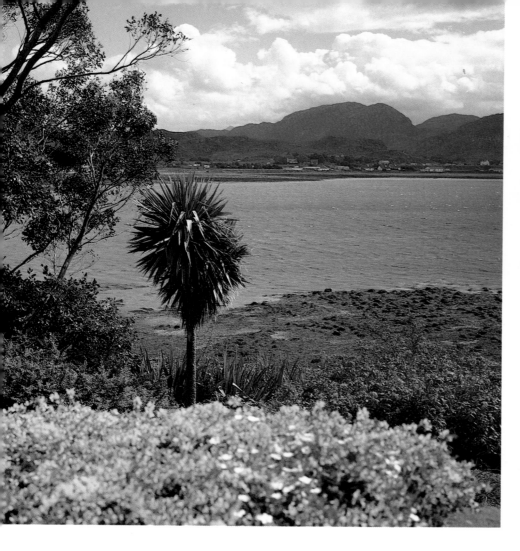

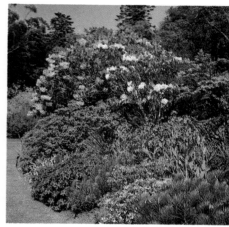

Two vital ingredients for good garden features are *overall* views and *specific* views:

Inverewe is a sub-tropical garden in Scotland where a pocket of warm air from the Gulf Stream creates a unique microclimate. *Overall* views, with distinctive landscape features such as this palm tree, rugged mountains and blustery sky, help to establish a sense of "place."

In addition to palm trees, Inverewe has exceptional plantings of rhododendrons and blue poppies. In this *specific* view of a perennial border, I was able to capture both in one picture. These pictures were part of a series photographed for *Architectural Digest*.

paths. An overhead canopy of green leaves from tall trees produced filtered light, while masses of primroses, phlox, columbines, ferns and other wild plants carpeted areas of forest floor threaded with footpaths.

Architectural Digest loved it, and I was soon back to the owner with a release form to request permission for the magazine to use the material.

WOMEN'S MAGAZINES

Some women's magazines pay the highest rates for photography, especially publications such as *Woman's Day* and *Family Circle* sold at the supermarket checkout counter. They are service oriented, and their garden features generally must appeal to a population of apartment dwellers and homeowners. Competition between these magazines is fierce. If you find yourself contributing to

one, my advice is to stay loyal to it and not jeopardize your relationship by working for the other.

I have regularly contributed garden articles and plant photography to *Woman's Day*. Of all the magazines I work for, this one is my favorite.

My work came to the attention of the magazine's features editor, Cynthia Kellogg, as a result of a book I wrote on vegetable gardening. She invited me to help them with an article on that topic. The article was a success and I continued submitting ideas that fell on fertile ground. It was a period in the magazine's history when they were aware of an increased interest in gardening and were receptive to innovative gardening features with popular appeal.

Although graphics are important at *Woman's Day*, a garden story is usually bought first on the basis of the manuscript and only

then does the art department become involved to create effective pictorial material. After I gained acceptance as a writer, it was natural that the art department should consider me as a resource for photography. Each year they buy a large number of pictures separate from my articles.

I submit several ideas at one time to this magazine, with a brief outline describing how each article would be treated, enclosing good picture material to back up the outline. The editors then decide which ideas they like and I proceed to put the articles together, giving them a complete package of text and pictures. My favorite assignment for *Woman's Day* was a photo feature on cacti and succulents. The flowering kinds are so beautiful that they can surpass orchids in sheer brilliance and exotic form. After receiving the assignment, I decided that my

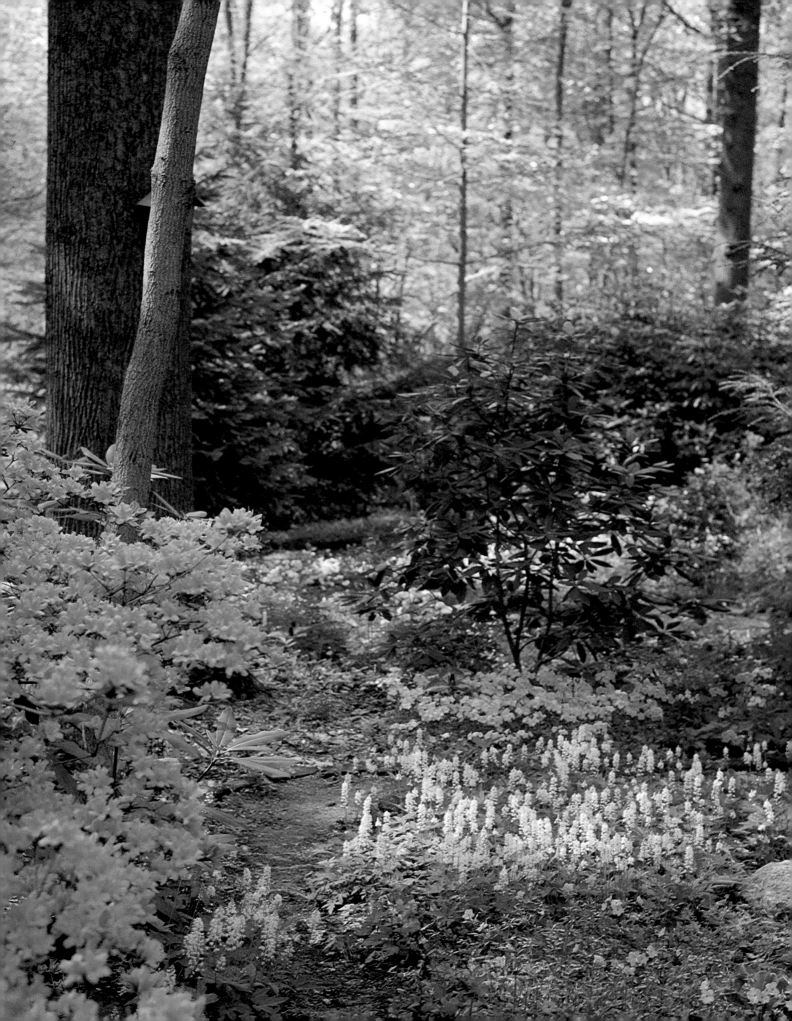

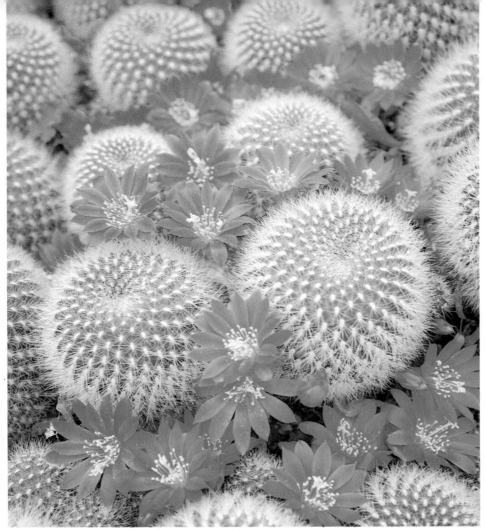

In spite of their fierce appearance, cacti have some of the most beautiful flowers in the world of plants, rivaling orchids in sheer brilliance. The Rebutia, or crown cacti, are free-flowering, and the spines form interesting swirling patterns. Although I could have moved in even closer, my picture is better from afar. It shows a large area of flowers and includes as many barrel shapes as possible.

Echinopsis, or Easter-lily cacti, have flowers that rival even the waterlily. This cluster of flawless blooms was growing on a single plant. The whole group makes a better picture than a single flower in close-up.

existing cactus picture selections needed to be expanded with a bigger assortment of flowering kinds, so I contacted a local cactus grower, Far Out Cactus, near West Chester, Pennsylvania. The owner advised me when his prize specimens were coming into bloom. At that time I spent several hours shooting, and returned with the most beautiful flowering plant pic-

Opposite: To gain experience in shooting gardens, you can often find spectacular gardens close to home. This wildflower garden was located just three miles from my home, and was published across a two-page spread in Architectural Digest.

tures I've ever taken—especially close-ups.

Similarly, photo features on geraniums and begonias in *Woman's Day* used a number of my pictures to make colorful presentations, and an article I wrote on ferns and palms used picture material from two other photographers in addition to my own.

GARDEN MAGAZINES

There is not as much rivalry among garden magazines. It's possible to enjoy a profitable relationship with them all, whether you are supplying pictures, manuscripts or both.

Although garden magazines are easier to sell to, the fees are not

very high. I've found the best way to work with them is to sell text and pictures together. When the photo and writing fees are combined, you can earn a good amount. My relationship with several garden magazines is such that they will accept just about anything I care to send them, but I usually query the editor first with a brief outline and a representative selection of color transparencies to show the quality of the picture material. I also provide pictures for garden magazines after receiving want lists or calls from the picture editor.

I especially enjoy working with *Plants Alive, Flower & Garden* and

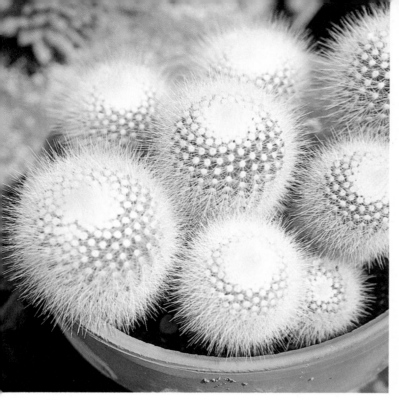

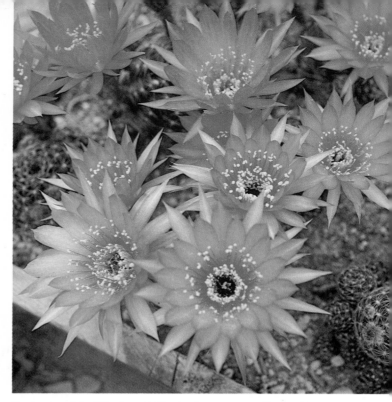

Even when not in flower, cacti can present a wealth of textured shapes, some like modern sculpture. This gleaming cluster of silver barrel cacti, *Notocactus scopa*, reminded me of sea coral. Including the pot is important to the composition of this picture. However, when showing pots be sure they are *clean*. There's nothing more distracting than a pot with a chipped rim or ugly algae growth around the sides.

Again, I resisted the temptation to focus on one flower. The sheer brilliance and flawless beauty of many flowers makes this a striking group scene. These are cob cacti, *Lobivia arachnacantha*.

Horticulture. Features on Longwood Gardens, daffodils, grapes and new flower varieties are examples of stories placed in *Plants Alive. Flower & Garden* has used color material on zinnias, coleus, impatiens and tomatoes, generally slanted toward the how-to-grow angle.

Some of my best work has appeared in *Horticulture* magazine. I was especially pleased with their treatment of an article entitled "The Culbin Forest," an account of how a desert area in the north of Scotland had been turned into a verdant forest. Pictures of desolate sand dunes showing how the area looked *before* forestation and pictures of the mature forest with lichen and mosses carpeting the forest floor *after* forestation vividly communicated the miraculous transformation. Also, I produce an article each year for *Horticulture* about "New Flower and Vegetable Varieties," illustrated with my color transparencies.

Most of my garden features are speculative. Gardens are very difficult to shoot as assignments. Unlike interiors, which you can always shoot with proper artificial lighting, gardens can suffer badly from inclement weather—and even if the weather is good the day you are there, the plant material may not be impressive.

Harry Smith, the famous plant photographer in England, had what I consider the perfect assignment—illustrating *The Rothschild Rhododendrons.* The photographs were made at the Rothschild estate, Exbury, in Hampshire, England. The publishers wanted Exbury and its plant material photographed at every season of the year, so Harry made an arrangement with the head gardener to be called whenever outstanding plant material was at its best. This involved a series of trips beginning in winter when the first witch-hazels are in bloom, and ending in fall when the grounds display magnificent fall colors. The book is a masterpiece because of Harry's photography, which could never have been accomplished in a single day or even in a single season.

Don't overlook the chances of good salesworthy pictures at well-known facilities. Although Longwood Gardens, Kennett Square, Pennsylvania, is one of the world's best known gardens, I have sold several features on it, and find it a rich source of specimen pictures.

TRAVEL

It pays to travel. Each year I try to visit a different area of the world noted for beautiful gardens. I usually have no trouble recovering my expenses and turning a profit as a result of selling unusual photo features, even if I don't have a special assignment. However, it always pays to tell editors where you are planning to travel because this will sometimes produce some assignment work.

For example, I advised *Architectural Digest* of a proposed trip to the Scilly Islands off the coast of England. They confirmed interest in seeing photographs of Tresco Abbey Gardens, a subtropical

garden on one of the islands. Similarly, when I visited Hawaii, several garden magazines expressed interest in special kinds of photo features and subsequently purchased them, even though they did not give me a definite assignment.

Hawaii is a photographer's paradise, and you would think that every aspect of it has been done to death in magazines. However, it was relatively easy to place a photo feature entitled "The Gardens of Hawaii" in *Popular Gardening Indoors.* I went to Hawaii mainly to improve my collection of tropical fruit illustrations. Crops such as sugarcane, pineapple, papayas and banana trees are always in demand by publishers, and I realized that by going to Hawaii, I could quickly and conveniently obtain a good cross-section of tropical food crop photos. There was also a chance of getting some good landscape and scenic views for lecture work, particularly for a program I was developing entitled "Great Gardens of the World."

When flying to faraway places and shooting to a rigid time schedule, it is crucial to plan ahead and do as much research as possible. Ahead of time I contacted a friend who was retired from the agricultural department at the University of Hawaii, and he provided me with a list of the best gardens to visit, including some good private gardens.

After renting a car, I methodically located each garden, concentrating mostly on the islands of Oahu and Kauai. Kauai was a fascinating place because of its contrasts. Within a few miles of the "wettest place on earth," where ferns grow in profusion, is a magnificent cactus garden called Plantation Gardens, in a dry area of the island. Hawaii is full of surprises!

Europe is rich in beautiful gardens, especially France, England, Italy, Holland, Germany and Denmark. Some of the grand old English estates are especially

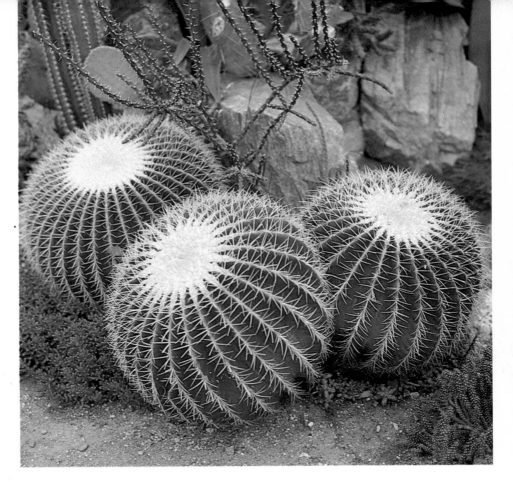

Cacti don't have to be in full bloom to create striking pictures. This is a personal favorite, a group of golden barrel cacti, *Echinocactus grunsoni.* The three perfectly-formed specimens are better than a close-up of one or even two.

I took this picture of a ball cactus, *Notocactus crassieissus,* in flower for a magazine cover. The blooms are centered with plenty of space above for the magazine's name, and there is also room at the sides and below for titles.

beautiful, with gleaming free-form lakes, gazebos, sweeping lawn vistas and noble trees. Each year I travel there to different gardens. The British have a useful directory containing more than 1,500 gardens, large and small, which are open to the general public. It is *Gardens of England & Wales,* and is available from The National Gardens Scheme, 57 Lower Belgrade Street, London, SW1W 0LR, United Kingdom. Another book, *Scotland's Garden Scheme,* is available from Scotland's Garden Scheme, 26 Castle Terrace, Edinburgh EH1 2EL, United Kingdom.

I found the spaciousness of the Palace of Versailles near Paris, France uncomfortable to work in, and could find little in the immediate area that had not been exhaustively photographed and already published. My interest perked up only when I began to explore outlying areas of the palace gardens. I began shooting roll after roll of intimate garden

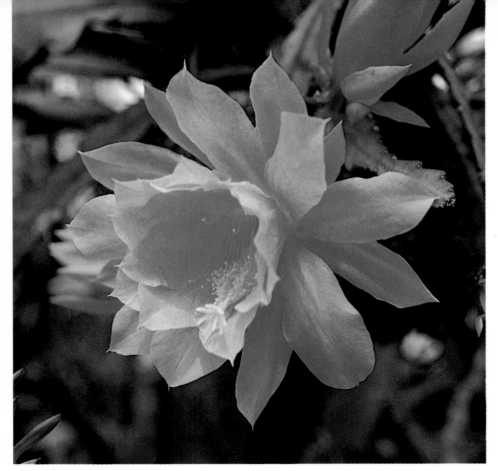

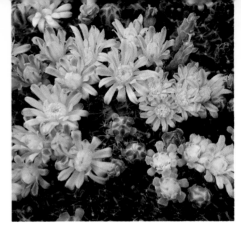

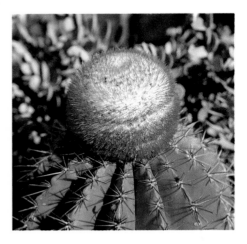

Orchid cacti, epiphyllum hybrids, are tree-dwelling plants. The flowers form at the end of long pendulous branches, lasting only a day. They are quite large, and ideal for dramatic close-ups of one perfect flower in peak bloom.

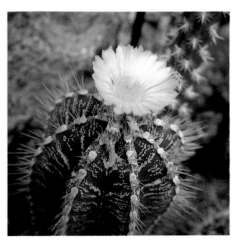

Top: A mass of flowers in peak bloom often photographs best with the flowers filling your frame and "bleeding" off to the sides, like a galaxy of stars.

Center: The bizarre flower ball of Turk's cap cactus, *Melocactus intortus*, is an impressive sight, so it occupies the sole focus of my attention, with care taken to ensure the background provides a good contrast for the chestnut-colored ball.

Bottom: Before shooting cactus flowers in close-up, consider the rest of the plant and decide whether its lower portions have interesting shapes and textures that should be included in your portrait. This picture of a star cactus, *Astrophytum ornatum*, in full flower is interesting because of the column shape and freckled ribs of the main stem.

scenes that even the official guide books failed to recognize.

One of my favorite artistic landscape pictures was taken there. Within the grounds is a community of cottages called Le Petit Hameau—The Little Hamlet—where Marie Antoinette, last queen of France, loved to spend her private moments, away from the formalities of court life. The cottages surround a peaceful waterlily pond, bordered with trees that dip their branches lazily to the water's edge. I circled the pond, seeking a picture that would convey the seclusion and tranquility of the place, and found a gap in the trees where I could not only show part of the hamlet framed with greenery backlighted by weak sunlight, but a beautiful set of reflections from the mirror-smooth surface of the pond. This picture demonstrates the attraction the location had for a queen who was always the center of

attention and who valued quiet, intimate places.

Close to Versailles is an unusual garden center called Florelites. Garden centers normally do not offer much except piles of peat moss and regimented lines of transplants and nursery stock, but Florelites is different. It features a huge display garden in addition to a spacious selling center. I found model vegetable gardens, herb gardens, waterlily gardens, miniature orchards, espaliered fruit trees, greenhouses fully stocked with flowering plants, shade gardens, rock gardens, perennial borders and acres of flowering annuals in the display garden. Everything was neat and clean. There is nothing like it anywhere else in the world, and the resulting photographs helped me sell a feature to one of the leading nursery trade magazines, *Nursery Business.*

On my arrival in Japan to visit

Top: Deadly nightshade, *Solanum dulcamara*, offers a poisonous berry cluster that is highly attractive to children.

Center: Black walnut, *Junglans nigra*, fruits ripen in fall. These outside nut cases turn oily black when fully ripe and drop to the ground.

Bottom: This rabbit's foot fern, *Davallia griffithiana*, was growing in a commercial greenhouse. Although such greenhouses are generally untidy places, and are unsuitable as backgrounds, in this case the busy background is a good contrast.

The simple beauty of this perfect *Alocassia watsoniana* leaf makes a dramatic close-up.

some of the leading seed companies and photograph Japanese gardens, the first item on my agenda was to buy as many Japanese garden books as possible. The bookstores were full of them, and they provided me with ideas for shooting Oriental gardens to the best advantage. One realization was that I had come at the wrong time—early September—which is too early for the fabulous fall coloring that enlivens every Japanese garden, and too late for the crisp green colors and sparkling fresh blossoms of spring.

Although I did visit many of the more famous Japanese gardens, such as the Katsura Imperial Palace and the Golden Pavilion, I deliberately sought smaller, more intimate, lesser-known gardens, and found a greater sense of satisfaction from the pictures of these unknowns.

From Japan I flew to Taiwan. Although that area is not noted for outstanding gardens, its scenery is breathtaking. The place gave me a feeling of Hawaii, with happy, smiling people, a tropical climate and spectacular mountain ranges plunging into the sea. Unfortunately, my stay in Taiwan was too brief to explore some of the wilderness areas, and I had to content myself with visiting a few temple gardens with their emphasis on elaborate pagodas and moon viewing bridges, rather than exotic plant material.

On my return to the United States, I had no difficulty selling a photo feature contrasting the Japanese style of gardening with that of the Chinese. In addition, I had a lot of good material to improve my "Great Gardens of the World" lecture series. Furthermore, I was able to add to my picture library a number of specimen shots of plant material difficult to locate in the United States.

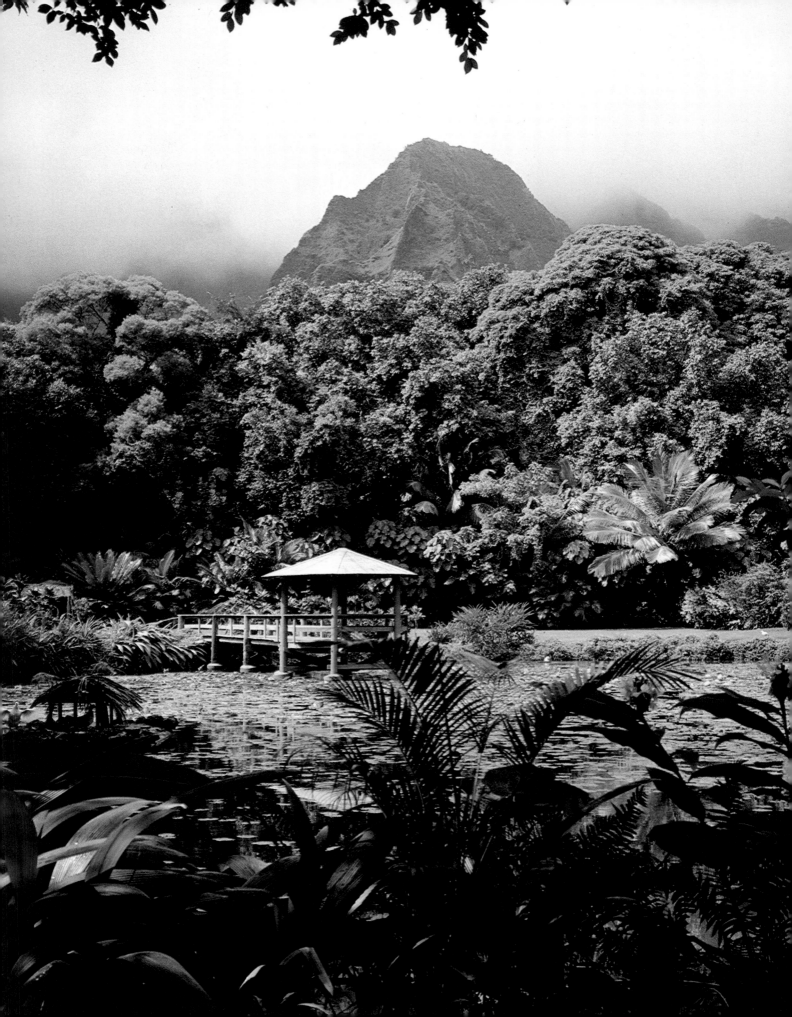

Sweeping branches of an oak tree and its reflections in a waterlily pond help frame a hamlet where Marie Antoinette, last Queen of France, loved to seek solitude.

Opposite: My most thrilling travel experience was visiting the gardens of Hawaii. This overall view of Haiku Gardens near Honolulu was published as a double-page spread in *Popular Gardening* magazine to illustrate my article, "The Gardens of Hawaii."

TEAMWORK PAYS OFF

No two publishers seem to work alike. In my experience some publishers really make a lot of work for themselves because they have no idea how to work effectively with photographers. For example, when publishers produce heavily illustrated reference books, they usually work with a horticultural consultant who dreams up lists of plant varieties. The art director or picture editor then has to search for pictures to match the lists. How much easier and less expensive it would be to first consult with several photographic picture libraries, find out what pictures are generally available, and then make up the lists.

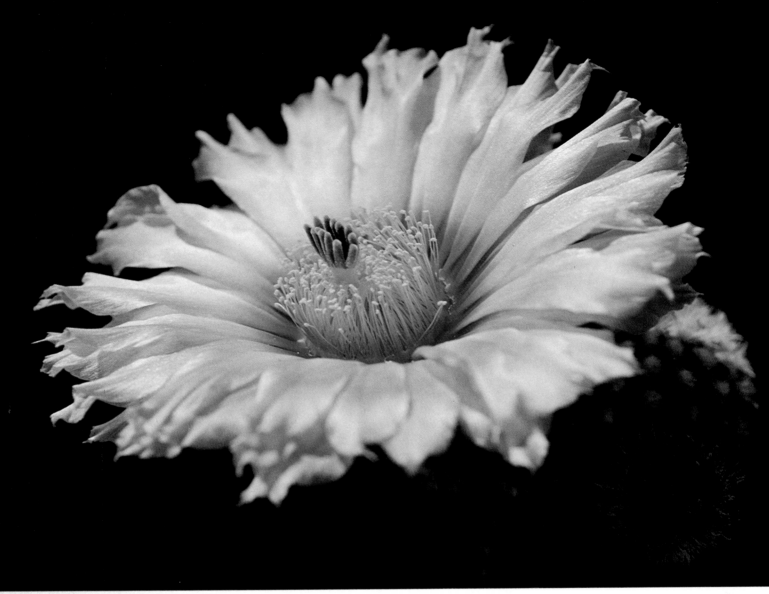

Although I prefer to shoot close-ups of flowers with natural backgrounds and avoid using artificial backgrounds, I do like the occasional use of a black background. This close-up of a single bloom of a hedgehog cactus, *Echinocereus reichenbachii,* would be less spectacular with any other kind of background.

One picture editor admitted the frustration of trying to match lists with pictures, and said that if they'd had the foresight to find out picture availability first, they could have cut their budget by 50 percent. In some cases the savings can be even greater: When pictures cannot be found after extensive searching, photographers must then be hired to shoot them on assignment at much higher daily rates, whereas a plant photographer using stock pictures from his files can often work out a very economical bulk rate.

Some catalog houses have the right idea. Several catalog managers will call me ahead of planning their spring catalogs and ask to go through my files, seeking effective pictures. They go through the files and decide on what to feature in their new catalogs on the strength of a salesworthy picture. They realize that a good picture will often make the difference between profit and loss for a catalog item. One catalog manager told me that normally a black-and-white picture will sell *twice* as much product as a plain listing, while a color picture will normally sell *six* times more.

When publishers can be flexible in choice of pictures, they may be able to save a lot of money and acquire good picture effects. I'm not suggesting this should always be the case, but where a picture is the most important component of a published piece, it pays to talk with a photographer with file material *before* the project is finalized.

Index